WARHOL'S
MUSES

ALSO BY LAURENCE LEAMER

NONFICTION

Hitchcock's Blondes:
The Unforgettable Women Behind the Legendary Director's Dark Obsession

Capote's Women: A True Story of Love, Betrayal, and a Swan Song for an Era

Mar-a-Lago:
Inside the Gates of Power at Donald Trump's Presidential Palace

The Lynching: The Epic Courtroom Battle That Brought Down the Klan

The Price of Justice: A True Story of Greed and Corruption

Madness Under the Royal Palms:
Love and Death Behind the Gates of Palm Beach

Fantastic: The Life of Arnold Schwarzenegger

Sons of Camelot: The Fate of an American Dynasty

The Kennedy Men, 1901–1963: The Laws of the Father

Three Chords and the Truth:
Hope, Heartbreak, and Changing Fortunes of Nashville

The Kennedy Women: The Saga of an American Family

King of the Night: The Life of Johnny Carson

As Time Goes By: The Life of Ingrid Bergman

Make-Believe: The Story of Nancy and Ronald Reagan

Ascent: The Spiritual and Physical Quest of Willi Unsoeld

Playing for Keeps in Washington

The Paper Revolutionaries: The Rise of the Underground Press

FICTION

The President's Butler

Assignment

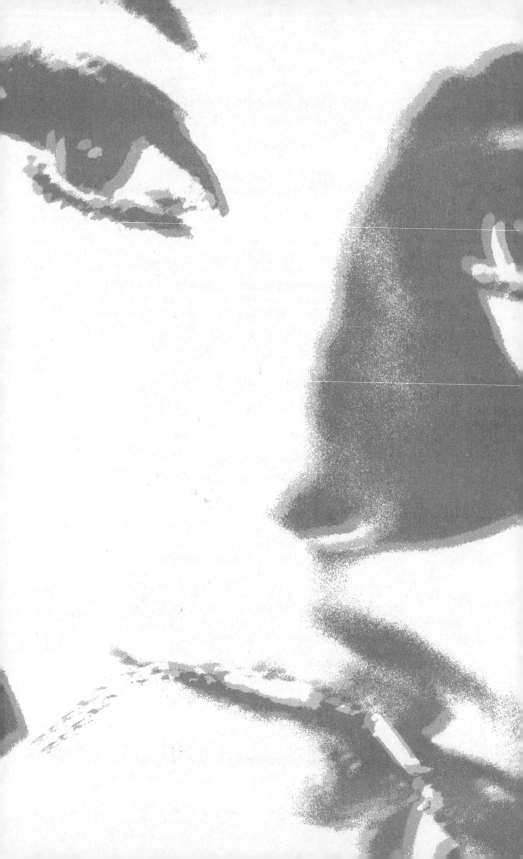

WARHOL'S MUSES

The Artists, Misfits, and Superstars
Destroyed by the Factory Fame Machine

LAURENCE LEAMER

G. P. PUTNAM'S SONS
NEW YORK

PUTNAM
— EST. 1838 —

G. P. Putnam's Sons
Publishers Since 1838
An imprint of Penguin Random House LLC
1745 Broadway, New York, NY 10019
penguinrandomhouse.com

"Coming Up for Air" by Gerard Malanga originally appeared
in *Poetry* (February 1967). Used by permission of Gerard Malanga.

Photo credits appear on page 301.

BOOK DESIGN BY KRISTIN DEL ROSARIO

Library of Congress Cataloging-in-Publication Data

Names: Leamer, Laurence, author.
Title: Warhol's muses: the artists, misfits, and superstars
destroyed by the Factory fame machine / Laurence Leamer.
Description: New York: G.P. Putnam's Sons, [2025] |
Includes bibliographical references and index.
Identifiers: LCCN 2024044554 (print) | LCCN 2024044555 (ebook) |
ISBN 9780593716663 (hardcover) | ISBN 9780593716670 (epub)
Subjects: LCSH: Warhol, Andy, 1928–1987—Friends and associates. |
Warhol, Andy, 1928–1987—Relations with women. | Artists—United States—Biography. |
Classification: LCC NX512.W37 L43 2025 (print) |
LCC NX512.W37 (ebook) | DDC 700.92/273—dc23/eng/20241230
LC record available at https://lccn.loc.gov/2024044554
LC ebook record available at https://lccn.loc.gov/2024044555

Printed in the United States of America
1st Printing

The authorized representative in the EU for product safety and compliance is
Penguin Random House Ireland, Morrison Chambers, 32 Nassau Street,
Dublin D02 YH68, Ireland, https://eu-contact.penguin.ie.

To Susan Nernberg

If there's a better person, I've yet to meet her

To George Abagnalo

Sometimes new friends are the best

CONTENTS

CONTENTS

WARHOL'S
MUSES

PROLOGUE

June 1968

Late in the morning of June 3, 1968, twenty-three-year-old Margo Feiden returned to her Brooklyn apartment after a pediatrician's appointment for her eighteen-month-old daughter, Bambi. There on the stoop sat a strange creature; Feiden could not tell if this was a man or a woman. Summer was almost upon the city, but the person wore a heavy wool coat, fingerless gloves, and a black cap.

Valerie Solanas introduced herself. She said she was there because Feiden was a "woman producer," and Solanas had an urgent matter she wanted to discuss with her. "I'm a playwright," Solanas said. "And I want to talk to you about a play I've written."

At that point, many mothers would have clutched their babies tightly, hurried up the stairs, and locked the apartment door. Feiden did not even consider doing that. She had a certain daring coupled with an artistic sensibility that had always served her well. She'd already produced a successful Broadway musical version of *Peter Pan* with actors from the High School of Performing Arts—when she

herself was just sixteen years old. Over the next several years, the precocious Feiden had produced other plays, but nothing with the success of her first effort. Still, she was an established and successful theater- and art-world mover and shaker. Solanas knew Feiden would be the perfect person to produce her new play, which she clutched under her arm.

Feiden was always looking for new ideas and people to inspire her work. So why not invite this woman up and hear her out? They ascended the stairs together. Still wearing her coat, Solanas paced back and forth in Feiden's apartment, bursting forth in a manic monologue of startling originality. Thirty-two-year-old Solanas had rarely been so articulate and persuasive or had an audience that listened so long or so attentively.

Solanas laid it all out there for Feiden, not just the play she had written, but her life story: how her father had sexually abused her, how other men had hurt her in different ways, and her proposed solution, a world largely devoid of men. Solanas expressed her ideas with energy and sarcastic wit. She had an answer to everything.

"But aside from procreation, what about women who want to have sex with men?" Feiden asked.

Solanas had it all worked out: "We'll keep men in bullpens, and women will come and choose which one they want (number 3, number 30, number 98)." In her feminist paradise, it was one of the few roles some men might genuinely enjoy.

Listening to Solanas, it was clear to Feiden that this woman in front of her was not the new Karl Marx elucidating themes from a feminist version of *The Communist Manifesto*. She was more like the savage satirist Jonathan Swift, whose *A Modest Proposal* suggested the Irish could work their way out of poverty by the poor selling their children as food for the rich.

Feiden saw pacing before her a brilliant young woman "with in-

telligent, sad eyes," but a "tragically damaged person." If only Solanas could pull back a little, asserting a greater measure of sanity, her prospects were endless.

After Solanas had gone on for three and a half hours, detailing her vision of a brave new world, she segued abruptly to the purpose of this journey to Brooklyn. She asked Feiden to produce her play, *Up Your Ass*. The main character in the wild farce is Bongi, a sardonic lesbian hustler meeting a series of over-the-top characters on a long, twisted road leading nowhere.

Solanas's play lacked the commercial upside or artistic vision to intrigue Feiden. "You're wasting your time," Feiden said. "I won't produce it." Seeing those dark, desperate eyes, Feiden might have been better off letting Solanas down gently. It would have been disingenuous to say she must read the play before deciding, but that might have walked Solanas back off the ledge.

Feiden was a member of the sisterhood, and Solanas did not blame her. But she was determined to get what she came for. Solanas pulled a gun out of a cloth bag.

"Do you know what this is?" Solanas asked, as if there were any doubt.

"It looks like a gun," Feiden said.

As Solanas pointed the Beretta .32 automatic at the ceiling, Feiden stayed very still. She thought of her infant daughter, sleeping in the next room.

"If you don't agree that you will produce my play, I am going to shoot Andy Warhol," Solanas said as she held the gun in her hand, giving her threat more gravitas. "Then I will become famous, my play will become famous, and you will produce it."

Warhol was the most famous person Solanas knew, and the pop artist had already spurned her play. That's why Warhol was her natural target. Kill him, and she and her work would have their own fame.

"You don't want to do that," Feiden said. "You don't need to shoot Andy Warhol, because that won't get me to produce your play."

As Solanas left in the early afternoon, she handed Feiden a copy of *Up Your Ass*. Despite Solanas's menacing rhetoric, it was reasonable for Feiden to think her impromptu visitor had been simply spouting idle threats. Why would shooting Andy Warhol help this woman's artistic cause, anyway?

But Feiden had a disturbing sense that her new acquaintance might be deadly serious. Something in her eyes, her tone of voice, the meandering ramblings of a disturbed mind that kept circling back to Warhol and vengeance—it was all just too concerning. Feiden knew it was about a half hour subway ride from her Brooklyn home to Andy Warhol's Factory, the Union Square–area studio that was his workspace, home base, and the cultural hub of his world. Was that where Solanas was going after she'd left Feiden's home? If so, Feiden figured she might have just thirty minutes to prevent a tragedy.

Feiden locked the door behind Solanas. Then she started making phone calls. Her first call was to her local police precinct to warn them about the young woman with a gun and a grudge. They treated her like a prank caller. Next she called Warhol's precinct. When the response was no better, she dialed Manhattan police headquarters. She even tried the offices of Mayor John V. Lindsay and Governor Nelson Rockefeller, but no one she spoke to expressed any interest in her increasingly desperate pleas.

Feiden did not realize Andy Warhol Films was in the phone book. Had she reached that number, whoever talked to her would probably have locked the entrance door and warned Warhol. Solanas would have gone away disappointed, but as she slowly came down off her manic peak, she might have set her mad scheme aside.

Feiden turned on the television, fearing the soap operas would be interrupted to say Warhol had been shot.

||||||||||||||||||||||

When Solanas arrived at the Factory, Warhol was not there. Obsessed with what she must do, she returned as many as seven times that afternoon, trying to catch him. Solanas had ditched the hat she had worn earlier at Feiden's house, and she had exchanged the cloth sack for a paper bag containing two pistols: the Beretta she had waved before the young producer and a Colt .22 revolver. Her short hair was neatly coiffed, and she wore lipstick and makeup as if prepared to have her photo taken. She had lost the manic rage Feiden had seen in her and was in a zone of clear purpose and steely resolve.

When thirty-nine-year-old Warhol exited a Checker taxi in front of the Factory at 4:15 p.m., wearing a brown leather jacket over a black T-shirt, Solanas was waiting for him. As Warhol paused on the sidewalk, his boyfriend, Jed Johnson, strode up. Hired initially to sweep floors at the Factory, Johnson had transitioned to a new role as Warhol's lover and constant companion. A nascent interior decorator, Johnson was carrying fluorescent lights back to install in the studio. Solanas entered the building and waited for the elevator beside Warhol and Johnson.

Warhol, always studiously observant, understood the importance of clothing as a defining characteristic representing who a person was (or wanted to be). He noted that Solanas wore a turtleneck and a thick fleece trench coat that would have been perfect for a frigid January day . . . but it was a muggy June afternoon. Her lipstick and makeup were thickly yet inexpertly applied, as if their wearer were not used to such cosmetics. Something was definitely off.

Solanas followed Warhol and Johnson into the Factory offices. Warhol gave her an appraising look that didn't invite approach. It was his way to push back from people with whom he did not wish to be associated. She had made a bit of a nuisance of herself over the past few months. He wasn't about to encourage her.

Warhol took the phone to talk to Viva, his friend and one of the glitzy "muses" who were always flitting around—accompanying him to parties, starring in his movies, and adding a tinge of glamour to the louche proceedings. Viva was having her hair done across town at Kenneth's, *the* premier beauty salon of the moment.

Viva was Warhol's newest Superstar, and she was a real find. Viva was tall and lithe and had incredibly long legs. Her face was like Dietrich or Garbo, so well defined that it was beyond beautiful, and she spoke extemporaneous lines worthy of a stand-up comic. Her upscale hair appointment was being paid for by movie studio United Artists, in advance of her appearance in a small role in *Midnight Cowboy*, the John Schlesinger film being shot in Manhattan. A story of two Times Square hustlers, it showcased the dark, gritty underground of New York City. It's hard to imagine the movie being made without Warhol's groundbreaking 1966 film, the infamous *The Chelsea Girls*, preceding it.

Warhol rarely had *short* phone conversations with his friends during his free time. And Viva was particularly chatty. He was usually perfectly willing to listen to her giddy tales for an hour or so, but today he felt exhausted as she detailed the shades the colorist was applying to her hair. As Warhol sat in his Eames chair with the receiver up to his ear, half listening, his eyes darted around the studio before settling on Mario Amaya, an art critic and curator and one of his new friends.

Amaya was a self-conscious, self-made, often self-aggrandizing man with an uncanny knack for attaching himself to success. The

Brooklyn-born critic spoke with a perfectly cultivated British accent that could have gained him entrance to the family quarters of Buckingham Palace. His stylish dress matched his posh, put-on accent. Amaya looked with condescension at the collection of characters littering the Factory, including the odd figure of Solanas skulking around the perimeter. She was dirty, unseemly. She had no business around Warhol, a famous and successful artist. Amaya was bewildered at how a man as intelligent as Warhol could "surround himself with dreary, creepy people." It was pathetic.

Solanas was used to people hardly noticing her or dismissing her when they did. No one paid any attention as she pulled out her Beretta and pointed it at Warhol. When the first shot rang out, Amaya thought it was a sniper's bullet fired from another building. Only Warhol understood immediately what was happening.

"Oh, Valerie!" Warhol shouted. "No! No!"

1.

Riding the Whirlwind

In 2022, nearly four decades after his death, Andy Warhol's silkscreen portrait of Marilyn Monroe sold for $195 million, a record amount for an American painting. Warhol's iconic look (a silvery wig with pasty features and a slim, black-clothed silhouette) are instantly recognizable—almost a "personal brand" before such a concept even existed. He is the most famous and successful twentieth-century American artist.

Warhol is the defining figure of pop art, an artistic movement that burst forth in the early sixties, taking fine art on a wild roller-coaster ride. In the same way that jazz is the first uniquely American music, so pop art is profoundly American, a pure product of mid-twentieth-century American culture. Pop art took the common artifacts of life—including cartoons, movie star shots, and advertisements—and blew them up into stunning images. Warhol and his fellow artists democratized art, taking it out of the sedate salons and into a garish new world.

But Warhol impacted American culture and life far beyond his art. Although he lived within a narrow world, he understood what was happening in society far better than the cultural and political radicals of the sixties, with their glorious visions of the future. He pierced America's facile optimism and saw a society riven with alienation. By his own making, Warhol became something of a cartoon figure, yet he was a messenger carrying a dark message.

As an emerging pop artist, Warhol sought a way to enter the world of the rich and famous and, once there, to make his artwork an integral, must-have feature of grand homes from Manhattan to Bel Air to Palm Beach. In early 1960s America, most artists had little interest in such self-promotion. Since only a niche audience for contemporary art existed, they saw little reason to reach out beyond their world. Warhol looked beyond the previously defined role of "artist" in society. He did not want to be sequestered in his garret studio, cut off from the world.

Warhol sought to be famous beyond measure. That was his great challenge: not the art he quickly assembled in the Factory, but making himself such an iconic figure that art connoisseurs could not live without a Warhol on their walls.

Warhol was not a naturally gregarious social creature. Nonetheless, to further his career and his ambition, he went out almost every evening, soaking up both the high-society world he wished he'd been born into and the low-life world that fascinated and repelled him. He knew that cultivating a unique image was the best advertisement for himself and his art.

Warhol also knew he could not get where he wanted to go by himself. He was, by his own admission, a weird-looking gay man in a world and an era that wasn't hospitable to such as him. "I really look awful, and I never bother to primp up or try to be appealing because I just don't want anyone to be involved with me," he said.

Alone, Warhol could travel only so far in society's rarefied circles. He realized he needed to be around stunning women. They would raise his social cachet dramatically and bring him the publicity and public adulation he so desired.

With a beautiful woman on his arm, a man—even a quiet, awkward man (as Warhol understood himself to be)—could go almost anywhere. So, Warhol started to collect these women, like trophies or playthings. He called them his Superstars, gave several of them new names, featured them in his underground films, and accompanied them to places he could not have gained admittance to alone.

By the time Warhol met most of these women, he had completed much of his so-called "major" art, but his Superstars helped to raise his profile and his work into the stratosphere. While the Warhol Superstars did not necessarily influence the making of his work, they played seminal roles in its wide acceptance—and they were integral to what is possibly Warhol's greatest and most enduring creation: himself.

These women were not just his Superstars, they were his artistic muses who helped turn the Pittsburgh-born son of Eastern European immigrants into international artist Andy Warhol. They talked to him every day and were key to his emotional life. And while many of them have received attention, their contributions to the artistic world they helped to define—and their own artistic ambitions, personal struggles, and occasional triumphs—have been largely overlooked. Just like muses have been across time.

These women were intriguing and complex. They lived dramatic, often troubled lives. While the allure of Warhol's downtown bohemian New York was its unconventional, carefree, and often dark atmosphere, most of these women came from upper-class families whose members rarely traveled to such a downscale world. Their presence was its own form of rebellion from society's norms.

Warhol often christened them into their new lives by bestowing upon them new names that reflected not who they'd been, but who they wanted to be. Or at least, who *he* wanted them to be.

The first Superstar was Jane Holzer (Baby Jane), whose father had extensive real estate holdings in Palm Beach. Holzer had an incredible mane of blond hair that set her apart from her contemporaries.

But Holzer had nothing like the lineage of her successor, Edie Sedgwick, whose ancestor landed in the Massachusetts Bay Colony in the seventeenth century. Sedgwick was a petite beauty whose features the cameras loved.

Brigid Berlin's father was the chairman of the Hearst Corporation, giving his daughter keys to New York's elite world. Often rotund and always foulmouthed, Berlin lived to offend her mother.

Mary Woronov's life changed when her mother married a prominent Brooklyn surgeon. Tall as a Viking princess and unwilling to let Warhol change her name, Woronov took great pride in exuding a fierce, almost masculine aura.

Susan Bottomly's (International Velvet) mother was a Boston Brahmin. Although she was only seventeen when she first met Warhol, Bottomly was sophisticated beyond her years.

Susan Mary Hoffmann's (Viva) father was a highly successful lawyer in Syracuse, New York. With a wicked wit and savage intelligence, Hoffmann was game for almost anything.

Isabelle Collin Dufresne (Ultra Violet) had an upper-class European background. Salvador Dalí's former lover had an erudition unique among Warhol's muses.

Not all the Superstars were from privileged homes. Christa Päffgen (Nico) was brought up in decidedly humble circumstances in Germany during World War II.

Ingrid von Scheven (Ingrid Superstar) came from a modest New Jersey background.

James Slattery (Candy Darling) hailed from a lower-middle-class home on Long Island.

"The superstar was a kind of early form of women's liberation," argued Danny Fields, a music manager close to Warhol. "They were so smart, beautiful, aristocratic, and independent. . . . Everybody fell in love with them. . . . They're the women we all want to worship. . . . At the same time, they were very destructive people—self-destructive and other-people destructive. They were riding the whirlwind."

In a society that still widely disregarded and disrespected homosexuality, Warhol's Superstars softened his queerness for public consumption and brought him a dose of added glamour, even respectability. Those women from largely upper-class families took Warhol into a social world he could not have otherwise moved through. Unable to unlock those doors, he would have had difficulty developing the contacts and publicity crucial to his rise. Without his Superstars, Warhol might never have become a world-celebrated artist.

From Jackie Kennedy and Marilyn Monroe to Elizabeth Taylor and Judy Garland, many of Warhol's most memorable portraits are of iconic women of the age. This peculiar little man created images of strong, beautiful women as immortal as the subjects themselves. His ever-changing array of Superstars were, for the most part, not the subjects of his art, but they played indispensable roles in elevating him into the world-renowned artist we know today.

Warhol's Muses is the story of these women and what happened to them when they entered Warhol's world.

2.

Party of the Decade

Warhol's show at Manhattan's Stable Gallery in April 1964 was the most important event so far in his professional life, and he had prepared for the opening with meticulous concern.

The artist began by creating four hundred faux boxes of Brillo pads, Heinz ketchup, Kellogg's Corn Flakes, and Mott's apple juice. A child of his discontented time, Warhol wanted to stick it to the establishment and the mandarins of high art who controlled the content of the museums. And what better way to do that than to create an anti–high art, turning images of grocery store products into art?

But how to display it? This was industrial art. It would not do to set the plywood boxes off by soft lighting like the *Mona Lisa* at the Louvre. He had the wooden boxes stacked up one on top of another, as if in a warehouse waiting to be hoisted onto a truck for delivery to supermarkets.

To most viewers in 1964, such a tableau would not be recognizable as "art" at all. Art was an oil painting in a frame. A bronze

sculpture in a park. Maybe a perfectly composed photograph. Not a bunch of empty boxes piled on a gallery floor.

Warhol was an impresario as much as an artist. He had realized early on that *anything* could be art—much like the Dadaist Duchamp (and his infamous urinal) had done half a century before. And now, thanks to his witty ideas and a canny knack for self-promotion, Warhol was emerging as a key figure in a burgeoning pop art movement that turned artifacts of mass culture into art. He did not run from controversy. He knew that some considered his work—the whole pop art movement—to be little more than an embarrassing joke. Warhol embraced the controversy.

Warhol knew this show would get attention, but he did not necessarily think the pieces would sell out. Maybe a few items would go for the modest $200 to $400 asking price. After all, the publicity generated was already noteworthy, and the line to get into the gallery that night stretched down the block on East 74th Street. But as the evening wore on and nothing sold, Warhol had reason to be discouraged.

At least Warhol had Robert and Ethel Scull. The couple had promised to buy twenty Brillo boxes, paying $300 a piece or a neat $6,000. The Sculls owned a fleet of taxis called "Scull's Angels," hardly a business that brought them much social contact with the upscale residents of Manhattan. But over the last few years, the couple had slowly insinuated themselves into the art world, cannily selecting artists they admired and slowly acquiring a few pieces from them, then more. By now, they were well on their way to being leading pop and minimalist art collectors. This taste and artistic glamour—not their money—were the key that opened previously locked social circles to the couple. It was a lesson Warhol observed closely.

After the opening, the Sculls agreed to cohost a party for Warhol

with the socialite Marguerite Littman. The affair would be held at Warhol's scruffy studio at East 47th Street between Second and Third Avenues. It was ample space for a big party, almost eighty feet long and half as wide, with two filthy bathroom stalls.

When Warhol had moved in at the beginning of the year, the walls had been grimy and crumbling. His assistant Billy Linich (later called Billy Name) silvered the walls, applying aluminum foil to everything, until the space looked like a poor man's spaceship. In the middle of the room sat a red sofa that had been picked up off the street. It was so soiled that it probably should have been cordoned off, or better yet heaved into a dumpster downstairs. Instead, it was the focal point of the room. Name and his friends called the studio the Factory. The name stuck.

A few years earlier, almost no one of consequence would have taken a freight elevator up to the fifth-floor quarters to celebrate an artist obscure to nearly everyone beyond avant-garde circles. But by the mid-1960s, even more socially conservative New Yorkers were going places they once would have disdained. They were looking for good times in new places and, in doing so, unknowingly challenging the ways and rules of traditional society.

Social customs among the upper class in Manhattan had been clearly defined for most of the twentieth century. People of consequence lived on the Upper East Side. They saw their friends in privileged places: the Metropolitan Club, the Yale Club, and the Union Club. They went nightclubbing to only a few venues: El Morocco and the Stork Club. A few big annual charity events, such as opening night at the Metropolitan Opera, were obligatory.

In the Eisenhower years the social order was dominated by corporations and white-collar lives. But the 1960s shook things up in sudden, surprising ways. A new generation looked at their parents' lives as boring and reeking of hypocrisy. They wanted out. Longtime

social rituals fell apart. Young scions of wealth fled their parents' world, seeking new identities and new freedoms. Across the economic spectrum, people fended for themselves in a society without clear boundaries. It was exciting but frightening, for it was unclear where it was headed, what had been lost, and what would emerge.

Warhol was as much his own creation as any of his art. Born with a rounded nose, Warhol decided in June 1957 at the age of twenty-eight that his nose was so unattractive that he had to do something. He went to a surgeon not for a classic nose job, changing the shape of the nose, but a procedure that regrew the skin. Afterward, Warhol felt he looked better, but still did not believe he had an attractive face. It also did not help that he was so nearsighted that he stumbled around half-blind without glasses. Contact lenses solved that problem, but they were yet another thing he had to put on when he woke up in the morning.

Morning was also when he applied a thick coating of pancake makeup to cover up his blotchy, pale skin. The final touch was the toupee he glued onto his half-bald scalp. If one wore such a thing, he knew, there was no going halfway. Make it a glorious, thick mop of hair. Warhol kept changing colors on his toupee—one iteration of brown and blond after another—until he finally decided on the silver color that would by 1965 become part of his signature image.

The wig and makeup were the masks Warhol wore to greet the world. His public life was a continuing challenge. He sometimes struggled for words, but silence was the smarter move.

The crowd at the party kept getting bigger and bigger until people pressed up to each other, cheek by jowl. If a fire warden had come stomping in from the elevator, he likely would have sent half the people home. Many of the guests did not know Warhol. It was just another night out in the great, pulsating city.

Jack Heinz, the CEO of H. J. Heinz, and Drue, his art-collecting wife, stepped out of the creaky elevator. The Heinzes were among the most elite Pittsburgh families, but Jack and Drue were often in Manhattan for social events. Warhol had himself grown up in Pittsburgh before moving to New York City in 1949, though he did not hobnob with the likes of the Heinzes back in his Steel City days. Now this couple—Pittsburgh royalty—were here making their way across his crowded, unprepossessing Midtown loft.

The giant jukebox hauled in for the evening played rock that got people dancing. Among those cutting it up on the floor was supermodel Jean Shrimpton, an icon of Swinging London whose face had recently graced the covers of *Vogue* and *Glamour* magazines. Boogying away in his tam-o'-shanter was Allen Ginsberg, a beat generation poet of despair and prophecy. ("I saw the best minds of my generation destroyed by madness, starving hysterical naked.") And there across the room was the radical Black poet and playwright LeRoi Jones. ("You are / as any other sad man here / american.")

How strange that these boundary-pushing artists were to be found here in the same room as the Heinzes and Senator Jacob Javits, a liberal Republican lawmaker who hailed from the Lower East Side. But they had each found their way here, to this grungy silver spaceship. This party felt like the white-hot center of the world.

Warhol's cachet brought forth the crème de la crème of the pop art world to this party, too. Roy Lichtenstein. Claes Oldenburg. James Rosenquist. Tom Wesselmann. They were all there and they were the artists Warhol felt he had to best.

Lichtenstein and Warhol were often mentioned together. Five years older than Andy, the New York–born Lichtenstein was an art professor at Rutgers University. Warhol had first heard about Lichtenstein back in the spring of 1961, when he'd walked into the prestigious Leo Castelli Gallery. Warhol himself was represented by no

gallery in those days, so he was always scoping out the top gallerists to make his presence felt.

When Warhol bought a Jasper Johns drawing of a light bulb on its side, he asked gallery director Ivan C. Karp if he had anything else of interest. Karp pulled out Roy Lichtenstein's *Girl with Ball* painting. It was an enticing cartoonlike image based on an ad for the Mount Airy Lodge in the Poconos that frequently appeared in the *New York Times*, showing a young woman in a bathing suit holding a ball over her head. The image was bold, bright, like a still from the Sunday funny pages, reproduced larger than life. It felt fresh and modern.

Warhol could not hide his distress. "Ohh, I'm doing work just like that myself," he said. That year Warhol took cartoon images of Dick Tracy and Superman and turned them into paintings, while Lichtenstein appropriated a cartoon image of Donald Duck from a children's book and made his unique art out of it.

Gallery owner Leo Castelli weighed in on the matter. "Well, you seem to be too similar to Lichtenstein and he came before you, so it will be him for the time being," he told Warhol. When Warhol left the gallery, he was worried. If Lichtenstein succeeded, he feared it would leave little room in the market for his own, similar style. Warhol might have to scrap his work and move on to something else or risk appearing a pitiable copycat.

His fears were not unfounded. At Lichtenstein's show the following February 1962 at Castelli, the comics-inspired artworks were a raging success. His paintings sold out, for prices as high as $1,200, setting up Lichtenstein as the premier artist in the emerging pop art world.

Lichtenstein painted images from comic books, but his approach was intellectual and full of wit. Well-versed in art history, he saw himself as another step in that journey. Peppering his paintings

with tiny Ben-Day dots, he infused his cartoon images with gentle irony. "I think the art was parodying the time in a serious way even though some of the art is humorous," he said.

Warhol, on the other hand, saw himself as a truth-sayer, exposing a darkening world drained of humanity. His portrayals of Brillo pads, Campbell's soup cans, and electric chairs are not funny at all. Some critics viewed pop art as an upbeat celebration of the products of capitalist enterprise. Warhol fancied he was chronicling the end of an age. "Everybody looks alike and acts alike, and we're getting more and more that way," he said. "I think everybody should be a machine."

Campbell's soup cans are the perfect product of the machine age. They are bright, shiny, instantly available in millions of American homes, and eminently disposable. Warhol portrayed them often. There is the moment when the cans pose, ready for their lemming-like journey to be opened up, their contents devoured; the two hundred small soup cans stand in ten rows and twenty columns, like a parade of soldiers. Then comes the next stage, a can opener about to eviscerate the shiny metal top. And then inevitably the final stage, the can empty and dark, the label half torn off. There is the industrial age in a soup can.

While the show that night had focused on Warhol's Brillo box installations and other industrial products, that wasn't all his pop art. Starting in 1962, he'd been creating silk-screened images of all-American, machine-age emblems—from Elvis Presley to Marilyn Monroe to, yes, Campbell's soup cans—and elevating these basic forms through his art.

To create these images, Warhol first selected a picture, a photograph from a magazine, or a snapshot. He had an exquisite sense of knowing which image would work. His assistant outlined the picture on tracing paper. Then Warhol or his assistant filled in the

shapes with quick-drying Liquitex paint. They had previously gone to the manufacturer for the exact silk-screen dimensions. They took the silk screen and pushed the acrylic paint across the surface with a squeegee. Warhol was a brilliant colorist, creating something markedly new. When done, they lifted the finished canvas off the silk screen. The process took no more than two hours.

The photographers at Warhol's silver loft that night wanted a group picture of America's leading pop artists: Warhol, Lichtenstein, Wesselmann, Rosenquist, and Oldenburg. So the five men gathered together in front of giant Warhol images of two of the most wanted criminals in America, to pose for the photo. They milled around awkwardly, strangely formal with each other. Warhol is wearing a suit and tie. Lichtenstein has on a groovy turtleneck under his jacket. None are staring at the camera.

Though he showed his teeth in the group photo, Warhol's grin is more a grimace than a smile. He never again would let himself be photographed with his fellow pop artists. As far as Warhol was concerned, he was sui generis, and the world had to know.

||||||||||||||||||||||

W arhol was not the only person at the party upset with the photographers. The Sculls—his art patrons who had paid for at least half of this evening—were feeling left out. They'd paid big bucks to buy their way into this world (as far as they were concerned, this evening was about publicity and the chance to see and be seen with the right sort of New York people). But the photographers, especially the one from *Vogue*, ignored Ethel. She would not be in the pictures of the party, despite bankrolling much of the affair. She was livid.

As the party raged on, Warhol drifted toward the parameter, watching the revelry. People thought Warhol was shy. There was

some of that in him, to be sure, but for the most part, that supposed shyness was a studied stance. He liked to stand back and observe. He remembered everything and forgot little. He acted as if everything before his eyes was done for his enlightenment. And so he stood back and tried to make sense of everything.

Later in the evening the radical photographer Nat Finkelstein arrived with Jeanne Krassner, the wife of Paul Krassner, the founder of the provocative magazine the *Realist*. They had met earlier in the evening at another event and hit it off, and by the time they'd made it to Warhol's party they were feeling amorous.

The couple stood before the tawdry sofa that looked like it could have been in a downscale Paris brothel and decided, why wait? Before long they were having sex on the couch, in front of everyone, party be damned. They were not the first couple (before or after) with that idea. When one of Warhol's lovers, the art critic Robert Pincus-Witten, came down with crabs, he was not sure if he should blame Warhol's crotch or the couch.

As Finkelstein and Krassner got dressed afterward, she realized someone had stolen her purse. Always the Marxist, Finkelstein concluded, "Well, this is really the ragged edge of bourgeois capitalism."

As the hour got late, the party only got more frenetic. The world would not end at dawn, but by how some of the guests danced, they might have thought so. Jill Johnston, the dance critic for the *Village Voice*, decided no one would limit her moves to the floor. She jumped up on the jukebox, grabbed a silvered pipe, and began swinging above the crowd.

Warhol watched all this with amusement, neither criticizing, cautioning, nor cajoling. It was all so strange. Finally, in the pre-dawn hours, the last of the guests left. It had, everyone agreed, been a singular success. Some of the most powerful, famous, influential, and infamous people in the city had been there that night. Most of

the people who had traipsed into the Factory knew almost nothing of Warhol and his work. They were there for the scene, the social capital, or sexual connections. The fancy folks had enjoyed slumming with the artistic underground, taking away stories they would tell at Park Avenue and Central Park West dinner parties for weeks to come. But they had spurned his art.

Warhol had hoped patrons would walk out of the event with wooden boxes under their arms, selling out his inventory of audacious artwork. But instead, visitors had left empty-handed. The after-party was a blast, but it could not compensate for that distressing failure.

And even worse: the Sculls had unceremoniously canceled their order.

The guests who had shown up to his after-party included some of the most famous people in America, and New York socialites with wallets stuffed with money. But Warhol had gotten nothing out of it. *Nothing.* They drank the booze, ate the food, and boogied all night, and they bought nothing. That had to end. He had to create such a gigantic image of himself that people would feel compelled to buy his art. He just had to figure a way to get to that place. The question was: how?

||||||||||||||||||||||

After the party, in the early morning hours, Warhol returned to his townhouse on upper Lexington Avenue, where he lived with his seventy-one-year-old mother, Julia Warhola. In her basement apartment, a crucifix and a picture of JFK hung on the wall. The sofa was covered with a sheet the way people do who are afraid to risk damage to a precious piece of furniture. A slew of cats roamed the premises as if the residence was their private preserve.

Warhol had brought his widowed mother to live with him in Manhattan twelve years earlier. It was a surprising choice for this artistic, urbane man. After all, he could have simply contributed money to support her back in Pittsburgh, where his two older brothers would have watched over her. But Warhol insisted that Julia live with him in New York.

Warhol had been born Andrew Warhola—he Americanized himself by changing his name to Andy Warhol—on August 6, 1928, in a two-room apartment with outdoor plumbing in Pittsburgh's tough immigrant neighborhood of Soho. Later in his life, Warhol would often obscure or even lie about his humble origins, saying that he hailed from other places (including Philadelphia and Newport), attempting to distance himself from Steel City and his family's immigrant beginnings. Yet when visitors to Warhol's townhouse saw this foreign-appearing woman with a thick accent and strange dress, the secret was out.

To Julia, New York was a strange new world. She had been born in a small village in the Carpathian Mountains, then part of the Austro-Hungarian Empire and now northeastern Slovakia. Julia and her future husband, Andrej, were Carpatho-Rusyns, members of an ethnic group with their own dialect but not their own country. Julia married her husband in 1909, when Andrej returned from a year in the United States. Julia was only seventeen and had no desire to marry, but a catch like Andrej did not come along each season. Her father beat her into submission, and after Andrej gave her chocolates, she agreed to marry him.

Three years later, afraid that he would be drafted to fight in the impending war, Andrej sailed to America, leaving his pregnant wife back in the village. Julia lost the child and lived with her in-laws, who treated her like a servant. She could only pray that Andrej

would return and take her with him to America. That did not happen for nine years, and when she arrived in Pittsburgh, she saw that it was not quite paradise.

Slavs were looked down upon and typically given the worst jobs for the least pay. It was even more difficult for people like the Warholas, who spoke an obscure dialect that almost nobody understood. It would have been easier if they learned English, but they had no one to teach them, and there were few English speakers around them. Julia never mastered English.

Warhol's father was only five and a half feet tall, but his heavyset body rippled with muscles. He labored in the Jones and Laughlin steel mill, a baptism in flames and heat, and then worked moving buildings on rollers. Andrej hardly ever missed a day of work and may not have been there for his third son's birth. Andrej was not emotionally demonstrative and left the job of raising children where he knew it belonged—in his wife's hands.

The petite Julia was the most important woman in Warhol's life, his first and forever muse, and his first artistic guide. She did not have a broad peasant face, but abrupt, feral-like features full of intensity. Unable to afford canned soups, Julia did what she would have done in the old country: made soup from scratch, and if one dared say it, the dish was far better. There was no money for the elaborate toys American kids found around their Christmas trees. She cobbled together paints and paper and taught her sons to draw. She made flowers from discarded tin cans and sold them in the neighborhood to make extra money.

Slight little Andy would never march down the road to the steel mill and go to work. He was a sickly child of preternatural sensitivity, and his mother tried to protect him. Warhol needed more nurturing than his two older brothers, who were their father's sons. Andy was different, and Julia did her best to shield him.

When Andy was thirteen, his father passed away. This was the first time Andy confronted death, and he dealt with it the way he would the rest of his life. He fled from any contact with the darkness, hiding under his bed for the three days of the wake. A son goes to his father's funeral and stands there over the open grave, but it was too much for him. His mother feared his "nervous condition" would worsen, and he stayed home that day.

While his older brothers, John and Paul, set out in the world with working-class lives, Andy headed off to the Carnegie Institute of Technology in a suit and tie to study art, a secretly gay young man desperately trying to fit into a world that had no space for such as him. Warhol's coming out as a daring, belligerent, creative spirit came in 1948, when he did a series of student paintings of a man picking his nose. In his art and in his life, Warhol thumbed his nose at the world.

Upon graduation in 1949, Warhol moved to Manhattan, where a gay man had some chance for a life without the risk of public rebuke and danger. Setting out to become a commercial artist, he had come to the right place at the right time. The industry was egalitarian in the best sense. If one's drawings effectively evoked the product, there was no end of work. Warhol had hardly arrived when his lively, beautiful drawings of shoes appeared in *Glamour*, a leading magazine of the era. That led to steady gigs for shoemaker Israel Miller. Warhol's shoes had a unique panache and were instantly recognizable. His drawings were minor works of art. They looked like the product they were selling, but they had a magical aura. He also did window dressing and over the course of a few years became one of the most successful commercial artists in the city. He eventually made enough money to purchase a townhouse at Lexington Avenue and 89th Street in 1959.

Not satisfied standing at the pinnacle of one field, in his free

hours Warhol produced his own fine art. He had an extraordinary range of subject matter—from genitals and male nudes to tender renderings of a leaf. He also undertook portraits, such as an ink and watercolor portrait of cosmetics entrepreneur Madame Helena Rubinstein and even a drawing of a young James Dean.

For several years before his foray into the experimental fringes of the art world, Warhol showed his drawings in galleries around Manhattan. And while his early work was relatively standard and conventional in execution (still lifes, portraiture), it always had a unique flair and distinctive design. In 1957, he displayed at the Bodley Gallery "such gilderies as a still life with coke bottle and any number of golden cats," a harbinger of the commercial-product-obsessed pieces he would do a few years later. It was not pop art but was immediately recognizable as the work of a unique artist.

To Julia, a day without work was wasted, and she cleaned the Upper East Side townhouse almost compulsively. Sometimes, she helped "little baby Andy" by doing the lettering on the ads he drew. Julia knew no one in the city, and her main expedition was attending church. Warhol went to church, too, but did not stay for the full Mass. Five or ten minutes was enough. It appeared to be an insurance policy if his mother's beliefs proved true.

Warhol was no more emotionally demonstrative than his father had been and rarely professed his devotion to his mother. But like nobody else, he was there for her as much as she was there for him. It was the most remarkable relationship in both of their lives. Here was Julia, an Eastern European peasant woman brought up in a culture where homosexuality is unspeakable, a sin against God. And yet she accepted and loved her gay son without judgment or criticism. And here was Andy, a queer artist who had gone to New York in part so he could practice his lifestyle freely, yet he invited his mother to live with him, a quiet observer to it all.

As often as not Warhol introduced his lovers to Julia before he and his friend headed off to a different part of the townhouse to do their thing. When he came home in the early morning hours she would be there with soup and half-understood adages in her dialect. As he set out to become famous, she was always there for him, grounding his life, a place to which he could always return.

3.

Strutting Her Stuff

JUNE 1964

In June 1964, two months after the disappointing opening at the
Stable Gallery, Warhol's friend the British-born photographer, ed-
itor, and designer Nicholas "Nicky" Haslam invited him to a party
at the home of Jane and Leonard Holzer, who lived in a twelve-room
apartment at 955 Park Avenue with a maid, a butler, a Yorkshire ter-
rier, and a toy poodle.

Warhol did not know the rich couple, but when he entered the
thirteenth-floor apartment, situated on a quiet block between 81st
and 82nd Streets, it was just as he might have expected: old masters'
paintings on the walls in the living room, and furniture so heavy it
looked like it could crack the floors.

If Warhol had his way, the day would come when the Holzers
and their neighbors would take down their Flemish masters, Picas-
sos, and Renoirs (or at least move them to a hallway) and replace
them with Warhol's silk-screen portraits of Jackie and Liz, and

maybe even one of his electric chairs, if they were daring. Those were among his subjects, each one more cheeky than the last.

That day, when Warhol's art was widely accepted, seemed like it would be very far away. While the 1960s culture was starting to burble up and disrupt the established order of things in the wider world, on Park Avenue change would be a little slower in arriving.

A Princeton graduate (Class of '59), the evening's host, young Leonard Holzer, wore a suit and a tie, de rigueur for Park Avenue dinner parties, even for men not yet thirty. Leonard's father had made a fortune in real estate, and Leonard was following in the family tradition by developing shopping malls, a lucrative if staid profession. It was not a subject that interested Warhol. Leonard was rich, conventional, bourgeois. But Leonard's wife, Jane—well, she was something else.

Warhol had always been intrigued by female fashion, and twenty-three-year-old Jane wore designer clothes and had a distinctive style that was all her own. With a long, abrupt face that, at unguarded moments, looked haunted, Jane possessed a distinctive, arresting look. She was attractive, yes, but her glory was her magnificent hair—an enveloping golden mane reminiscent of the MGM lion's, a splendid statement that announced her presence to the world. Jane was much more than simply pretty. She had *presence*.

She was also, it soon became clear to Warhol, part of the sedate Park Avenue social scene, but not *of* it. There was something restless and different about this young woman.

Jane Holzer had asked her friend Nicky Haslam to make out the guest list for this party, and the stylish editor had delivered a star-studded lineup. He invited his houseguest, Mick Jagger, who had just arrived from London for the Rolling Stones' first American tour. Jane had met Mick and his bandmate Keith Richards the previous

summer when she was visiting the UK, and she'd tooled around London with them, seeing their star power and charisma firsthand.

That was before practically anyone in the States had heard of the group, but Holzer was convinced that soon their music would be the very song of life. Mick made himself completely at home in the tony apartment, leaning back and putting his feet up on her prized Chinese lattice table. That gaucheness would have gotten anyone else banished from her premises, but this was Mick, and it was fine.

The other guests included the British photographer David Bailey, who had taken Holzer's picture for British *Vogue* during her time in London and who had initially introduced her to the Rolling Stones. It was a lively gathering, and Holzer talked animatedly to Warhol and all the guests. But in truth, while she was an avid fan of the latest music, she cared nothing about pop art. Her idea of art was the European masterpieces in her living room, not the strange things Warhol and his ilk produced.

Warhol was a quiet presence at the raucous party, but his silence did not signal disinterest. He was like a Roomba, constantly sweeping the room, picking up useful scraps. Mick's and David's clothes, for one thing, intrigued him. They didn't dress like anyone in New York at that point. David was dressed all in black, while Mick wore an unlined Carnaby Street suit. Warhol was so conversant with style that he immediately clocked both men were wearing Anello and Davide boots, a company known for its ballet shoes. Combined with the bold suits, the effect was utterly modern and completely eye-catching.

The pop artist was particularly impressed with Jagger. "It was the way he put things together that was so great," Warhol said. "This pair of shoes with that pair of pants that no one else would have thought to wear." Warhol copied clothing styles as quickly as he did

pictures, and before long, his personal style could have been categorized as "Mick Jagger in a wig."

In 1964 everyone was talking about the Beatles, but as far as Holzer was concerned, they were already passé, boy toys for the establishment. Fed on the scraps of the elite, they had gotten flabby, literally. Each time Paul McCartney appeared onstage, it was said, his bottom grew. Mick, on the other hand, was so deliciously lean that he looked like he hardly ever ate. Holzer served him dinner—or more accurately, her butler, Johnny, did.

Holzer was unconventional in many things, including her butler. No one on Park Avenue had a butler quite like Johnny. He served meals, washed Holzer's linens, and dyed her stockings. He also tried on her clothes and underwear to ensure everything was right for her and fit perfectly. He performed this task admirably, slipping in and out of her clothes with pleasure.

What Holzer had liked about the hip new London she'd first encountered a few months before was that people there were "switched on . . . feeling and living every minute of the day and night, loving and suffering and everything."

Look at who was switched on. Rudolf Nureyev, the greatest male dancer of his generation, had defected from Russia in 1961 and started living a life of the wildest freedom. He might dance in *Swan Lake* before thousands at Covent Garden and later in the evening boogie to rock and roll in a nightclub wearing dungarees. Dungarees! Not a suit and tie like some uptight New York businessman. Switched on! And look at Mick wearing a wild shirt. Switched on!

Holzer had returned to the United States as an avowed Anglophile and a prophet of Swinging Sixties London. She cared not about the old order of kings and queens and Oxford accents but the new hip world of Carnaby Street, working-class heroes, and rock and roll. She affected a full-blown Cockney accent, slurring her words as if

she'd drunk a pint too many. Holzer changed her dress, too. No longer was she the stylish young New York society matron but a London hipster in black jeans and sweaters—though, if the occasion called for it, she quickly reverted to her old self.

But Holzer's party pooper of a husband didn't share her bohemian conversion. He liked to stay home in the evenings. Jane, an heiress dependent on Leonard for nothing beyond her last name, did what she pleased. And what pleased her was heading down the elevator alone to the waiting limousine that whisked her to various parties and clubs.

Holzer was a newcomer to the great city. Her birthplace was Palm Beach, Florida, the winter watering spot of the East Coast upper crust. Five years before Holzer's birth in 1940, her father, Carl Bruckenfeld, moved to Florida from Brooklyn after purchasing lots on Palm Beach's Worth Avenue. As the street was developed into a celebrated shopping venue, his buildings became the centerpiece of a real estate fortune.

But money didn't mean acceptance for the Bruckenfeld family. As more Jews came to Palm Beach, the town fathers feared an onslaught that would turn their beloved island into another Miami Beach—the town seventy miles down the coast that had become a vacation haven for New York Jews, a Catskills South. To prevent that from happening in Palm Beach, they invoked exclusionary policies banning Jews from the major clubs and the Breakers, the leading hotel.

So Jane Holzer grew up in an enclave within an enclave—a small, separate Jewish community that was among (but not part of) the exclusive Palm Beach society. She did not think that much about it until she became a teenager, when she realized that she'd never be invited to the Bath and Tennis and Everglades Club dances or feel welcome in the homes of some of her school friends. For a highly social person, the exclusion "hurt terribly," she recalled.

The teenager could have stayed in Palm Beach, attended a public high school, and shown her horses across South Florida. Instead, she headed off into the larger world with a belligerent attitude toward anything that gave off a whiff of the establishment. After attending a Connecticut boarding school, she enrolled at New York's Finch College.

Finch was not a rigorous place of learning, but rather a "finishing school" for privileged young ladies. The educational demands were minimal, but even so Holzer could not bring herself to study. She was too tired, having sneaked out to dance at Manhattan hot spot El Morocco in the evenings.

After sleeping through one too many classes, Jane was placed on probation, but it did little good, and her bold antics continued. The Finch administrators were not used to having their authority so brazenly challenged. It was almost impossible to be thrown out of a school like Finch, but the administration eventually had enough of Miss Bruckenfeld, her insubordinate ways, and her miserable grades and sent her on her way. But what did she care as long as the nights were long and the music continued until dawn?

|||||||||||||||||||||

Three or four days after the dinner party, Holzer was walking along Madison Avenue with David Bailey when the photographer waved at Warhol on the other side of the street. The pop artist came sprinting over. Warhol had been intrigued by Holzer, and he would not miss this opportunity to develop a relationship.

After spending several years devoted to making pop art, Warhol had started spending much of his time creating underground movies. He hated the label "underground," though. "I can't see how I was ever 'underground' since I've always wanted people to notice me," he said years later when talking about the public reception of his work.

Warhol was always about getting attention. But at this point, nobody outside a narrow bohemian set in Manhattan had paid any attention to either his art or his movies.

When Warhol asked Holzer, after chatting for a few minutes, if she would like to be in one of his films, she immediately said, "Sure, anything's better than [being] a Park Avenue housewife." She was hardly a housewife, but she was canny enough to know that a little self-deprecation goes a long way. The two sized each other up right away. Warhol saw a dynamic, charismatic woman with money and connections. Holzer, for her part, wanted to be a star and thought Warhol could get her there. The sight of a camera sent shivers through her. "My chin goes up," she said. "My tummy goes in."

A plan was quickly hatched: Warhol would feature Holzer in his underground movies and accompany her to parties and dinners around Manhattan. He would give her a bit of his downtown cool and avant-garde excitement, and she would give him entrée to elite circles he could not move in alone. "I think he saw somebody just made for his purposes," reflected Isabel Eberstadt, who at that time was writing a profile of Warhol and his scene. "She [Holzer] was very narcissistic, very ostentatious. She was packageable."

Holzer was also, for all her bravado, a bit intimidated by Warhol and the motley group that surrounded him. Holzer's fortune had allowed her to travel widely and meet many different people in her young life, but Warhol's world was entirely different. Something scared her about the Factory. "Some of the people around Warhol gave me the creeps," she said years later. She truly enjoyed being around Andy, and the two clicked immediately. But his friends and associates—who were always hanging around him—were another story.

Warhol loved to surround himself with people like Billy Name. Formerly an off-Broadway lighting designer and a waiter, he had a

stunning presence. Handsome in his aviator glasses, he had an always-moving, whippet-thin frame that seemed not just a physical state but a reflection of his restless inner life as well.

Name had been Warhol's lover for a short while, but it was hard to have great sex with a man who recoiled at being touched. "If you put your hand on his shoulder he would jump," Name said. In the queer society around Warhol, spurned lovers did not always wring their hands in dismay, moaning audibly over their lost partner. They just traversed on to new lovers and new lives. Name moved into a tiny closet-like space at the studio's far end that also served as a darkroom.

Name was an amphetamine addict. The drug intensified things, speeding life up and slowing it down simultaneously. Name worked with incredible focus and detail and did not speak for days, a haunting presence lurking on the periphery of the Factory.

Name's amphetamine-addict friends spent time at the Factory, too, some shooting up in the corners. Many of them had nowhere to live. They crashed in doorways, in communal pads, or on the floor of someone's apartment. They came to be known as the Mole People or A-heads; some of them were former beatniks from New York's recent bohemian past. Many of them were called "brilliant" or "full of promise," but they produced almost nothing with all their talents. Creatures of the dark side of the creative underworld, they had willfully made their way down into this world, from which it was not easy to exit.

Bob Olivo, known to everyone as Ondine, was the titular head of the Mole People and spent a lot of time at the Factory. With his Roman nose and dark eyes, Ondine was just short of handsome. Intellectually fearless, he took on anyone with his fierce wit, scalding his victims with merciless mockery. Ondine's intellect could have taken him almost anywhere—if it weren't for his giant drug

habit, which hobbled his life and made it so he sometimes went days without sleeping.

Ondine had no money or job, which did not diminish his sense of authority. The self-styled pope of Greenwich Village roamed the perimeters of his world. In the seedy downtown underbelly of New York, you could find whatever you wanted, from a choice of drugs to a choice of partners or both at once. One evening, Ondine was taking part in an orgy when he noticed one man not participating but keeping back, observing the writhing bodies. That violated the event etiquette, and Ondine asked the man to leave. As they talked, the bystander introduced himself—Andy Warhol—and they kept talking. That's how Warhol met Ondine, who soon became a regular at the Factory and a star in several of Warhol's films.

The Mole People began calling Warhol "Drella," a combination of Dracula and Cinderella, playing on his cadaverous, almost gothic look. It was hardly a flattering appellation, but it stuck. Warhol did not shoot up with the Mole People, but took Obetrol daily, a diet pill containing amphetamine salts that is now called Adderall.

The Obetrol revved Warhol up, charged him with focus, and turned him into someone who said he slept only two or three hours a night, the late evening and early morning hours punctuated by phone calls. He took enough of the drug, in his words, to "give you that wired, happy, go-go-go feeling in your stomach that made you want to work-work-work."

The Factory's habitués were overwhelmingly gay and predominantly Catholic. And they were almost all taking amphetamine. In the sixties, "speed"—the nickname that precisely describes what the drug does—was everywhere, not just in the downscale bohemian world. The drug was prescribed by psychiatrists and other medical professionals and purchased on the black market. Between 1963 and 1969, Americans took between 8 and 10 billion pills annually.

Speed was the drug of choice for college students studying for semester exams, for "ladies who lunched" wanting a lift before their first martini, and for politicians and celebrities who felt they needed a boost of youthful energy. Marijuana and LSD, the favored drugs of the emerging youth culture, promised entrance into a world full of profound insight and knowledge. That may not have been true, but speed, on the other hand, made no such promise, often bringing alienation and isolation.

The drug also appeared to influence the content and construction of Warhol's films, which were, in their own way, boundary pushing and utterly new. They certainly didn't seem like any movies Jane Holzer had seen before. When she'd agreed to appear in Warhol's underground films, she'd assumed they would be, if not *normal*, then at least framed within a recognizable narrative arc. Since the beginning of human history, after all, people have told each other stories with beginnings, middles, and ends. That is typically what Hollywood movies do. But Warhol eschewed that. His movies are an assault on conventional meaning.

In those years most avant-garde filmmakers employed handheld cameras and frequent edits to create an intimate, modern quality. Andy, on the other hand, sat the camera in one place and let it film, sometimes with no one even monitoring it. Many of Warhol's films are full of such repetition and tedium that the average moviegoer would have thrown his popcorn at the screen.

The first Warhol film in which Holzer appears is *Kiss.* The black-and-white film consists of several couples kissing. In the overwhelmingly gay atmosphere of the Factory, women were generally treated like decorative items to be moved around and positioned for maximum dramatic and aesthetic effect, and in *Kiss* Holzer's role is no different. She is asked to kiss her friend Nicky Haslam (who had first brought Warhol to her house and who was now the art director for

a new magazine, *Show*) in an extended embrace as the camera looks dispassionately on. Holzer understands the assignment and kisses him enthusiastically, as if she's deeply in love . . . and as if Haslam is straight. Warhol must have liked what he saw, because he shot her with his Bolex 16mm camera in another kissing scene for the movie—this time with John Palmer, a handsome young future director of a decidedly heterosexual bent. They may have had some real physical attraction, but they held back, tentatively embracing like teenagers kissing for the first time.

Holzer's greatest job of acting was not on the screen but pretending to like much of what she saw going on at the Factory. She did not feel comfortable among the druggies and weirdos, but she loved being in Andy's films and going out with him to party after party in the evenings. It was a price worth paying.

<div align="center">॥॥॥॥॥॥॥॥॥॥॥॥॥॥॥॥</div>

W arhol loved television. He kept multiple TV sets on at home, periodically glancing back and forth between the screens. When he came home late at night, he watched a different kind of advertising that only came on in the witching hours. The on-air huckster touted a color television for $11.99. When the postman delivered the device, it turned out to be a red plastic sheet to paste on the TV screen, making everything look scarlet. Then there was a tonic to cure arthritis, migraine headaches, and many of the other ills known to humankind. That turned out to be no more effective than a sugar pill. And the magical knife that could cut its way through anything God created. While others waited for the ads to be over, Warhol couldn't wait for them to begin.

Some wanted to monitor the ads to ensure they told some measure of the truth. But Warhol saw these falsehoods as spectacular moments, more amusing than the programs themselves. "You know,

I'm really in love with TV commercials," he said. "I think they're among the best things on TV, and they should run much longer than they do."

Warhol learned about the inner workings of TV commercials from his friend Lester Persky. The ad man was a 1960s version of Professor Harold Hill, the con artist who schemed to sell nonexistent band instruments and uniforms to the naive folk of River City, Iowa, in *The Music Man*. Persky's persuasive talents were ready-made for Madison Avenue, and he made a fortune producing television commercials for all sorts of consumer products. So what if they were not the miraculous, life-changing devices they purported to be.

Those commercials gave Warhol the idea for his next film. In *Soap Opera*, Warhol interposes footage of Persky's actual ads for such real-life products as the "Amazing Beauty Set Shampoo," the "Morse-Whitney Cordless Electric Miracle Knife," and "Roto Broilette" (a toaster oven) with various scenes that have nothing to do with the commercial footage. The story such as it is features Holzer and the curator Sam Green as a married couple whose primary pleasure is cheating on each other. If only the trysts were intriguing.

Warhol's film slyly presents the thesis that *commercials*, not the narrative between them, are the most exciting things on television. For while Persky's ads jump off the screen, Warhol's scenes (many featuring Holzer, often again kissing other men) are tedious and disconnected. But boring or not, Warhol's images offered a sharp commentary on the banality (as he saw it) of much modern TV content. His film had also served as a stepping stone into the high society he'd been working so skillfully to access.

"Andy, Jane, and I used the movie as a way to social climb," said Sam Green. They asked those with East Side penthouses and co-ops that took up entire floors if they might film scenes there. To the

owners of the apartments, this was almost as good as being asked to star in the film themselves. Of course they said yes. Holzer was the key Warhol used to unlock a whole new social circle. Social climbing is the only sport in which you lose if people know you are playing the game, and few realized what Warhol was doing.

Holzer is a featured player in another Warhol film, *Couch*. The 1964 black-and-white film is a supposed day in the life of the infamous Factory couch—a raunchy, sweat- and semen-stained sofa ready for any action. The voyeuristic Warhol enjoyed shooting sex scenes, and there are many of them in the film. In one scene, a naked woman is sandwiched between two men, who are pleasuring her. Another scene consists of oral sex between two men.

Holzer is unique in the annals of Warhol's filmmaking in that she kept her clothes on. In her scene, she sits with two other women and a man peeling bananas. Holzer chooses the biggest banana of them all, a thin, lengthy sheath that she peels with decided expertise. Then she opens her mouth fully, takes a bite, and chews with delicious intent, her eyes wide like a tigress's. Holzer starts to eat last, but she finishes first, placing an enormous hunk in her mouth and chewing with her mouth open. She's a long way from Park Avenue.

Holzer also features in two of Warhol's hundreds of three- to five-minute "screen tests"—silent films in which he told the subject to sit, not move, and look at the camera. He called them screen tests to suggest the idea that the individuals were trying out for his underground films. These simple clips showed the raw, seductive power of cinema. People would do almost anything to be part of a film, even if it were unlikely to be seen in public.

In Holzer's two screen tests, Warhol would not let her pose like a fashion model for *Vogue*. He insisted on her chewing gum and

having a toothbrush in her mouth. The films were unlikely to be regarded as monumental achievements in film history, but at least she wasn't kissing someone other than her much-neglected husband.

Holzer remembered that toothbrush with great fondness. "It was just like eating a cock, it was incredible, the sexiest thing, because I didn't know what I was doing," she said.

These were not wide-release movies. Many of them were never shown outside the confines of the Factory itself. If Warhol's films *were* shown in a theater, it was almost always at Jonas Mekas's Film-Makers' Cinematheque on West 41st Street. This was a venue for screening avant-garde cinema, and Warhol's underground movies might run there for only one or two nights to a crowd of art-world denizens and lovers of semi-porn.

The Lithuanian-born Mekas was a filmmaker, poet, and passionate supporter of underground filmmaking. He had a daring spirit and would show almost anything in the theater, no matter how obscene, if it had the imprimatur of art. He did have some limits, though; *Couch* was so pornographic that it could not possibly be shown even there.

So that film and others were screened at the Factory, and the forbidden nature of *Couch* drew a crowd. Alas, sex or not, *Couch* is boring beyond belief. When the audience members could take it no longer, they left to get a cup of coffee. When they got back, the boffing was still going on. The only person who observed this without a break was Warhol. With his legs crossed like a Boy Scout at camp, he was content to watch every moment of his film for the umpteenth time.

Making films continued to be an exquisite device for getting Warhol into the homes and lives of the rich. One day early that summer of 1964, Holzer joined Warhol at Caumsett Manor, a major estate on Long Island built by Marshall Field III, to make scenes in his next film, the unfinished seven-hour *Batman Dracula*. To Warhol,

plot was as anachronistic as the minuet, a melody to which one never danced. In *Batman Dracula* there is no clear story, poor Batman has no real part, and Dracula is relegated to a man in a black cape running into the sunset.

As soon as the group arrived at the estate, many of the actors with the notable exception of Holzer and Warhol took off their clothes. "They sort of stripped all their clothes," Holzer said. "And there was this big fat nude girl being waited upon by this posh Irish maid, and I mean the sight was not to be believed, these crude Warhol people in this incredibly stately mansion. . . . I wish someone had actually made a film about what was going on instead of about the silliness of Dracula because it wasn't to be believed."

That film within the film was not made, and like many of Warhol's misadventures, *Batman Dracula* was never shown theatrically.

|||||||||||||||||||||||||

J ane Holzer had a new patina of glamour about her. Now, when she went out on her evening rounds to both the exclusive uptown parties and the seedier art-world hangouts farther downtown, people were beginning to recognize her. And while she had the newfound prestige of a movie actress, she did not have to be embarrassed by having her East Side friends see the films.

Overnight success rarely happens overnight. In Jane's case, her celebrity percolated for more than a year, until it exploded into the heavens and beyond in the fall of 1964. Suddenly, her face was everywhere. And she even had a new name—Carol Bjorkman, a *Women's Wear Daily* columnist, named Holzer "Baby Jane," after the 1962 horror thriller *What Ever Happened to Baby Jane?* (in which Bette Davis plays a demented woman who tortures her disabled sister, played by Joan Crawford). Baby Jane hardly seemed a flattering title, but the name stuck.

As Baby Jane Holzer traveled from the upscale world of fashion and society to the deepest regions of the hip and new and culturally dangerous, she appeared as comfortable in one world as the other. She never wore the same thing twice. How could she when the paparazzi constantly shot her? Baby Jane was there when *Glamour* magazine hosted a splendid party at the Palladium dance hall. When Coco Chanel showed her new collection the next month, Baby Jane flew to Paris to be in the front row, perfectly attired for a day of haute couture. She was everywhere. She knew everyone. And she was *fabulous*, darling.

The society reporters decided that Baby Jane Holzer was someone their readers wanted to know about. If she attended an event, they almost always mentioned her. If she wore a designer gown, the designer's name was often in the paper, too. But they didn't squander their words on Warhol. As notorious as he might be to some in the art world, to the public he was still an obscure artist of no consequence. No matter how close Warhol hung on to Baby Jane, the columnists treated him like he did not exist.

Baby Jane took Warhol to the Rolling Stones' first New York performance in October 1964 at the Academy of Music theater on East 14th Street. The event occurred in the afternoon, when most rock and rollers have barely woken up. Baby Jane arrived early and had the credentials to go backstage to meet the band. Mick greeted her, "Koom on, love, give us a kiss!"

Warhol arrived in a limousine alongside his assistant Gerard Malanga dressed in a pin-striped black suit. Malanga had sultry good looks and nearly shoulder-length blond hair. Warhol had hired the college student in June 1963 for the $1.25 minimum wage. Since Malanga had already had a summer job silk-screening fabric with antique designs cut up into ties, he had the necessary skills to jump right in and create alongside the artist himself. Malanga's first task

was working on a portrait of Elizabeth Taylor. He and Warhol had worked together on these silk-screened images for more than a year at this point. Malanga was not simply a technician but a collaborator, suggesting innovative ways to transform some pictures. He even signed some of the paintings when Warhol was not rubber-stamping them with his name.

As the vehicle reached the front of the theater, the reams of teenage girls outside started screaming, pounding their hands on the car. They weren't going crazy for Warhol. They had mistaken the lean, handsome Malanga for Mick Jagger.

When the Stones hit the stage, it could have been midnight by the way they played. "Oh, God, Andy, aren't they di*vine*!" Baby Jane said. Warhol was not into superlatives. He observed quietly, his usual taciturn self.

As Baby Jane looked up onstage, she saw a new kind of star emerging and felt the atmosphere of fame and celebrity shifting, almost in real time. She tried her best to put this feeling into words. "It's like a whole revolution," she said. "I mean it's *exciting*, they're all from the lower classes. . . . There's nobody exciting from the upper classes anymore. There is no *class* anymore. Everyone is equal." Her maid and butler might have disagreed. But Baby Jane was picking up on the spirit of the times—change was coming, and the social order was already being disrupted.

The following evening, Baby Jane celebrated her twenty-fourth birthday. The party occurred in a loft at Park Avenue South, which was at the time the rather déclassé end of Jane's fashionable residential street. The event was so full of the powerful and celebrated— from politicians to rock stars to scenesters—that the society reporters could no longer ignore this world, even if it was far beyond their normal wanderings. It merited enormous black headlines in the *New York Daily News*:

IT'S MOD, MOD WHIRL AND THE WILDEST YET!

Baby Jane wore a black velvet jumpsuit and boots that would have fit a member of the Rolling Stones. That was perfect, for the other guests of honor were Mick Jagger and the rest of the band. Well into the evening, a roar was heard outside the window. Below, a brigade of leather-garbed motorcyclists dismounted from their massive machines to head up to the party. By then, everyone was there, including Jackie Kennedy's gorgeous press secretary (and JFK mistress) Pamela Turnure, dancing to Goldie and the Gingerbreads, an all-girl band, until four in the morning. Warhol was presumably present, too, though one would not have known from the press coverage.

The group headed to the Brasserie on East 53rd Street in the predawn hours. No more than thirty-five other people were sitting there, closing out the dregs of the evening, as full of life as cold coffee. But when Baby Jane entered looking as fresh as the dawn, they turned toward the new arrivals with a frisson of self-satisfaction; they, too, were sharing part of their evening with the girl of the moment.

Suddenly, everyone knew Baby Jane's name. They didn't know *why* they knew it, but they did. Perhaps it was because she was on the cover of the November issue of *Show*, a classy new magazine. And it wasn't just any cover, but an image not easily forgotten. Baby Jane wore a red captain's hat and strange blue, dark glasses with circles around them. Her only clothing seemingly was an American flag on a stick, whose end stuck in her open mouth in a gesture beyond provocative.

If you had not read *Show* or had the cover jump out at you on the newsstand, perhaps you had seen that month's *Vogue*, where David Bailey had another photo of his favorite subject. This time, she was wearing a black bodysuit, open in the back down to a body part usu-

ally not openly discussed. If you saw that picture, you surely read the words of *Vogue*'s celebrated editor Diana Vreeland, christening Baby Jane as "the most contemporary girl I know."

Or if somehow you missed all that, maybe you had flown to London and seen the cover of the November British *Vogue*, with Baby Jane in a standard front-on fashion magazine pose, her eyes glistening like gigantic raindrops.

Every door in the city opened for Baby Jane. When her Rolls-Royce pulled up to Trude Heller's nightclub in Greenwich Village one evening, a long line of people stood outside seeking to get into the hot club. The doorman swept her to the front of the line, shepherding her past the waiting crowd. At the doorway, she hesitated, gesturing to her companion.

"Is it all right if I bring Mr. Williams in, too?" Baby Jane asked.

"With you, Baby Jane, anybody gets in," the doorman said. Thus, the celebrated playwright Tennessee Williams entered the club.

But many people wondered: why Baby Jane? There was no question that she could kiss, dance, and pose and knew enough to direct her limousine driver to the party of the moment. But her accomplishments ended there. And her comments were often vapid.

In a strange way, though, her very blankness was what made her a perfect avatar for whatever someone wanted to project on her. That's part of what Tom Wolfe, a writer for the *New York Herald Tribune*'s Sunday magazine, set out to examine when he made her the subject of a piece in late 1964. Wolfe had the unerring ability to write about people that no serious journalist would have chosen and turn them into provocative stories that elucidated the times. He and several of his colleagues, including Norman Mailer and Gay Talese, were developing what came to be called New Journalism, employing many of the techniques of fiction and sometimes making themselves part of the narrative.

Wolfe named Baby Jane Holzer "the Girl of the Year" and set out to chronicle her life, times, and world. As long as there had been "society" there had been a so-called Girl of the Year—usually a debutante from a good family who accepted the honor graciously with a proper picture in the society pages. These young women came from families who lived by the axiom that other than for a debut, a person of merit appeared three times in the newspaper: birth, wedding, and death. But that was changing. By the 1960s, even old money Yalies brought up to despise the mindless seeking of public attention sought celebrity.

To write his piece, Wolfe did not just sit down in Baby Jane's Park Avenue apartment to interview her like a traditional reporter would. He followed her around, sitting with her at the Stones' concert and attending her birthday party, re-creating the moments in a piece that read almost like a short story.

Wolfe's story, "The Girl of the Year," which ran in the *Herald Tribune* in December 1964, was a sensation among Manhattan's trendsetters. That was nothing compared to its impact the following year when the piece was published in Wolfe's book *The Kandy-Kolored Tangerine-Flake Streamline Baby.*

In November 1965, the first-time author flew to Austin to give a talk at the University of Texas. The garish flamboyance of Wolfe's style—over-the-top metaphors and monumental attention to seemingly trivial detail—disguised a writer who was a subtle satirist of American life. He called his talk "Why Baby Jane Holzer Is More Important than Viet Nam." No way did Wolfe believe Baby Jane's life was of more consequence than a war that would take over fifty-eight thousand American lives. But with this provocative title, Wolfe chronicled the growing trivialization of American life. Baby Jane's importance lay in the fact that she was as interchangeable as a spark plug.

But to Warhol, that very interchangeability offered something different: opportunity.

Warhol saw precisely what was going on with the evolution of celebrity, and he applauded it. He almost certainly did not say the line famously attributed to him: "In the future, everyone will be world-famous for fifteen minutes." But he believed it. In saying everyone would have their moment of stardom, he was saying nobody was a true star. He democratized the idea of celebrity while diminishing it.

Most people have part of them that is calculating, checking out all the angles, looking for an advantage. But Warhol calculated even the tiniest nuances of life, never missing an opportunity to further his goal of fame and riches.

"With me, fame happened as a result of intense preoccupation with an art form," Truman Capote said. "He [Warhol] was just moving around in various things, looking for a way to become famous. Fame is everything he's about."

4.

There Is Always a Price

Warhol enjoyed going out with Baby Jane and the access she provided to the insular wealthy world. Across America, there were only a few thousand serious contemporary art buyers. As likely as not, one or more of those people would be at these parties. The new generation of the wealthy was full of people consumed by immense insecurity, desperate to go to the right parties, sup at the right restaurants, and have the right paintings on the walls. Warhol wanted that "right painting" to be his.

But there was a human toll to this quest for fame. And at least at first, that toll wasn't paid by Warhol himself, but by the people around him in the studio—and the world—he called the Factory.

The Factory was located at 231 East 47th Street in an unchic neighborhood full of undistinguished businesses. No matter: some of the hippest, most avant-garde artists and proud bohemians in the city made it up to the fifth-floor studio to hang out with Andy.

They came to play, creating a vibrant subculture fed on drugs and sex that was as exciting as it was dangerous.

Warhol let into his presence all sorts of broken people who sought fulfillment in the Factory. As he stood back watching, often with his sunglasses on, they performed for him in explicit and inexplicit ways. He did not caution them about their excesses. He simply watched.

"He's a voyeur-sadist, and he needs exhibitionist-masochists in order to fulfill both halves of his destiny," said Henry Geldzahler, Warhol's friend and, for nearly two decades, the curator of American art and later twentieth-century art at the Metropolitan Museum of Art. "And it's obvious that an exhibitionist-masochist is not going to last very long. You go up in a fine burst of flames, and then you die. And then the voyeur-sadist needs another exhibitionist-masochist."

Warhol found one of his first exhibitionist-masochists in Freddie Herko. Warhol had been enamored with the incredibly lithe Herko, a dancer and choreographer who was like a magical fairy dancing along the outer walls of life. Warhol featured Herko in several of his films. In *Roller Skate*, Herko moves elegantly through the city streets on one skate. Herko might have risen to a life of artistic triumph. But amphetamine came to own him, and he became disheveled and disoriented, wandering the streets. He talked about killing himself, but nobody paid much attention. He was just another Greenwich Village freak, a weird addition to the scene.

One day in October 1964, twenty-eight-year-old Herko went to his friend's fifth-story apartment. He took a bubble bath, waltzed naked around the apartment, and then, with Mozart's Coronation Mass playing, danced out the window, the first of several suicides among the habitués of the Factory.

Warhol spent no time regretting that he had not tried to help

Herko. He wasn't a lifeguard watching out for the lives of others. He did have one regret, though. He wished he had been there as Herko soared out the window so he could have filmed the death. It would have been great footage.

One of Warhol's regular guests in his house was Emile de Antonio, a film producer conversant with the most provocative themes of American culture. He directed *Point of Order*, the classic 1964 documentary about the Army-McCarthy hearings, and would direct other nonfiction films.

An erudite Harvard graduate, de Antonio spoke in precise, passionately felt sentences. An intense observer of the world around him, de Antonio said Warhol looked like "a super-intelligent white rabbit, a voyeuristic one." But his friend had little apparent interest in current events or the wider world. Instead, Warhol's house was full of movie magazines and memorabilia, such as Carmen Miranda's shoes and a wooden carousel horse.

In his talks with de Antonio, Warhol discussed not such matters as the growing war in Indochina but how he could get rich selling the underwear of the famous. He decided to divide the underwear into two categories: soiled and unsoiled. How much, he wondered, would collectors pay for a pair of Cary Grant's or Tab Hunter's dirty drawers? He figured he could charge $10 for washed and $25 for unwashed. It was a perfect Warholian gambit, mixing celebrity and the unseemly.

De Antonio took pleasure in advancing the careers of artists he admired. He had been one of the friends who convinced Warhol to leave his successful commercial art career in 1961 and march boldly into the pop art world. Tinkering with this new artistic style, Warhol took images from popular culture and created what, in some measure, was anti–fine art, a middle finger to the establishment.

But de Antonio was unsettled at the world Warhol created at the Factory. "Andy set himself up as a sort of scorpion," the documentary filmmaker said. "He's like the Marquis de Sade. He made people come and do these ridiculous things, make fools of themselves, and destroy themselves. He did it through utter passivity. His very presence was a releasing agent in which people could live out their fantasies. Sometimes his guests stripped naked so Andy could watch, but in some cases, their fantasies went to violent places." Warhol was a flame in the night that attracted the dark and the troubled. Some were merely singed, but others flew into the flame. The specter of death floated above the Factory.

॥॥॥॥॥॥॥॥॥॥॥॥॥

Warhol had long wanted to be represented by Leo Castelli, America's most prestigious avant-garde art dealer. Castelli had turned him down previously, but in November 1964, he gave Warhol a four-week show at his gallery. As always, Warhol took his images from somewhere else, in this case, a photograph of four hibiscus blossoms in a recent issue of *Modern Photography* magazine. He created over nine hundred silk-screen images, thirty-six of which were selected to hang on the gallery's white walls. He produced as many as eighty paintings a day, working with Malanga and practically anyone who entered the Factory.

De Antonio chanced into the Factory when Warhol was working on the artwork. "What Andy did was have fifteen paintings on the floor and five different people painting them," he recalled. "He literally was mass-producing them."

The flowers were a radical departure from Warhol's recent work commemorating movie stars, criminals, and commercial products. This was artwork that could hang in a mansion in the Hamptons or a townhouse in Boston's Back Bay without seeming out of place next

to masterworks of a hundred years ago. To do so, Warhol had chosen the perfect image. And then when he colored the flowers, he worked quickly and intuitively, painting the blossoms in all kinds of unique, subtle ways.

Some people compared Warhol's flowers with Claude Monet's water lilies. Both had auras about them that made them unforgettable. Monet painted *his* flowers with laborious concern, discarding any that did not meet an excruciating standard known only to him. The artist spent his last three decades painting around 250 waterscapes of lilies. Through fading eyes, the aged French impressionist continued to rework some of the lilies.

Warhol would not be getting down on his knees as a half-blind septuagenarian silk-screening a few more flowers. Why should he? He had a machine in place that could quickly produce whatever he could sell.

Before, Warhol had often been disappointed by how little he got for his work and how much was left unsold. The Castelli show almost sold out, and the dealer sold another fifty flowers in the following twelve months, bringing in around $50,000. This was even more successful than Lichtenstein's celebrated Castelli show back in 1962 and elevated Warhol to stand next to his competitor at the top of the pop art world.

Not only was the show a commercial success but Warhol received the best reviews of his career. Many of the critics tried to outdo each other in the homage they paid him. "The artist is a mechanical Renaissance man, a genius," David Bourdon wrote in the *Village Voice*. The critics saw what they wanted in the flowers. Carter Ratcliff wrote, "What is incredible about the best of the flower paintings is that they present a distillation of much of the strength of Warhol's art—the flash of beauty that suddenly becomes tragic under the viewer's gaze."

That was just the beginning. If Warhol's name rose above the fray, there was no end to the amount of his artwork he could sell at premier prices and, with the silk-screen process, no end to the number of original works he could create. It was printing money.

One day in 1964, the East Village performance artist Dorothy Podber entered the Factory dressed in a black leather jacket, accompanied by two similarly attired friends and a Great Dane. Fuming with rage at how art had become a limitless marketplace, she shot a bullet through a stack of Marilyn Monroe paintings. Instead of restoring the artwork to its pristine state, Warhol fixed them with no more concern than patching a flat tire. One painting he sold as is, saying the hole in the canvas was "like a pimple."

Marco St. John; his wife, Barbara; and their son, Marco Jr., visited on another occasion. Marco Sr. was a Broadway actor of some distinction, a handsome man of excessive temperament who enjoyed tasting the delights of at least one of Warhol's Superstars. Little Marco was scarcely a toddler, but he was already following his father's wild ways, running back and forth around the studio. He boldly ran across a painting being silk-screened, leaving tiny footprints across the artwork.

The St. Johns were devastated, but Warhol relieved them. "Oh, no, don't get upset," Warhol said in his toneless voice. "It's kind of nice. I'm going to keep it like that."

Why should Warhol care? He did not see his work as precious, irreplaceable objects. How much did his art matter if the creative experience had been debased into an industrial process?

Art was the vehicle that brought Warhol celebrity. Much of his originality lay in promoting his work and image, tying them together in an irresistible package. "What is brilliant about Andy is not related to art," argued the late art critic and author Robert Hughes. "It's his capacity for manipulating media. Warhol was interested in

the condition of being something called a pop artist because it was there that he perceived it might be possible to become a celebrity."

Some of those closest to Warhol had a similar disregard for his stature as an artist. No one spent more time working with Warhol during his most creative years than his longtime assistant Gerard Malanga. During his decade with Warhol, Malanga developed a startling disdain for his employer as an artist. "Andy didn't invent an aesthetic or a way to proceed in and for his art," Malanga said. "The only way he did proceed was to use something someone else made and have his name put to it. Painting was for Andy not art at all but a way of gaining as much capital as possible."

The art critic Barbara Rose, who was married to the artist Frank Stella, also questioned Warhol's originality. Although Warhol sent the brilliant young woman various gifts, she did not turn off her dispassionate judgment. "He knew an original idea when he saw one," Rose said. "He couldn't have one, but he could recognize it quicker than anybody else and package it better. Andy had a tremendous ambition to be a great artist, and what he did was have a great career. That's part of the cynicism and the nihilism, which is: 'Well, if they take this, they'll take anything.'"

Warhol's fellow artists were the best judges of his work, and there were thorns on the roses. Jasper Johns was particularly critical. He felt Warhol was pillaging his ideas, a sentiment that Rose shared: "The Campbell Soup cans, the beer cans, they're terribly clever pastiches of things that came out of Jasper Johns and Frank Stella."

Warhol's ideas came mainly from other people. He admitted he had appropriated the silk-screening idea from his fellow pop artist Robert Rauschenberg. "I just thought it was such a clever idea I just took it from him," Warhol said. The flowers had been suggested by his friend Henry Geldzahler. He spoke to Warhol almost daily for several years and was a crucial influence. "Andy's greatness is in recognizing

the quality of ordinariness and focusing on it until it's no longer ordinary," Geldzahler said. "That's what Andy's magic touch is."

After 912 pages of writing followed by 747 pages of online notes, Warhol's most recent biographer, Blake Gopnik, concludes the artist deserves to reside in the pantheon beside Picasso, Michelangelo, and Rembrandt. Other critics may not be so quick to pull out a cheerleader's pom-poms, but they also see him as a singularly important artist.

On the other side, some see Warhol's oeuvre as a repudiation of the idea of the artist as a visionary. The art critic and author Jed Perl writes in the *New York Review of Books* that Warhol is "the defining figure for several generations that conceive of art as appropriation and replication."

Another period icon, Gloria Steinem, looked at Warhol's pop art with a decidedly feminist view. "Suppose a woman painted Campbell soup cans. What would happen to her?" Steinem asked. "She'd be laughed out of sight, perceived as superficial. It takes a man, and a man with the pretentiousness of Andy Warhol, to make Campbell soup cans into art."

If the cheerleaders are correct, schoolchildren should learn about Warhol's paintings as a monumental achievement of American art. If the naysayers are right, Warhol's work should be removed from Manhattan's Museum of Modern Art, carted down to Times Square, and raised high above the city as billboards, residing in their rightful place as one of the grandest artifacts of twentieth-century popular culture.

<div align="center">||||||||||||||||||||</div>

The filmmaker Emile de Antonio had Rabelaisian appetites for food, women, and drink. One afternoon in 1965, Warhol sat talking with de Antonio in the Russian Tea Room. That's when his

friend liked to start drinking. As far as de Antonio was concerned, nothing could compare to entering a likely establishment midafternoon "before drink time, when the bar looks like the living room of a seedy, comfortable country house. The Dom Pérignon perfect, cool, not cold."

De Antonio waxed rhapsodically about the pleasures of drink, but booze had taken hold of him. Mildly disheveled, he could barely button his wrinkled pants over his expanding stomach. In fact, de Antonio's drinking had gotten so bad that Warhol smelled an opportunity: he'd make a film of his friend, chronicling his descent into drunkenness. De Antonio, Warhol knew, was a macho alcoholic, proud of how much he could put away. "I'll drink an entire quart of Scotch whiskey in twenty minutes," de Antonio bragged. It was the kind of crazed, over-the-top scheme that de Antonio sometimes had and calmer heads usually dissuaded him from pursuing. But instead of intervening with his friend and saying he needed help, Warhol walked him to the Factory to film a one-person picture, *Drunk*.

The idea was simple: de Antonio would drink at least a quart of scotch, and Warhol would film what happened. The fact that people have died drinking less than that was not considered—or at least, it wasn't mentioned.

The first few drinks of scotch that de Antonio poured into a glass of ice loosened up his vocal cords, and he talked eloquently about all kinds of matters. As he drank glass after glass, he no longer spoke those perfectly constructed sentences but flared out in invective. "Down with everything," he shouted, tossing a soda bottle away. "If I drink this other bottle, I'm gonna be so fucking drunk; I'm gonna break up this whole joint, you know that?"

Slurring his words, de Antonio called out random threats. "I want to knock your fuckin' head off. Do you want that?" Then his words became incomprehensible. He was so drunk he could not

even pour himself another drink. No longer able to stand up, he began crawling along the floor on his hands and knees. He pounded his head against the wall again and again and again, and nobody did anything to stop him.

Warhol found this exciting. He stood back and kept the camera rolling for sixty-seven minutes. In the end, his friend lay there, de Antonio's only sign of life a twitching hand.

Isabel Eberstadt was there that day, working on her story about Warhol. She was so disgusted watching de Antonio collaborating in his "humiliation and degradation" that she left before Warhol finished shooting the film. She had spent a lot of time with Warhol over the last several months and was getting upset about all kinds of things at the Factory. A new group had started moving in, their lives punctuated with "an enormous amount of bitchery and malice." Instead of eschewing them, Warhol celebrated their arrival. As for his films, she considered most of them pornographic. Eberstadt was hardly a prude, but there was nothing erotic or sensual about his footage; it was crude, devoid of beauty.

As Eberstadt tried to remain the observer, she realized she had gotten sucked in emotionally to the whole scene. "What it did to me was fill me with desperation," Eberstadt said. "I would really feel the most insane, self-destructive urges." After watching Warhol shooting *Drunk*, she knew she had to get out for good.

Eberstadt decided the piece she was writing about Warhol was far more positive than what had become her genuine opinion. She tried to compose something different, but discovered she could not write about Warhol's world in all its complexities and dark veneer. Warhol was to be her entrée into literary journalism, but she never became the journalist she wanted so much to be.

Eberstadt was not the only person distressed by *Drunk*. "This is really one of the most reduced images of a human being I've ever

seen," said Callie Angell, who curated an exhibition of Warhol's films and was one of the few people to see *Drunk*. "It's almost like Andy Warhol tried to arrange a film of someone turning into a corpse before your eyes."

Jonas Mekas—the same man whose Film-Makers' Cinematheque on West 41st Street had been so instrumental in showing Warhol's early film work—was paying attention as Warhol's artistic star continued to rise. In the hothouse world of underground filmmaking, Mekas's stamp of approval meant something, which is why it was so meaningful that, in late 1964, his magazine, *Film Culture*, presented Warhol with its annual Independent Film Award, the highest honor among non-Hollywood filmmakers. Previously, it had been given to John Cassavetes for *Shadows* and Robert Frank and Alfred Leslie for *Pull My Daisy*, influential films that can still be viewed today.

Warhol received the award for *Sleep, Kiss, Haircut, Eat*, and *Empire*, films that have largely disappeared from public view partly because they barely entered it. Mekas bestowed the award on Warhol with hyperbolic praise: "Andy Warhol's cinema is a meditation on the objective world; in a sense, it is a cinema of happiness."

Other independent filmmakers, who had spent years developing their craft, were outraged at the award. "This guy comes along who does absolutely nothing and knows absolutely nothing," fumed avant-garde filmmaker Gregory Markopoulos. "Other people have to set his camera up, load it, focus it, and he just shoots nothing and he's the biggest thing going."

The criticism may have been one of the reasons Warhol decided not to attend the awards ceremony. Instead, Mekas came to the Factory bearing an edible trophy, a fruit basket. When Mekas picked up his Bolox to film Warhol accepting the trophy to be shown at the awards event, Baby Jane's moment had come. After rubbing an issue

of *Film Culture* as if it were Paul Newman, she plucked a banana out of the basket, caressing it as she might a lost lover.

||||||||||||||||||||

B aby Jane was a show-off. She wanted everyone to see her, whether fondling a banana or standing in a Paris street with a bold pose while a *Life* photographer clicked away. "I want to enjoy what I wear and to be seen enjoying it," she told *Life* in March 1965. "I don't kid myself. We are all snobs in our world."

At the height of her celebrity, Baby Jane appeared on *The Tonight Show* hosted by Johnny Carson. The other guests were individuals of unquestioned accomplishment: the actor Orson Bean, the writer Rod Serling, the singer Glenn Yarbrough, and California senator George Murphy.

It was a stellar list, but Carson had begun to realize guests of true attainment no longer satisfied an increasingly fickle audience. They preferred the Baby Jane Holzers of the world, fireworks that shot into the sky with a burst of light before falling into darkness. Such a person was lifted so high so fast that she might believe she would stay there forever. But even before getting used to her high perch, she plunged back into anonymity, wondering what had happened and why. This was the dark reality of the storied "fifteen minutes of fame." There was a savage logic to it, and it was often devastating.

As the spotlight followed Baby Jane wherever she went, she worried about where this might lead—and what might happen when the glare moved on. An editor called her, saying, "We want to do a story about you . . . because you're very big this year." Instead of being flattered, all Baby Jane could hear was "this year," and she was so upset that she was tempted to respond, "Well, pussycat, you're the Editor of the Minute, and you know what? Your minute's up."

Warhol wanted some of Baby Jane's fame. To get it, what could be better than hanging out with the Girl of the Year? On evening rounds of parties, Warhol often escorted her, typically bringing an entourage along with him. They bolted into the room with all the subtlety of shoppers entering Kmart at dawn on Black Friday, and the hosts were happy if the group did not stay very long.

On occasion, members of the old New York elite invited Warhol to their dinner parties. His only guidance was the linen paper place card with his name written in elegant twists and turns, setting out his place at the table. That was helpful, but when he sat down, on either side of the Limoges porcelain plate sat so much cutlery that his table setting looked like instruments prepared for heart surgery.

Warhol had done quite well so far using only one fork, spoon, and knife. He had no idea where to begin and where to end. Unwilling to be exposed as a rube, he did what he almost always did when he was uncertain: nothing. As the others began eating their dinner, he sat there, unmoving.

The lady to Warhol's left could not abide sitting beside an artist slowly starving himself to death. "But, Mr. Warhol, you haven't touched a thing," she said.

He looked at her blandly. "I only eat candy."

Like almost anyone who rises from nowhere in America, Warhol was a quick study. He copied not only pictures but human behavior, and soon he was a well-received guest at the finest homes in the city, picking up the forks and spoons as if he had been born to the manor.

Yet no matter how often Warhol supped at the tables of the anointed, he was always that poor boy from Pittsburgh. F. Scott Fitzgerald could have explained it to him. "Let me tell you about the very rich," Fitzgerald famously wrote in his short story "The Rich Boy." "They are different from you and me. They possess and enjoy early, and it does something to them, makes them soft where we are

hard, and cynical where we are trustful, in a way that, unless you were born rich, it is very difficult to understand."

Warhol was a terrible snob despite his humble background—or more accurately, *because* of it. Based in part on what he learned working for years around the fashion world, he looked with painful acuity at how people dressed and acted. Baby Jane had given him so much, but before long he turned his savage judgment onto her.

"Andy was very scornful about Jane in the early days," said Eberstadt. "He felt she was very crummy." Baby Jane did not have old money and old manners. Sometimes, she spoke in idioms she presumably thought were hip but her auditors deemed vulgar. She was not quite at the level of society where Warhol sought to be welcomed.

"For Andy, in the beginning, I brought glamour," Holzer said. "I would get him invited to parties, where he would always show up with 10 more people than were invited. . . . But in the end, he became so glamorous that I was tagging along with him."

As his star continued to rise, people started focusing on Warhol more than Baby Jane. Some bought his artwork. Others began issuing him invitations directly, not just as Baby Jane's plus-one. Baby Jane had done her job. Warhol was an astute manager of his emerging image, and he knew it was time to move beyond Baby Jane and find someone new to travel with him to the elite haunts of the great city.

That was just as well, for as much as Baby Jane liked Warhol and continued to be his friend, she could not stand to be around the Factory any longer. Warhol may have dubbed her a Superstar, but she was uncomfortable with much of what she saw happening at the studio. To Baby Jane, the whole scene had become "so faggy and so sick and so druggy, I just couldn't take it. There was madness to it, insanity."

Baby Jane wanted to be not a mere Warhol Superstar but a gen-

uine, true to the roots movie star. When she went to Hollywood, the executives greeted her like she already had her star on the Walk of Fame. In the business, the meeting length defined your importance, and Baby Jane's continued forever. But afterward, the strangest thing happened. *Nothing!!* The trades were full of stories about how she was starring in this movie or that play, but nothing. *Nothing!!* She was tested for a role in a new TV series playing a "Baby Jane type." How could anyone play the part better than the real thing? But the producers said she wasn't quite right.

Soon, it was clear that the press had gotten tired of Baby Jane, and how quickly. "We are a little surprised to be saying this," wrote syndicated columnist Ward Cannel in February 1965. "But really, we would prefer not to know any more about Baby Jane Holzer and what she thinks about things." Seven months later, the columnist wrote her epitaph: "Whatever Mrs. Holzer had that made her so contemporary last winter, she does not seem to have it anymore."

Eugenia Sheppard wrote a widely circulated fashion column. She rarely took out against anyone, but Baby Jane irritated her. "Jane Holzer, a gay, friendly girl with an easy charm has been highly over-exposed," she wrote. "Jane has been magnified into a character for outer space."

In July 1965, the *New York Times Magazine*'s dissection of "The In Crowd and the Out Crowd" was one long death knell. Baby Jane was not only named part of the Out Crowd but singled out for disdain: "Mrs. Holzer is a particular instance of someone whom the general public may believe to be In but who is nevertheless Out, for she is part of a horde of perhaps 5,000 would-be Ins who doggedly follow in the tracks of the In crowd but who never quite catch up with them." In the *Times*'s judgment, anyone who thought Baby Jane In was by that one judgment declaring herself a loser of the first order. It was clear. Best to stay away from Baby Jane.

Warhol got sucked into the whole business. Although he had never been close to an In, here he was, an Out, next to Baby Jane in a photo section where the Outs looked like faces on an FBI most wanted poster in the post office.

Although Baby Jane had done almost nothing to deserve the massive publicity she had received for the past year, she also had done nothing to deserve this savage rebuke flung at her like justice. "They built us up, then tried to rip us to shreds," she said, looking out at the wreckage of her media life.

Baby Jane's life was changing even in her household. She could not have dressed so spectacularly without her butler, Johnny, trying on her clothes and telling her what worked and did not work. He flew to Copenhagen and, after a sex change operation, returned, in the words of a gossip columnist, as "one of her maids."

When the spotlight is turned off, it is seldom turned on again, but Baby Jane had to try. "I really don't need to work," she said. "But I like to perform." By performing, she meant any public spectacle. A few months before, her presence was enough to send paparazzi and society reporters rushing forward. Not any longer. She had to do something, *anything*, to get attention.

Baby Jane's new manager pulled in enough chits to get her on the *Hullabaloo* musical variety show in March 1966, belting out "(You're Gonna) Hurt Yourself." This was a unique opportunity, and she did not want to risk having her debut as a singer overlooked. She decided to wear a see-through plastic dress over flesh-colored tights that made her appear naked. Shortly before she went on, the producers insisted she wear something else.

Two months later, at the opening of Manhattan's Cheetah discotheque, Baby Jane wore a transparent vinyl miniskirt with bands hiding what discretion said must be hidden. The next month, she showed up at an after-theater event in Midtown Manhattan in a

backless gown that, from the angle the photographer shot her, made her appear naked. At magnate Charles W. Engelhard Jr.'s fiftieth birthday party, she burst out of the birthday cake wearing what appeared to be pajama bottoms and a spangled bra. With such outfits, she did not have to say a word to get her name and picture in the dailies.

In Baby Jane's heyday, the press ignored the inconvenient fact that her husband was rarely present. Now, when they bothered to write about her, they listed her escort of the evening, whether it was author Jan Cremer, actor Timmy Everett, or other men who were clearly married. "Contrary to what she believes, that actor she's dating doesn't have a tolerant wife—he just has a wife," one columnist wrote.

Baby Jane decided she had to change her image. To emphasize her seriousness, she insisted that everyone start calling her Jane. Jane took acting lessons. Jane cut a single, "Rapunzel," swallowed up in the abyss of nothingness.

Jane went out to Hollywood again, and producers signed her for epics like *The Berlin Wall Teenager* and *Nothing but the Blues*, but nothing was made. Jane had vowed to escape Warhol's world, but her one role was in a quasi-underground film, *Ciao! Manhattan*, filled with Warhol's other Superstars. Then she got a part playing a pregnant woman in *Futz*, a comedy that had been an off-Broadway hit. It wasn't much of a stretch, since Jane was pregnant, giving birth to her son, Charles, by caesarean in June 1969.

The media blitz that had been Baby Jane's life was fading memories. Nothing had worked to get her back in the glorious spotlight. It was all over. So why not take her new son and her husband and start over anew?

In 1970, the Holzers purchased Chestertown House in Southampton. When the thirty-five-thousand-square-foot du Pont estate

was constructed in the twenties, it was the biggest mansion ever built on Long Island. With its fifty rooms, Chestertown House hovered in all its majesty above the land.

It took someone with royal intentions to be comfortable in such surroundings. Jane and Leonard settled in as if they had been born there. There, she introduced a new Jane Holzer, a socially conscious young matron and mother. She had always been one for hyperbolic proclamations. Jane was still at it, declaring, "The days of relying on Paris designers for clothes are finished." These days, she said, she shopped at boutiques, buying off the rack.

Jane had new friends like Gloria Steinem, who did serious things. Jane emulated her activist friend. She had observed the drug use at the Factory and said she was writing a script about drug addiction for a film that would be shown to schoolchildren nationwide. The film was never made, or not widely shown.

"I was a famous model of the '60s, and all the gossip columnists wrote me up, so I became a celebrity," she said. "But I was a creation and an image. That's illusion. Now I'm myself."

It all sounded so wonderful, and perhaps twenty-nine-year-old Jane was herself, but the Holzers were living a fantasy. They fancied they had no commonality with the mundane realities of middle-class life. But like so many couples, the Holzers were living far beyond their means. When they did not pay their mortgage and taxes, they were treated no differently than anyone else. The authorities threw them out, confiscated the estate, and auctioned it off in 1975.

Before "the Girl of the Year" left Chestertown House for the last time, she took with her everything of value. The du Ponts had been collectors of art and exquisite furnishings, including the smallest fixtures. Jane had her minions rip out the precious stained glass windows and antique cupboards. She hauled the bookcases off, too.

And when the whole place looked as bare as a barracks, she moved on to the hinges, the locks, even the knobs, denuding the mansion of everything but the walls.

Leonard took no part in this. Jane's husband had absconded for California.

Truth, Naked and Otherwise

Warhol chanced one evening to enter Max's Kansas City, a new steakhouse and nightclub venue in the déclassé outer reaches of Park Avenue South that had opened in December 1965. Artists and musicians had started hanging out in the big front room, which had a jukebox and paintings and sculptures given to owner Mickey Ruskin in exchange for food and drink. No one of any consequence would agree to a table in the back room, but that's where Warhol asked to be seated.

The room glowed with a strange red fluorescent light given off by Dan Flavin's provocative sculpture—*monument 4 those who have been killed in ambush (to P.K., who reminded me about death)*—a work of minimalist art protesting the Vietnam War. With Warhol holding court many nights, alongside 1960s New York icons like Philip Glass, William S. Burroughs, and Allen Ginsberg, that inner room soon became one of the hippest places in New York. Famous artists like Larry Rivers and Robert Rauschenberg attracted their fair share of

celebrities, too, but more than anyone else's, it was Warhol's hangout. If you were an artist or rock musician or had pretensions of becoming one, the back room of Max's was where you wanted to be.

The sixties bohemians were worse snobs than the Boston Brahmins. Warren Beatty showed up one evening dressed in Hollywood chic. The movie star was told to return to his hotel and change into something more fitting to sixties hipness. Warhol, his Superstars, and other assorted hangers-on sat at the "Captain's Table" at the back of the inner sanctum. If someone dared to walk up to Warhol's group, he would most likely be met with withering stares that would send him back to Scarsdale.

Dinner at Max's was rarely enough to make a whole evening out for Warhol. He hopped from one party to another into the early hours of the morning. One of his favorite places was Lester Persky's penthouse on East 59th Street. Persky—the Madison Avenue man who had helped Warhol produce the ads that became part of *Soap Opera* a few years before—wanted to move on from his less-than-prestigious occupation to become a Hollywood producer. The flamboyant ad man needed a way to break into an industry that was decidedly unimpressed with his credentials. Persky did so in part by sucking up to prominent creative figures and giving memorable parties in their honor.

One evening, Persky's guest was the wickedly sardonic Gore Vidal, whose 1948 novel, *The City and the Pillar*, had made him a hero in queer circles (and vilified in parts of the literary establishment). Vidal went up to Persky's penthouse on a rickety elevator that often stopped mid-floor, leaving guests praying for relief and safe passage.

Persky had a special treat for his honored guest. "Oh, Gore, we have a beautiful boy for you," Persky said. With that, a naked young man from Appalachia was brought in with his penis on a tray like a

jeweler displaying a precious item. Vidal went into the study to enjoy his hors d'oeuvre.

"Persky would inveigh famous writers into coming there for an evening," Vidal recalled. "There would be three or four, generally very crude, generally from Appalachia, boys from the Ozark Mountains, clean-cut, old-fashioned American boys. You would take the boy of your choice into another room." Even though Vidal disliked Persky, whom he called the Wax Queen, he returned twice more for Persky's special hospitality.

Warhol was far more private in his sex life and often went long periods without a lover. But when he did have a boyfriend, it was often an uneducated young man whose street smarts challenged him in ways his more sophisticated brethren could not. He lived for a few months with Philip Norman Fagan, a tattooed biker who looked as if he would as likely beat you with a chain as greet you with a handshake. Despite the image, Fagan had studied ballet at Texas Christian University and was a complex man and a searching soul. But it was that menacing image that made the handsome Fagan so exciting. Warhol loved shooting film of his lover, who left soon afterward to wander around Asia. Four years later, when Fagan returned to the States, he killed himself.

Persky may not have provided Warhol with rough trade like Fagan, but the ad man was startlingly observant of the artist's needs. He noticed that when Warhol showed up with Baby Jane, she no longer created the excitement of her first visits to the would-be producer's penthouse. Warhol needed somebody new, a splendid young woman to take him to Manhattan's elevated circles, including places Baby Jane would never be invited.

On his nightly excursions through the city's social life, Persky thought he had found Baby Jane's replacement. "You've got to have a

new Superstar," he lectured Warhol. "You've got to meet this girl, Edie Sedgwick. She will be your new Superstar."

Early in 1965, Persky invited Warhol to a party at his penthouse honoring the playwright Tennessee Williams, famous for *A Streetcar Named Desire* and *Cat on a Hot Tin Roof*. Persky hoped to produce plays and films from some of Williams's works. More interested in getting royally drunk than playing the great man, Williams shrunk into a corner, downing drink after drink. Warhol's resident screenwriter, Ronald Tavel, approached the playwright and began talking. Williams looked up at him with vacant eyes and said only one word: "Yes."

Persky had also made a particular point of inviting Edith Minturn "Edie" Sedgwick. Edie was the vivacious core of the evening. She danced like no one else. It was partially rock and roll, a bit of ballet, with some yoga thrown in, and it was mesmerizing. She had a model's thin body and exuded a sylphlike, androgynous image. The five-and-a-half-foot-tall Edie wore an exotic leopard suit and dark beehive hair, and had long legs that tapered to tiny feet that never stopped moving.

Though she was a sculptress of some talent, Edie's face was her greatest work of art. It was like a painting in a museum that one could not forget, especially those large, haunting eyes. She spent hours doing her makeup, every detail perfectly drawn, set out so it would stay true for all the hours of the night.

New York was a city of endless parties, one after another spilling into each other, and Warhol and Edie were both nonstop partygoers. They had met on a previous evening, and Warhol did not need Persky to introduce him to her. But Persky was keen to take credit, and sitting at a marble table, he brought the two of them formally together.

Jane Holzer had been new money, but Edie was a member of the old American upper class. Her ancestor arrived in Massachusetts in

the first half of the seventeenth century and the Sedgwicks had been members of elite society ever since. Warhol had finally learned which fork to use and had mastered the social patter of the elite, but he would never be one of them. It took generations, and it was more than the clink of money. It was in part confidence. Edie could walk anywhere, do anything, and feel she belonged.

Chuck Wein, a Harvard graduate with artistic pretensions, was hanging around Edie that evening. He was her supposed closest friend and de facto manager, though what he managed was unclear. He kept so close to her that he could have been welded to her with superglue.

Warhol knew immediately he wanted to be around Edie. After a while at the party, the artist and his entourage left with Edie in her old gray Mercedes. He was in awe of her—the kind of woman who could have sat next to the Pittsburgh Heinzes and conversed as comfortably as if they were relatives. Of course, he saw how useful she could be to him, but his feelings went far beyond that. He loved her in a way he had no other woman. Warhol was in awe of the almost magical aura Edie exuded. In the first days of their relationship, Warhol entered Edie's world, not the other way around.

When Edie and Warhol went for dinner at L'Avventura, an upscale Italian restaurant, as many as ten people sat at the table. Edie picked up the check. Her only concern was that she knew those next to her. Wherever they went, Warhol kept his hand firmly in his lap when the waiter arrived bearing the bill.

Edie did not have the typical upper-class reticence in talking about herself. During these long dinners, when Warhol was practically the only person not downing drink after drink, Edie often spoke in restless soliloquies about her past. Far from bragging about her privileged beginnings, she told tales of a troubled childhood that haunted her.

IIIIIIIIIIIIIIIIIIIIII

E die's early childhood home was Corral de Quati, a three-thousand-acre working cattle ranch in the Santa Ynez Valley, an hour from the Santa Barbara coast. John Ford could have shot *The Searchers* there with John Wayne riding his horse along the dry tableland. Over that vintage scene of the Old West, Edie's parents overlaid their aristocratic values and traditions. Wherever one roamed during the day, everyone dressed for dinner.

Over two centuries, the western Massachusetts Sedgwicks produced many distinguished individuals. That included a Speaker of the House of Representatives, the editor of the *Atlantic*, and Catharine Maria Sedgwick (1789–1867), a prolific novelist, biographer, and crucial figure in the birth of uniquely American literature. Shortly after her death, the poet William Cullen Bryant wrote of his dear friend as "the perfection of high breeding."

Edie's father, Francis Minturn "Duke" Sedgwick, wanted to live up to his distinguished family name. But as a boy, Duke was sickly, weak chested, and abused by bigger boys. He was not unlike the "ninety-seven-pound weakling" who, in the ubiquitous magazine cartoon ads of the era, has sand kicked in his face by a more robust youth who takes away his girlfriend. The boy trains using Charles Atlas's system, returns to the beach, beats up his tormentor, and wins back his girlfriend. The underlying lesson did not have to be shouted: the girl goes to the stronger boy.

With discipline and focus, Duke built himself up, purging himself of any abhorrent weakness and emerging strong, powerful, impervious to hurt or harm. Duke could have stood next to Charles Atlas in his ads in a bikini brief and shimmering body. He was a real man and a Sedgwick. With that, he could take on the world.

Like most of the Sedgwick men, Duke attended Harvard. He

was a Porcellian, a member of the exclusive private club he considered the only place for a young man of stature. As he saw it, the world was divided between "them" and "us," and there weren't very many of "us," people "out of the top drawer."

When the bold, handsome Duke became engaged to the taciturn, tender Alice Delano de Forest, it appeared the couple would sire a new generation of blue-blooded Sedgwicks taking their rightful place in the world. Although Alice's parents appeared delighted that their daughter was engaged to such a splendid young man, there was something about him that made them insist that he have a medical exam. It was clear to anyone who got close to Duke that he was troubled, and likely the De Forests had heard inklings of this.

The doctors diagnosed Duke as a manic-depressive, his moods sweeping from giddy highs to despairing lows. He spent three months in the Austen Riggs Center, a psychiatric treatment facility in Stockbridge, Massachusetts, the ancestral home of the Sedgwicks.

When Duke exited the center, his two doctors advised the couple not to have children. Medical professionals rarely intruded so profoundly into their patients' private lives, but they saw something so foreboding that they could not remain quiet.

Duke married Alice in a ceremony at Manhattan's Grace Church in May 1929 with pews full of the old New York select. Aided by the bride's money, the couple moved first to a fruit ranch in Goleta near Santa Barbara, California, before buying Corral de Quati. For more than two centuries the Sedgwicks had been a prominent Massachusetts family. It was unthinkable for one of them to travel west to live on a ranch. As Duke did so, he showed the doctors what he thought of their judgment. Alice gave birth eight times, to five daughters and three sons. With each birth, the shy mother became more withdrawn, standing back in the shadow of her husband.

Born in 1943, Edie was the next to youngest. As nervous as a

squirrel, the exuberant child explored the vast reaches of Corral de Quati, riding her horse bareback up in the hills, swimming lap after lap in the pool, and running like a fawn.

No matter how far Edie roamed, her father was an overwhelming presence. Tanned as brown as a saddle, Duke galloped across the plains on his stallion, the monarch of his domain. Duke was an amazing specimen of humanity, a beautiful creature from some other sphere. He was also a man of almost pathological narcissism, parading before his guests in tiny bathing suits, barely covering his genitals, his body glistening with oil. When he exercised, he did push-ups around the pool, where guests could appreciate his manliness.

Her father was embedded in Edie's head. It would have been difficult enough to move beyond this preening gentleman cowboy as the image of manhood, but her problems with her father went beyond that. His sense of entitlement included sovereignty over half the human race; he preyed on women who got within his reach, including his daughter.

"I had lots of attention from my father, physically," Edie said, by inference saying he gave her little *emotional* attention. "He was always trying to sleep with me from the age of about seven on, only I resisted that. And one of my brothers claimed that a sister and brother should teach each other the rules and the game of making love, and I wouldn't fall for that either.

"Nobody told me that incest was a bad thing or anything, but I just didn't feel turned on by them. And then I had the butler after me. And the foreman of the ranch. The butler used to come snorting around, and I'd let him play with me, but I never had actual intercourse with him. Came pretty close to it."

Duke showed his foreman, butler, and at least one of his sons

how he believed a man should act, and they followed his lead. He openly despised Black people and considered the "lower class" full of degenerates, but it was this upper-class gentleman who turned incest into just another game. He protected his young daughter from no one, not even himself.

In August 1954, partly to escape her family, Edie's older sister Pamela married on her nineteenth birthday. Many of her friends from Smith, the Massachusetts women's college she attended, flew out to be bridesmaids, spending a week at the Sedgwicks' new ranch, Rancho La Laguna.

The guests thought they had fallen upon a Western paradise. It was a working ranch with cattle and horses, the mythic West brought to life. There were also tennis courts, a swimming pool, mannered dinners, musical performances, and rides up into the mountains for picnics.

A few days before the wedding, Edie's older brother, twenty-one-year-old Robert Minturn "Bobby" Sedgwick, broke his neck careening down a hillside on his bicycle. His father only wanted muscular, macho sons who deserved the Sedgwick name. Bobby was a hyper-intelligent young man but did not exude manliness. In riding his bicycle as he did, he was trying to become the son his father would love.

Another of Edie's brothers, eighteen-year-old Francis Minturn "Minty" Sedgwick, did not even attempt to become his father's clone. Growing up, his parents made him wear a wire helmet to flatten his ears into the required position of a Sedgwick man's. Reminiscent of Dostoevsky's Prince Myshkin in *The Idiot*, Minty appeared stupid to some, but was full of a loving sense of life. Devoid of athletic ability, with a subtle artistic personality, he had nothing of the qualities Duke wanted in a son. Minty was a boy who cried, and a Sedgwick

man did not cry. Minty's father could not disown his son, only pester and mock him for what he considered his pathetic concave chest and sissy conduct. He beat him as if he could flog him into a real man.

Minty was an alcoholic by his fifteenth year, using the ubiquitous booze on the ranch to deaden the pain. He ended up serving with distinction in the army. Even though Duke had not fought in World War II, his son's service did not make him a real man by his father's reckoning. As Duke drove Minty further down in despair, he did not realize greatness is born as often out of seeming fragility and weakness than from those who pose with manly strength.

Believing that so-called "superior" people are good-looking, Duke never shied away from sharing his opinions, loudly and publicly, about who was superior and who was not. At Pamela's wedding, Duke applied his grading system to the bridesmaids. In front of them, he criticized those with bad legs and commented knowingly on the breasts of others.

One afternoon just before the wedding day, the bridesmaids sat around the pool in bathing suits and Peck & Peck Bermuda shorts. Duke decided to cut one out from the herd. "Come on, let's go sunbathing," he said to the young woman. The other bridesmaids were appalled to speechlessness. Everyone knew Duke sunbathed nude and where this would lead. The bridesmaids considered themselves sophisticated Smith students, but they had never heard of such an older man, especially not the bride's father, accosting a young woman.

Eleven-year-old Edie was the flower girl, a picture of innocence. But her words exposed her familiarity with sex—and, specifically, with her father's bad behavior, which to her was commonplace. "Oh, for God's sake, Fuzzy," Edie said, using Duke's nickname and walking away from the pool.

The bridesmaids realized they were not in paradise, not even

close. "Here was this great stallion parading around in as little as he could," recalled Mabel "Muffie" Wentworth Brandon Cabot, who later became First Lady Nancy Reagan's social secretary. "And we were all the mares, and there was just the sense of breeding. It wasn't sex. It was breeding a certain elite, a superior race, really the super race."

One day, Edie came running into one of the rooms at the ranch and found her father having sex with a visiting lady. As his daughter ran out, Duke jumped up and slapped her a few times, trying to convince her she had seen nothing. Then he called a doctor to fill her with tranquilizers.

Duke abhorred fatness, viewing it as a sign of weakness and a lack of discipline, another mark of the lower class. Edie appeared a model of how he thought a woman should look, but in truth she was suffering from severe eating disorders. Living in a world where one could have everything without consequences, she was bulimic, eating enormous meals, throwing up, and returning for another gigantic feast before disgorging again.

In the fall of 1958, Edie's parents sent their fifteen-year-old daughter to St. Timothy's, an exclusive girls' boarding school in Stevenson, Maryland. A continent away from Rancho La Laguna and her father's shadow, Edie began her year splendidly. The Episcopalian school was a club for the privileged, and the girls quickly sorted out who mattered and who didn't. They voted Edie class president; she was, by any measure, the most popular girl in the class.

On the ranch, Edie rarely dealt with groups of people collegially, in so doing, understanding the ups and downs of human relationships and the give-and-take of true friendships. At St. Timothy's, she befriended one girl, talking to her with great intimacy to the exclusion of all others. Then Edie dropped her and picked up with someone else. Edie did this so often that her classmates concluded she was manipulative and unworthy of their concern.

And then winter came. Edie was a California girl used to day after day of sunshine. Those cold, dark days likely brought on a deep depression. She flailed out at her teachers and several of her classmates. Refusing to wear the mandated clothes, she further irritated the headmistress. And then spring came, but it did not come for Edie, and she did not return to school the following year.

Back on the ranch, Edie loved to get on her horse, Chub, and gallop up into the mountains. One day, she was riding up there with her younger sister, Susanna "Suky" Sedgwick, when a great thunderstorm fell upon the mountain. Suky was terrified and rode back to the ranch. Edie loved the sheer menace of the storm, the rain lashing unrelentingly, and wanted to stay up there by herself.

Edie wore makeup and dressed with care for dinner, clearly to please her father. Duke called her "my little chorine," but after many months, he realized his little chorine was depressed, an emotion unacceptable in a Sedgwick. As a young man, Duke had been full of darkness that he may have passed on to his heirs. But that could not be. He slowly concluded that his children were not cut out of the Sedgwick granite, but some crumbling veneer unworthy of the family.

Duke dealt with problems in the family primarily by pretending they did not exist or as the fault of a child who had willfully fallen short. That's why he shipped his son Minty off to Silver Hill Hospital, a psychiatric facility in New Canaan, Connecticut. Duke decided he would have to send Edie off there, too, even though his wife opposed such a drastic measure.

Duke brought Edie's younger sister, Suky, into the conversation, assuming she would solidify his position against Alice's supposed weakness. "Do not send her to a hospital," said Suky, who considered these places depraved loony bins. Instead of engaging in further talk, Duke changed the subject.

"Who's stronger, Mummey or me?" Duke asked his daughter.

"Mummey," Suky said.

As Suky spoke what her father considered words of betrayal, he put his hands around her neck. Alice pulled her husband's fingers off their daughter's throat, and Duke fled. Alice got in another car and drove after him.

When the couple returned, Duke made it clear that if Alice did not agree to send Edie to a mental hospital, he would leave his wife. So she reluctantly agreed, and in the fall of 1962, the Sedgwicks sent nineteen-year-old Edie to Silver Hill.

When Edie arrived in New Canaan, Minty was long gone from the facility, living in Manhattan. When he drank, which was much of the time, he flailed out at the world or shrunk into a ball. In those years, he journeyed from one mental facility to the next, each time leaving as sick as he arrived. When he was out, he took his friends and others to dinners at the Stork Club and other expensive establishments, depleting his financial reserves into nothing. His psychiatrist believed Minty desperately sought his father's love but could not find it.

Silver Hill was a private hospital for the rich and the pampered, predominantly middle-aged alcoholics and depressives. These people did not pay all this money to be genuinely institutionalized and stripped of privilege. Edie could go in and out almost as she chose, and no one tried to stop her from throwing up her gargantuan meals.

The treatment was doing no good, and the Sedgwicks moved Edie to the Westchester psychiatric branch of New York–Presbyterian Hospital. At this no-nonsense facility, the staff watched over every aspect of the patients' lives. The institution worked on a hierarchical principle: as the patients improved, they moved to a higher floor with greater privileges.

Edie only wanted to get out. She did what she had to do to reach the top floor, where she could get a pass to leave the hospital. On one of those sojourns outside, twenty-year-old Edie had sexual intercourse for the first time, with a Harvard student. She ended up pregnant and, because of her mental condition, had a legal abortion at the hospital. As she told the tale, it was no more than a glitch in the night.

When Edie became healthy enough to leave the hospital for good, she did not return to Rancho La Laguna. Instead, she headed to Cambridge and the broad Harvard community, ready to make her own life. Having no intention of entering college, she decided to study art. Her father was a part-time sculptor; his realistic statues were giant in size and mediocre in quality.

Edie sculpted a far more subtle horse than anything Duke ever did. Growing up, as she rode into the hills, her horse had been a metaphor for freedom, and she was still obsessed with horses. Day after day, she returned to the studio, working and reworking every element of what looked like a Tang dynasty horse.

In the evenings, Edie partied with Cambridge's queer set as the lone woman member of their ranks. These sophisticated men had the manners and taste Edie had been brought up to admire inordinately. Thanks to their wit and irreverence, evenings with them were one bon mot after another. Edie was their equal. With a wit as sharp as a surgeon's scalpel, she sent out one stinging riposte after another. Some of her new friends were self-consciously dissolute, which made things even more amusing. Heterosexual men were not half so interesting, and she would have had to spend her evenings fending them off.

One of the men Edie met was Chuck Wein, a 1961 Harvard graduate who dressed like a peacock and made what income he had gambling on horses. As marginal as his life was, he could not pull away

from the Cambridge of his formative years. Wein had a strange obsession with Edie, seeing her as the vehicle of his advance. Ambiguous in everything, including his sexuality, Wein was not a member of Cambridge's gay set, but he did not make passes at Edie.

Sometimes, Edie would bring her big brother Bobby to meet her friends at the storied Casablanca bar. Bobby's broken neck had healed; now, he drove a gigantic motorcycle and, in his boots and leather jacket, looked more a Hells Angel than a Sedgwick. That was part of his technique to distance himself from his family. Fancying himself a Marxist, he had a short-lived career as a labor organizer. His mental problems had taken him to the psychiatric ward at Bellevue Hospital and to other facilities. Although Bobby was still troubled, he was well enough to become a graduate student at Harvard.

Edie was closer to Minty than she was to Bobby, and he was suffering, too. One day in October 1963, the authorities found Minty in Central Park standing by a statue, muttering gibberish; they took him to Bellevue. His mother said she was too busy to come to his immediate aid, but ultimately, she moved him back to Silver Hill.

The following March, 1964, Minty called Edie from the private hospital. He told his sister of a conversation with Duke in which his father rebuked him for his retreat into sickness. "Stop being depressed," he told his son. "You're a Sedgwick." With considerable courage, Minty told Duke the secret that brought him down. He was in love with a young man. Minty's admission that he was gay brought no understanding from his father. "I'll never speak to you again," he shouted. "You're no son of mine."

Minty then went through the names of all the family members, dismissing each one as unworthy of his concern. "Edie, you're the only member of the family I put any faith into," he said.

The next day, Edie got a call telling her Minty had hanged himself with his tie in his room at Silver Hill.

||||||||||||||||||||||

Edie was devastated by Minty's death, but her Cambridge friends were there to help her. Despite all the amusing soirees, a certain melancholy affected a group that coalesced around a Harvard they no longer attended and to which some of them had not even gone. This set was not going to last. The more ambitious or restless members left to make their lives in other places. In the evenings, farewell songs were often sung. As much as Edie enjoyed these times in the Casablanca bar, Cambridge was not enough for her. One night in the summer of 1964, she was the one to whom these songs were sung.

Twenty-one-year-old Edie packed her Mercedes, filling the back seat with a mishmash of assorted suitcases and boxes, and drove to her grandmother's apartment at 71st Street and Park Avenue in Manhattan. Wein moved to New York almost simultaneously, aspiring to a close, if ill-defined, relationship with his friend.

Edie hoped to become a model, but not if it meant dragging her portfolio around half the day. The modeling agency told her that her legs were too thin. Consumed with her looks, she started working to develop her leg muscles and get her body into shape.

Edie could not live the life she wanted with her aged grandmother. In the fall, she took a small apartment in the East Sixties. It was fortuitous timing because she had just received an $80,000 inheritance from her grandmother, about $800,000 in today's money. Instead of investing some of the money or trying to harbor much of it, she started spending it as if there would be no end. She purchased cosmetics by the case and dresses by the score that she dumped in her unkempt apartment. In the evenings, she treated those she knew (and did not know) to extravagant soirees.

Even without her money, Edie would have had many admirers.

But by dispensing her inheritance as she did, she drew people to her like flies to sugar, and she soon had an ever-changing group of admirers and hangers-on. The New York nightlife could rage on until dawn and beyond; *this* was Edie's city. She loved to head out in the evening in her Mercedes, high on LSD that she kept in vials in her refrigerator, another accoutrement of the good life.

Acid could take a user off into distant worlds of ecstasy or despair, overwhelming every rational response in their body. Every time you took LSD you were rolling the dice, and Edie liked most of the numbers, but she eventually decided she needed a chauffeur to drive her around. Thomas C. Goodwin, a waiter at the Right Bank, a French restaurant on Madison Avenue, signed on for $100 a week. That worked just fine until Goodwin totaled the Mercedes, crashing it into a cab. Although Edie loved her car, she shrugged the whole business off and started hiring limousines.

Edie's parents heard about their daughter's profligate spending. That was one of the reasons they wanted her to fly back to the ranch for the Christmas holidays. Bobby would have liked to return to the family home, too, but his foray into Marxism and his déclassé motorcycle lifestyle further alienated him from his parents. Duke and Alice made it clear that their oldest son was not welcome. So he stayed in New York. He was a party guy, and nothing was better than New Year's Eve. But on the evening of December 31, 1964, he was a continent away from his family. He drove his motorcycle into a bus and died two weeks later. Bobby was reckless, and maybe it was just more of that Sedgwick bad luck, but Edie thought her brother had killed himself.

That same New Year in California, Edie ran through a flashing red light. In the intersection, a sedan smashed into her vehicle. She crushed her knee, but Edie and her companion could have been killed.

When Edie returned to New York, she would not let a little thing like a cast on her leg diminish her partying. Her doctor told her whatever she did, she mustn't dance . . . but what was life without dancing? Her money was running out, but she did not appear to care. She tipped her limousine drivers an extravagant $25 but stiffed their bosses and ordered whatever she wanted without intending to pay.

Edie appeared as the exuberant queen of nightlife. Only a few, like her former chauffeur Goodwin, saw beneath the facade. She had told him life was full of little sadnesses, all kinds of things that went wrong. Then there were those on the edge of the edge "who had seen the big sadness," the blackness that overlays everything, and could never return from that terrible vision. That's what she suffered from: the big sadness.

<p style="text-align:center">||||||||||||||||||||||</p>

In mid-April 1965, Edie and Wein arrived for the first time at the Factory. She had been in strange places in her nocturnal wanderings, but nothing like Warhol's studio, a whole different universe. Warhol was making a film about every other week. Edie and Wein had just happened to arrive as he was about to film his latest epic. The film was initially called *Leather*, an appropriate title for the all-male drama. Warhol preferred *Vinyl*. It was not so obvious and had a nice edge to it.

The movie was based on Anthony Burgess's dark dystopian satire, *A Clockwork Orange*. Warhol had little use for the tedious business of buying the rights to others' creative work; better to take it and move on. In this instance, the one-scene screenplay that director Ronald Tavel wrote in a day had little to do with the narrative thrust of Burgess's novel.

Warhol's assistant Gerard Malanga starred in the film, some-

thing he had long wanted. To play the other roles, Warhol assembled several young men adept at sadomasochism in their personal lives. To help them in their savage endeavor, the few props included weights, a leather mask, straps, a funnel, a candle, and a razor.

Malanga rehearsed with Tavel for a week. That irritated Warhol so much that he sent his employee off on absurd tasks, keeping him up much of the night. The last thing he wanted was a film with an actor who spoke his lines professionally.

Just before the camera rolled, Warhol had one surprise. He insisted Edie be in the film. That irritated Tavel, who had no choice but to follow Warhol's dictates. He sat Edie on a trunk next to Malanga, where she chain-smoked, looking like she had wandered in from a ladies' luncheon at the Metropolitan Club.

With her thin frame and hair streaked with silver, Edie appears to be Warhol's female double. As one cruel scene after another occurs next to her, she appears bored with the whole business. When a torturer high on poppers places a leather hood over Malanga's head so he can be righteously abused, her head slumps forward as if she's about to fall asleep.

At her best, Edie is a hip Madame Defarge, knitting while the guillotine slices away. At her worst, she is an absurd non sequitur destroying any measure of seriousness *Vinyl* might have had. But throughout the film, she exudes an irresistible aura that draws the eyes away from the sadomasochistic gay epic in the middle of the screen to focus on her.

The stoned cast and crew paired off as soon as the shooting ended. Some got it on in the hallway; others went up to the roof, while one couple stayed in the Factory, using the sofa for its favorite application. Edie sat talking to Warhol, who was eating a hamburger.

Warhol went out with Edie in the evenings, and he soon became

half of New York's hottest new pair. Edie brought him the attention he so fervently desired. Traveling from the bohemian abodes of Greenwich Village to the upscale venues of Park Avenue, they were more than the sum of their two parts, a glorious couple the center of almost everywhere they went. She brought glamour to him, and he brought an artistic persona to her. "Like binary stars, they revolved around each other to create ever-changing shifts in luminosity and sparkle," David Bourdon writes in *Warhol*.

Warhol was taken with Edie. It was sheer magic being with her. "One person fascinated me more than anybody I had ever known," Warhol said. "And the fascination I experienced was probably very close to a certain kind of love."

Seeing how the camera adored Edie, Warhol immediately starred her in a film created especially for her, *Poor Little Rich Girl*. Warhol shot the sixty-six-minute piece of cinema verité in Edie's small apartment in the spring of 1965. Warhol cared so much for Edie that he could have made a film detailing her life in an empathetic way. But he was incapable of doing that for her or for anybody.

The vulnerable Edie had no friend to say it was perhaps not a good idea for her to participate in this exploitation of her troubled life. Wein fancied himself her protector, but he stood behind the camera throwing questions at her that attempted to rip into her psyche.

The film begins as Edie wakes up late in the afternoon, which is not an unreasonable scenario. "Could you send me five orange juices and three coffees?" she says into the phone.

These early scenes are so out of focus that it's hard in places to know what's happening. In conventional filmmaking, the cinematographer who shot such footage would have been reprimanded if not fired, and the film in question discarded. In Warhol's filmmaking, the error becomes an artistic triumph. Later, the screen goes

blank for forty-five seconds, another mark of connoisseurship that only the initiated would understand. In the end, they reshot the film and combined the two versions.

At one point, the camera zooms in on Edie's crotch and her black panties. It isn't erotic, for the shot displays Edie's emaciated body. Her ethereal beauty overwhelms the screen when the camera focuses on her face. As she puts on her makeup, she has an unspoiled quality, as if she is a ten-year-old trying on her mother's cosmetics for the first time.

In the background, Bob Dylan sings "It Ain't Me, Babe." The song is a taunting lament. A man tells a woman he will not be there for her. No way will he stay with her forever or pick her up. As she listens to his harsh, uncompromising words, he warns her to step back gently from the ledge as if she is thinking of killing herself. Maybe Edie does not listen to the words, but they are a theme song for her life. At the film's abrupt end, Edie picks up the phone as she did at the beginning and mumbles unclear words.

Warhol understood the transient treasure he had in Edie and went on her arm to the gala preview of the Metropolitan Museum of Art's enormous exhibition *Three Centuries of American Painting* in April 1965. There was irony in Warhol—who was swiftly becoming the face of the new pop art style and asserted that fine art was dead—attending this celebration of classical painting. Warhol breezily dismissed the five hundred–plus paintings on display, among the most outstanding achievements of American culture, as "no longer relevant." But for Warhol, this evening was primarily about not art but mingling with the social elite, including getting his picture taken with the First Lady of the United States, Lady Bird Johnson. That was the get of the evening, which he might not have achieved without Edie.

Warhol sought to be both one with these people and above

them. Thus, he was not about to dress like the rest of the male guests. He adhered to the formal standards of the evening by wearing a tuxedo jacket, but his pants were splattered with paint as if to say *I belong on the wall, not down here with you.* Edie stood out, too, described in the *New York Times* as "a vision in a lilac jersey jumpsuit and a furry shoulder purse."

No hippie, Edie had six fur coats: three minks, a leopard, a Mongolian lamb, and a monkey fur. She had sometimes adorned herself with a $20,000 star-sapphire ring that mysteriously disappeared during a night of discoing. Edie shrugged the loss off as a matter of no consequence. She looked so spectacular in the tights she wore most of the time that the *Times* declared she had "the best-looking dancing legs since Betty Grable." Despite her signature tights, she loved designer clothes, but she was down to 103 pounds, and the Balenciagas and Diors that hung in her closet no longer fit properly.

Those who saw her on her evening rounds or read about her in the society columns assumed Edie had everything: beauty, money, and a celebrated artist on her arm. She knew the drugs she took, and the darkness she fled from that almost overwhelmed her. She knew there was no reason to envy her.

6.

"The Times They Are A-Changin'"

One day, Isabelle Collin Dufresne was having tea at the St. Regis, the luxury hotel on Fifth Avenue and 55th Street, with her lover, the celebrated Spanish surrealist artist Salvador Dalí. The artist's studio in the hotel was a cluttered warren of every kind of bizarre flotsam imaginable, all to inspire the artist's imagination. There was a collection of gold crabs and lobsters and an aquarium full of leeches.

In the five years Isabelle had been with Dalí, she had learned that art was not just about art. It was, in part, about creating a unique image. With his signature mustache, a thin line that rose rakishly off each side of his face in defiance of logic and gravity, Dalí had forged an unforgettable character. Even those who knew nothing of the artist's singularly strange art recognized him.

As part of his image as this rakish devil-may-care artist, Dalí needed a beautiful woman or two or three by his side. Isabelle fit the bill perfectly. The daughter of a wealthy French glove maker, she had

a "do not touch me" aristocratic demeanor that was one of the many illusions about her. Her lips were thin and often pursed. Her eyes were dark, flitting back and forth, constantly observing. And her legs were so long and perfectly formed that it was as if they existed apart from the rest of her body.

Isabelle noticed another crucial element of Dalí's success. When he smelled the slightest hint of someone of fame or money, he was like a truffle dog, rushing toward the object of his attention, ready to sniff them out.

The strange little man walking toward them this afternoon was hardly worthy of that kind of concern. As pale as a person with albinism, he looked like he lived in a cave from which he rarely ventured. And the wig. He had not even reached their table, but it was obvious this bizarre business that sat slightly akilter on his head was not the hair God gave him. God did not make such mistakes.

"I'd like to present Andy Warhol," Dalí said. "Andy, this is La Comtesse Isabeau de Bavière, née Collin Dufresne."

Dalí knew nothing impressed Americans more than European titles, even if they were suspect.

Warhol listened intently. He was a copyist of the highest order, be it a picture of a can of Campbell's soup or human conduct. Warhol had been observing the Spaniard for several years. How did Dalí do it? That was the question. Not how he created his art. That was irrelevant. The question was how he created *himself*. How had he glommed on to those with celebrity and worked his way up their ranks?

Starting in 1965, Dalí began signing as many as fifty thousand blank lithograph pages for which he charged $10 apiece. That was not illegal, but it allowed others to create thousands of fake Dalís. Warhol did the same thing legally. He could churn out endless "originals" with his silk-screen technique. Warhol did not talk about the

extent to which he modeled his conduct on the Spaniard's, but Dalí was undoubtedly one of Warhol's teachers.

"Oh, you're so beautiful," Warhol said to Isabelle. "You should be in film. Can we do a movie together?"

Warhol had no use for the elaborate social niceties so beloved by Europeans. He was a cut-to-the-chase kind of guy. Isabelle was taken by Warhol's abruptness. Like teenagers in America devouring movie magazines and dreaming of discovery in Hollywood, she wanted to be swept away into a rarefied cinematic life. Isabelle had no idea this wasn't Mr. Hollywood sitting across from her sipping tea but an underground filmmaker whose semipornographic films would probably be shown for at best a few nights in the Cinema-theque.

"When?" Isabelle asked.

"Tomorrow?"

When Isabelle walked into the Factory for the first time, Warhol recalled she was wearing "a pink Chanel suit and bought a big Flow-ers painting that was still wet for five hundred dollars." Isabelle was a wealthy art collector of the sort who occasionally came slumming into the Factory. She lived in an apartment on East 80th Street and was driven around town in a chauffeured Lincoln limousine.

Isabelle took up Warhol's invitation but ended up having a background role in his newest film, *The Life of Juanita Castro*, an anti-Castro farce filmed in March 1965 and written by Tavel. Despite the fact that she was only playing an extra, that was enough to give Isabelle the bug to be a Warhol Superstar with her own unique name. The twenty-nine-year-old Frenchwoman was half a decade older than Warhol's other Superstars, but that did not dissuade her. From now on, she would be called Ultra Violet, and she dramatically transformed herself into a creature worthy of that name.

It began with her hair. As much as Isabelle wanted to create an

image to match her new name, Ultra Violet would not burn the life out of her vibrant hair with commercial dyes. After extensive experiments with a garden's worth of various red-hued fruits and vegetables, she concluded only cranberry juice created the proper violet hue. Warhol went with her to an East Village thrift shop, where she picked out a vintage purple dress to match her hair.

Before she went out to the party scene properly outfitted, Ultra Violet placed a large beet in her gold mesh evening purse. Several times in the evening, she pulled out the beet, cut off a slice or two of the vegetable with her minuscule gold knife, and rubbed it against her lips and cheeks until she achieved the desired hue.

Ultra Violet was just as obsessed with publicity as Dalí and Warhol. Because she had only a sliver of accomplishments, Ultra Violet had to garner attention in innovative ways. When anyone took a group photograph of Warhol or Dalí, she rushed forward and stood at the right so her name would be mentioned first in the newspapers.

<div style="text-align:center">||||||||||||||||||||||||</div>

One afternoon, Warhol and Ultra Violet took a taxi to the Plaza Hotel to have tea with Truman Capote. Warhol worshipped Capote and did everything but bow down before him in obeisance. Ultra Violet's idols were artists, and she looked at the famous writer with a dispassionate gaze. Capote had a red scarf wrapped around his neck, so long that the tiny author could have tripped on it.

Ultra Violet had no medical training, but fancied she could diagnose diseases by looking at a person's tongue. She asked Warhol to stick out his tongue. It looked like a piece of white fish darting in and out of his mouth.

"A white tongue is an early sign of stomach trouble," Ultra Violet said, staring at the suspect body part.

Then Ultra Violet asked Capote to display his tongue. It had a crack down the middle and was even more disturbing. "There is trouble in your nervous system or brain. Watch your heart," she said.

Teatime at the Plaza was not a place where famous men stuck out their tongues, and the waiter was astounded. That was nothing compared to his feelings when Ultra Violet stuck out *her* tongue. It was six inches long and curled languidly out of her mouth like a garden snake. The waiter dropped his tray, breaking several glasses.

||||||||||||||||||||||

Warhol's flower painting show at the Castelli Gallery at the end of 1964 had been so successful that the Ileana Sonnabend Gallery in Paris invited the artist to the opening of *their* flower painting show in May 1965. Warhol loved to travel and there was no question but that he would take Edie with him. Bringing Edie meant Wein went along, too. And Malanga would go to stand at Warhol's right hand.

The impending European trip was an excuse for Persky to give a goodbye bash. This was no pedestrian wine and cheese cocktail party but a celebration at the Factory for the "Fifty Most Beautiful People." As Persky saw it, a celebrity was, by definition, beautiful, and he invited a slew of them.

Tennessee Williams had given Persky the right to produce several of his plays, and he was there that evening. Several stalwarts carried Judy Garland, already an icon of queer America, into the Factory. Distraught she had not been offered a role in one of Williams's plays, the diminutive, drunken star rushed up to the playwright. "Fuck you, Tennessee, how dare you say I can't act," Garland said, hardly the audition likely to win her a role.

Garland moved on to Rudolf Nureyev, who taught her to dance the Frug. The great ballet dancer was a phenomenon everywhere he

went. But he was largely ignored by the A-heads, as were Montgomery Clift and other famous guests. Nor did they pay much attention to the couple having sex on the sofa.

Warhol hovered at the crowd's edge, looking out as if the evening was a performance for his benefit. In the center of the Factory, twenty-two-year-old Edie danced not the Frug or the Chicken with standard moves but a routine that no one could have choreographed. Her stunning charisma was impossible to define, making her a focus of attention among all the conventional stars.

Warhol and his little entourage flew off to Paris a few days later. "Andy Warhol Causes Fuss in Paris," headlined the *International Herald Tribune*, and so he did. For half a decade in New York, Warhol had assiduously courted attention, night after night, attending parties and cultivating anyone who could advance his position in the world. And here, in the City of Lights at least, it paid off spectacularly.

French journalists dogged the group. Photographers from *Elle* and *Paris Match* made their living memorializing whatever was provocatively happening, and they shot Edie for their magazines. In her black tights, lengthy shirt, and long, dangling earrings, Edie symbolized the American fashion of the street that made haute couture seem passé. In her hotel room, they took her picture in a nightgown that made her look like a sexy ingenue.

Warhol designed department store displays early in his career and grasped the synergy between art and fashion. He knew Edie's pictures in French magazines would also call attention to him and his art. A diverse crowd of artists, authors, and rich art devotees attended the show's opening. Several hundred of Warhol's flowers lined the gallery walls. As diverse as the paintings were in size and color, they were all the same image. The result was not a distressing similarity but a radical statement about art. It was the greatest triumph of Warhol's career until this point, and he chose this mo-

ment to say he was "a retired artist" and would not be creating any more work.

It was an incredible thing to say. Only six months before, he had his first major artistic triumph with the overwhelming success of his Castelli show, a monthlong event that was not only largely critically applauded but showed Andy could make real money from his pop art. And now he wanted to put his silk screens and colors away—or so he said.

Warhol was not like Picasso, who until his death at ninety-one was still painting with new forms, always reaching onward. Warhol was not about to die with a paintbrush in his hand. He had gotten what he wanted out of his version of pop art. If he continued, he would merely repeat himself and risk being seen as an artistic Xerox machine. Instead, he said he was moving on to a new, wildly contemporary form of creativity: filmmaking. He'd been fiddling with movies for several years with minimal success, and it was a daring shift for the artist.

"I've had an offer from Hollywood, and I'm seriously thinking of accepting it," Warhol told the *New York Times*. "At least, that way you can eat. And then I can come back to Cannes next year."

Warhol had discovered the free press was a wonderful thing. He could say anything, no matter how outrageous. The diligent scribe took it down word for word and his editors put it in the paper the next day for all the world to see.

Warhol loved Paris. "Everything is beautiful, and the food is yummy, and the French themselves are terrific," he said. "They don't care about anything. They're completely indifferent." That was the best of it, the Parisian disdain for the world around them, unlike the Americans with their concern for the humdrum rituals of everyday life.

Warhol and the others often went to Castel, a private dinner and

dance club in Saint-Germain. Edie had not given up entirely on her upper-class dress; she wore a white mink coat over black tights.

One evening at Castel, Warhol and his entourage met a statuesque German woman. She was transcendently beautiful with an overwhelming purity of features. No boxed hair coloring could have created the luminous blond hair that fell down her shoulders—it was all natural, and it lent an almost mystical quality to her loveliness. Her deep, husky voice was full of provocative tones that sounded male and female, happy and sad, all at the same time. At a statuesque five feet eleven inches tall, she looked like a different species.

The woman's name was Nico. She was a model and actress, but that was hardly enough to define her. In fact, while this was their first meeting in person, Warhol had seen Nico in Fellini's *La Dolce Vita* and had been transfixed. He had been so taken with her that he'd sought out a picture of her in a magazine, cut it out, and put it in his scrapbook. Now here she was in the flesh, right in front of him. He was in awe, and that didn't happen often to Warhol.

Of all the people Warhol knew intimately in his life, no one had traveled as far as Nico—and only part of it was geographical distance. Nico was born Christa Päffgen in Cologne in 1938. Her father, Hermann Päffgen, was the scion of a prominent German family. His family looked down on his lower-class wife, Grete, and they attempted to annul the marriage even before Nico was born. The Päffgens wanted nothing to do with this child, who reminded them of their son's indulgence. Then Hermann went off to war and died in France.

Nico's was not a childhood of dolls and birthday parties. Her mother had so little to live on that she apparently sent her firstborn to the Kinderheim Sülz orphanage, a massive institution that attempted with brutal discipline to turn unwanted children into honored citizens of the Nazi state. Nico's name does not appear in the orphanage

records, and like so much in her life, it is unclear what is true and what is not true. Nico wrote in her diary: "My mother came to see me every Sunday, when she was not at the factory making weapons."

Grete left Cologne with her daughter to live with Nico's grandparents in the village of Lübbenau, an hour outside Berlin. While Grete went to work in a factory making flying boats, Nico spent much time at home with her grandmother. But war was always close at hand. Her grandfather was a railroad switchman guiding trains full of soldiers to the Russian front and Jews toward the final solution at Auschwitz.

As the years went by, the bloodshed got closer until bodies lay on the streets of their little village, and the scent of death perfumed the air. When the war ended, the German people climbed out of the rubble and started rebuilding their society.

In the process, there was still a great deal of chaos and violence. Nico said that when she was thirteen years old, an American GI raped her. No criminal records of this exist, but in those days, not everything terrible a foreign soldier did was duly recorded. Women often just got up, straightened their dresses, and walked on.

People generally trade in whatever attribute will get them the furthest. In Nico's case, it was transcendent beauty. As a young teenager, she haunted Kaufhaus des Westens, a grand Berlin department store that stood gem-like above the city's drabness. There, amid the other beautiful things, she hoped to be plucked out of obscurity and given work as a model. It was an absurd idea for most young women . . . but most young women did not look like Nico. Her plan worked, and she was soon an in-demand model whose picture appeared in *Bunte Illustrierte*, a popular magazine, and other publications.

Nico's career rose so fast that she could hardly see it going by. At sixteen, she left Berlin for Paris, the center of the fashion world.

There, too, she thrived as a model—three years later, she often made as much as 10,000 francs a month, an enormous sum for those times, and real money in impoverished postwar Europe.

The young photographer Herbert Tobias was the first of her many mentors. To become one of the iconic models of the era, he felt she needed a new name. Tobias had been in love with the Greek director Nico Papatakis, who had been married to the French actress Anouk Aimeé. To honor Papatakis, in 1956 Tobias gave his protégé the name Nico. It had a mysterious, remote quality—attributes she lived up to in all aspects of her life and that allowed her to shed much of her German past.

For one thing, Nico rarely spoke more than a few sentences in her deep, dark voice. When she did speak, her words were often strange and cryptic. Some people thought her dumb, but if one listened closely, sometimes her words had more meaning than those of people who asserted themselves by blathering endlessly.

That sense of mystery never left her. In 1973 the twenty-two-year-old guitar player Lutz Graf-Ulbrich had an affair with the thirty-five-year-old Nico. "Nobody knew who she really was," said Graf-Ulbrich. "There was a strange aura, and lots of rumors, and nobody knew what to make of all that."

At night, Nico liked to hang out in the boîtes of Saint-Germain. The left-bank world of Hemingway's Paris was long gone, but the music played there remained authentic. Jacques Brel, Georges Brassens, and a few others wrote their chansons and sang them as if every syllable mattered. It was in essence a sophisticated Parisian folk music, telling the intimate stories of individual lives.

Nico sometimes carried a copy of Nietzsche's *Beyond Good and Evil* under her arm. Was she reading it, or was it just a prop? People whispered she was bisexual. Was that true? Did she have an affair

with the seventy-one-year-old designer Coco Chanel and also with the French actress Jeanne Moreau? Or were those just more myths?

In talking about her life, Nico could be evasive. She did not, she said, think the truth was a bunch of facts to be pinned down like a dead butterfly. Everything was in shadow. Truth and falsehood rode so tantalizingly near to each other that it was hard to distinguish one from the other.

Was this casual relationship with facts an attempt to justify hiding unpleasant realities? Or was it an alternative philosophy of life, one uniquely suited to the work and the world in which she found herself?

Whatever her beliefs, Nico knew her beauty was a magic wand that opened doors. Nico was staying with friends in Rome, who took her to visit Cinecittà, the Roman film studio. While there they encountered the Italian director Federico Fellini, who after making such classic neorealist films as *La Strada* wanted to make movies with more extravagant visions.

The Italian director was a man of exaggerated gestures and dramatic proclamations. When Nico appeared, he was taken aback by her beauty. "I have dreamt of you," he said. "I recognize your face." Fellini immediately cast her in a supporting role in his 1960 film, *La Dolce Vita*.

In Fellini's masterpiece Nico is memorable, playing a character named, naturally, Nico. On a Via Veneto jammed with all the flotsam of Rome, Nico meets the tabloid journalist Marcello Rubini (Marcello Mastroianni). With nary an apprehension, she jumps into Rubini's little convertible sports car and heads off to a party with dissolute aristocrats. The celebrated film is a dark comedy-drama that exposes the fraying of traditional beliefs, replaced by little but an overwhelming feeling of emptiness. The Roman jet-setters

journey from one party to another, never finding anything of meaning, sinking deeper and deeper into decadence.

"By 1965, they'll be total depravity," an actor in the film says. Alienated from God, family, and purpose, Fellini's characters wander the world of privilege. Warhol was no Fellini, but these themes consumed him as well in both his own films and in the rest of his life. In *La Dolce Vita*, the quest for celebrity and its exploitation consumes a world preoccupied with trivia, precisely the world Warhol saw before him.

After her role in *La Dolce Vita*, Nico was slated to play the female lead in *Purple Noon*, directed by the French director René Clément and costarring rising star Alain Delon. (*Purple Noon* was a 1960 French adaptation of the Patricia Highsmith novel *The Talented Mr. Ripley*, which was remade in 1999 with Gwyneth Paltrow as the Marge character.)

The role in *Purple Noon* likely would have made her a star. But Nico wouldn't be pinned down by something as boring as a film production schedule. She had what some celebrated as a quirky sense of independence and others viewed as irresponsibility. Regardless of how one would characterize it, she arrived on the set after the picture started shooting and lost the role to French actress Marie Laforêt.

Nico did take away something. She had an affair with Delon. A former French sailor with criminal underground contacts, he not only played dangerous men but knew them. As she saw it, he was a real man, not some prissy model in love with himself. Alas, Delon had other romantic interests, particularly with the German-French actress Romy Schneider.

Left with nothing but the crumbs of Delon's life, Nico spent another night with him in New York a few months later. "I've just slept with Alain Delon!" she boasted to a friend. Nico paid a heavy price

for her momentary dalliance. Not only was she pregnant but Delon refused to acknowledge his son, Christian Aaron, known as Ari.

Nico had to bring Ari up fatherless—just as she had been. The child was of such interest to the French public that mother and son appeared on the New Year's 1963 cover of the popular magazine *Elle*. With her disregard for the institutions and formalities of everyday life, Nico registered the newborn with neither the French nor the German authorities. That left Ari stateless.

Nico continued modeling and starred in one failed film, *Strip-Tease*, but she had an enduring dream to become a singer. It was perhaps a strange aspiration for someone whose voice was an amalgam of female and male and sometimes wandered off-key.

Nico had long taken amphetamine to keep her weight down, but that was not working so well any longer. She knew her days being photographed for magazine ads were numbered. As it was, modeling had become a large bore, and she could hardly take it anymore.

One day in the spring of 1964, Nico was walking the Paris streets when she met the folk singer Bob Dylan. He would soon become so famous that he could no more walk down Boulevard Saint-Michel than Broadway, but that day had not yet come. He saw the most beautiful woman he'd ever laid eyes upon.

Dylan's new album with its title song, *The Times They Are A-Changin'*, had just been released in February 1964. It quickly became the anthem for a generation, and he would soon emerge as the poetic troubadour of the sixties. Dylan's show at London's Royal Festival Hall had sold out, showing that young people felt the same in England as in America. And here he was, strolling around Paris like any other tourist. To Nico, it felt like fate. To Dylan, it was a meeting of the minds. They both talked in this cryptic, mumbling idiom as if they were speaking a language related to but divorced from English. But they seemed to understand each other perfectly.

Dylan went to Nico's apartment, and they later flew to Greece, taking Ari with them. While the threesome stayed in a villa outside Athens, Nico watched Dylan fiddling with new songs and, already, moving on to different directions from the acclaimed album he'd just released. Like Picasso, whose art was forever evolving, Dylan said what he had to say and traveled on to something fresh. He was beginning a journey that would take him far beyond folk music. Listening to Dylan, Nico realized how limited she had been with her steady diet of torch songs.

As Nico looked back on her days with Dylan, she remembered his youthful energy and playfulness and how much fun it had been. She also remembered, "He did not treat me very seriously." That's how it was, not just with Dylan. Drawn to her beauty, men wanted to bed her. They might listen to her tales and hopes and artistic dreams, but they tuned out when they got what they sought.

During their days together, Dylan wrote a song for her, "I'll Keep It with Mine," and then he was gone. One could not mourn endlessly. Life was a matter of scenes, moments splendid and miserable. One takes whatever one can, be it Delon or Dylan, and moves on, opening new doors.

Before Dylan left for good, he suggested when Nico was in New York for modeling gigs in the fall of 1964, she should sing at the Blue Angel, a chic cabaret on Manhattan's East Side. Nobody knew Nico as a singer. The only gig she could get was to perform during cocktail hour. Later in the evenings patrons paid attention to the likes of Eartha Kitt and Bobby Short, but not when Nico sang. Drinkers did not come to listen to her. Like barroom singers everywhere, she had to suffer through a crowd, few of whom were interested in the poignant songs she sang. "They would offer me drinks and shout dirty things at me and try to maul me," she said. "It was degrading, this behavior. They would not have done this to Marlene Dietrich."

Nico had a troubled, short affair with the Rolling Stones' diminutive guitarist, Brian Jones. Addicted to drugs and sex and profoundly disturbed, Jones was on a short road to an early death. Nico did not have real conversations with him or romantic evenings. He was into hurtful kinds of sexuality, one time shoving a loaded pistol into Nico's vagina as a dildo. Pain was not her thing, but maybe it would be worth it if, through Jones, she met the Rolling Stones' management and other top people in the music industry. That's how much Nico wanted to succeed as a singer.

||||||||||||||||||||||

One evening at Castel in Paris, as Nico weaved the names of one celebrity friend after another into the conversation, including her former lover Dylan, Edie sat playing with her lipstick. Nico was the center of attention. Edie could do nothing to show her displeasure but act terminally bored.

Nico was taken with Warhol's assistant Gerard Malanga, who she thought looked like a lean Elvis. Malanga reciprocated and gave his number to the actress/model before inviting her to the Factory on her next trip to New York.

Edie and Malanga got up to dance, the Fred Astaire and Ginger Rogers of the bohemian set. Edie made her moves while Malanga brandished a long whip, snapping it back and forth as he whirled around the floor. Nico played the tambourine.

After their marvelous stay in Paris, Wein led the group to Tangier, the Moroccan city he had visited after college. Wein assumed his friends would be taken by the exotic venue immortalized by the beat writer William S. Burroughs. Warhol's companions were intrigued by the cacophonous Casbah and the ample hashish. Warhol liked none of it, not even the Arab boys available for a pittance. To him, the whole place "smelled all over of piss and shit."

One day, Malanga watched as Edie swam in the hotel pool. The beauty of her sleek body struck him as she cut through the water, her head rising out of the water for an instant and then down again. The scene was so mesmerizing that he wrote a poem about it, published in *Poetry Magazine* two years later.

COMING UP FOR AIR
For Edie

The face that grows out from the magazine
Covers some simple indication
That long earrings are coming
Back into fashion
At the parties that were
Beginning over
Night in the city
Limits, and the surprise
Package of whatever explains the false
Hood of logic to keep us
Guessing at the eventual sun
Rise, brings me home
In the film of our favorite soft
Drink starring you.

The Youthquaker Loses Her Way

E die had hardly gotten back to New York when Warhol put her in the lead role in his newest film, *Kitchen*. It was supposed to make her a star. Shot in late June, *Kitchen* tells the story of Jo (Edie) and Mikie's (Roger Trudeau) troubled marriage. The cast rehearsed for a week with a script, again written by Warhol's resident screenwriter, Ronald Tavel.

Amphetamine kept Edie going, but no way could she memorize the script on the drug. Edie was told to sneeze when she could not remember so she could be fed her lines. During the sixty-seven-minute film, she had fits of sneezing.

As the film begins, Edie sits at a table in a kitchen typical of a working-class apartment. She is dressed in high heels, dangling earrings, fishnet stockings, and black panties, Warhol's preferred outfit for his creation.

As Edie puts on her makeup, a chore that takes up most of the movie, a half-naked Trudeau enters and seeks to kiss his wife's neck.

She gets up on the kitchen table to do her bicycle exercises, pumping her legs while her husband kisses them. That leads her to spank him.

"Why did you throw my undergarments into the litter basket?" Mikie asks, the most dramatic question of the film. The couple exchanges nasty banter, the common parlance of a troubled marriage.

"I can't figure out what my part is in this movie," Edie shouts in her role as Jo, a comment any of the cast members could have made.

In the end, Mikie puts Jo on the table and strangles her. As he does so, the still photographer runs onto the set to get the money shot. Although she appears dead, Jo rises off the table, and *Kitchen* continues for a few more desultory minutes until Edie sneezes for the forty-fourth time.

To Warhol, the film's meaning is the *lack* of meaning. It did not bother him that Edie botched her lines. The fact that the still photographer kept rushing in and out of the shots, blocking the camera at one point, is a quirky addition to the film. As for the wavering lines across the movie in the early minutes, that is not an appalling mistake but another feature that sets *Kitchen* off from a mainstream film. What upset Warhol were the few times when *Kitchen* makes dramatic sense. "It looks like a Hollywood movie," he complained when the two main characters hugged.

The average filmgoer would have considered *Kitchen* a chaotic mess. But the movie was not intended to be on view at a suburban theater on a Saturday evening. Only the self-styled avant-garde intellectuals of Greenwich Village, Berkeley, and other special spheres had the sensibilities to appreciate the masterwork.

No one loved *Kitchen* more than Norman Mailer, the king of sixties literary hip, who went on to make his own often unintelligible films such as *Wild 90* and *Maidstone*. He said *Kitchen* "may be the best film made about the twentieth century." Although it was "almost unendurable to watch," *Kitchen* made a profound statement.

"They talk and you can't understand a word," Mailer said, to him a mark of singular quality. "You almost can't bear it but . . . when in the future they want to know about the riots in the cities, this may be the movie that tells them."

The sixties was a decade of radical political and cultural dissent. In his 1965 "Ballad of a Thin Man," Dylan sings about Mr. Jones, who has no idea what is happening. Poor Mr. Jones looks out the window and can't figure anything out. Strange bands of hippies are starting to emerge on college campuses and in city streets, portending a daring spiritual revolution asserting the fundamental goodness of man. And near them are anti-war and civil rights activists developing the most potent progressive movements since the turn of the twentieth century. And then there is the outlier Warhol, who stands back silently observing, disdainful of much of what he sees. Mr. Jones hunkers down, bewildered at where his country is headed.

Warhol made his own record of what was happening. In 1965, he got hold of one of the first personal cassette tape recorders and began documenting his entire life, from his first phone call in the morning to his last conversation late in the evening. He needed hundreds of tapes. Warhol contacted Richard Ekstract, the publisher of *Tape Recording*, who reviewed tapes in his monthly publication. Ekstract gave the used tapes to schools. Warhol asked if the magazine publisher would give the once-recorded tapes to him instead. Ekstract was a genial sort, and he passed on the tapes to Warhol to be used again.

Within a few years, cassette recorders would become as common as toasters, but they were at the cutting edge in the sixties. It did not occur to many people that Warhol was recording them, and he rarely bothered to tell anyone. As often as not, he did so surreptitiously, having the conversations transcribed later for his own personal record.

His ad man friend Lester Persky said that because of his taping, Warhol "doesn't have to participate in life." The tapes became one more barrier between Warhol and the rest of the world he was wryly chronicling in his art. He had begun recording the conversations around him with the idea of using some of the dialogue in his films, but it soon went far beyond that. The tapes became a separate life that existed only for him. He was the grand chronicler, godlike in his omniscience. Whatever devastating revelations people made, he had the record of them. After a while he started calling the tape recorder "my wife, Sony," and what a wonderful spouse Sony was—loyal, quiet, available whenever he needed her, and incapable of betrayal.

The taping allowed Warhol to be in control and to achieve the distance from people that made him comfortable. "The acquisition of my tape recorder really finished whatever emotional life I have had," he said, "but I was glad to see it go. Nothing was ever a problem again, because a problem just meant a good tape, and when a problem transforms itself into a good tape it's not a problem anymore."

Warhol preferred talking on the telephone to conversing in person. "I've never had as good a conversation with Andy face-to-face as I have had on the telephone," said his longtime friend the curator Henry Geldzahler. "Face-to-face, he's got to put a tape recorder between you and him or he's got to sit behind a camera or something has to intervene. . . . The terrible thing is that after talking to him for an hour and a half on the phone, you realize he's been pumping you for gossip and that he's hardly told you anything you didn't know before, but you've told him everything plus a few things you've made up in the meantime, because that's the only way to keep the whole thing going."

Since Warhol recorded people without telling them, he was at a huge advantage—he could adjust his remarks to convey the image or reality he chose to present at a particular moment . . . and he

could egg on the other speakers to reveal their lives in intimate detail. Most of them had no idea he would have their words transcribed and saved for posterity. The two surviving people who are on the tapes of that period, Viva and Marco St. John, say Andy never told them he was recording them. Eventually, a few people realized what he was doing, and their behavior changed.

Once Brigid Berlin learned what Andy was doing, she began taping almost as assiduously as her mentor. She asked one of the other Superstars if she would like to hear the just-recorded tape of her morning conversation with Warhol. Brigid didn't just memorialize her conversations with Warhol. She turned on the recorder whenever she had sex, amusing herself later by listening to the sounds of the tryst.

Warhol had set off a plague of taping. For him it was unnerving not knowing when he was being recorded.

"Everyone, absolutely everyone, was tape-recording everyone else," he said. "The running joke between Brigid and me was that all our phone calls started with whoever'd been called by the other saying, 'Hello, wait a minute' and running to plug in and hook up."

To make taping easier, Warhol later acquired a reel-to-reel recorder that he could set in place for eight hours without changing tapes. There were over 3,400 tapes at his death, a record of an individual life like no other. Almost forty years after Warhol's death, the fragile tapes sit undigitized and largely unheard at Pittsburgh's The Andy Warhol Museum, their access controlled by the Andy Warhol Foundation for the Visual Arts in New York City.[*]

[*] When the author sought access to the tapes, the Warhol Foundation turned him down, saying the recordings are full of talk of "sex, drugs, and illegal activities." Later, however, the director of archives at The Andy Warhol Museum, Matt Gray, allowed the author to copy almost 1,500 pages of transcripts for the period of this book—rare and valuable access that shed new light on many of the people and events depicted in this book.

||||||||||||||||||||||

E die and Andy were stars of New York nightlife, evening after evening, scurrying to one party after the next. They would arrive with their entourage of as many as a dozen people in tow, but almost as soon as they got there Edie would get antsy, looking over the shoulders of the other partygoers. Before long, the group would move on to the following invitation. It was no exaggeration when *Time* wrote that the couple went to "more parties than a caterer."

Edie and Andy often dressed alike, the androgynous couple of the moment—lean, silvery hair, dressed in dark tones. Edie continued to spend several hours each day putting on dark makeup. It would emphasize her pure beauty, yes, but the true effect was to create an overdramatic, unforgettable look, her bright eyes peering out of darkness. The tens of thousands of dollars she spent on her wardrobe was not to meekly affect the haute couture of the moment; it was all in service of her own unique style. Her favorites were black tights on her splendid legs and long dangling earrings. When the occasion arose, she dressed with distinctive panache, arriving in a glorious mink or black ostrich-trimmed cape.

Andy bragged that Edie invented the miniskirt, but fashion was rising out of the streets in the mid-sixties, and there were a thousand inventors. Her pictures were so often in the press that she was one of the primary progenitors of this new style. Edie was also a precursor to a generation of nearly anorexic models.

Edie symbolized things she had not sought and did not understand. *Vogue* called her a "youthquaker," as if she stood on the barricades with her contemporaries. The magazine's full-page photo had Edie in her signature black tights doing an arabesque on her bed, standing on her right leg, her left leg perpendicular behind her, arms spread out, looking as if she could fly off into a different world.

Not to be outdone, in July 1965 the *New York Times* headlined, "Edie Pops Up as Newest Super Star." In the celebrity world, no one could rise without someone falling, and the *Times* pointedly noted that Baby Jane was gone. The reporter had a hard time figuring out what Edie was all about, but no harder a time than Edie in figuring herself out. She had bitten nails and a voice full of sadness and uncertainty. "It's not just that I'm rebelling," she said. "It's that I'm just trying to find another way."

When things got bad, there was always Dr. John M. Bishop. He was everyone's favorite doctor. Although he had been married twice and had eight children, Dr. Bishop was a player, as hip as they come. Edie liked being in his office with all the mod paintings on the walls, the stereo blasting, and the sauna. That was one of the perks of being his patient. But it was all about the vitamin shots laced with amphetamine that brought the Greenwich Village crowd into his waiting room. One of those, and you left so high you could look down on the Empire State Building.

Dr. Bishop had other treats in store for his preferred patients like Edie. One evening, he shot her up with cocaine. She had never done that before, and it was disappointing. She felt nothing. So the good doctor shot her up again. "All of a sudden, I went blind," Edie said. "And I ended up wildly balling him and flipping out of my skull."

Despite how difficult she was to deal with, Warhol realized he had a treasure in Edie and explored how he could use her. One who watched this with dismay was Rene Ricard, a teenage poet from Boston who was hanging around the Factory. Malanga had cast him as the houseboy in *Kitchen*. From his vantage point, Ricard saw Edie had become a business.

"Everyone was trying to get a piece of Edie," Ricard said. "Up until Edie, Andy was just a poor schlep! Edie brought him out. He never got to those parties before. He was an arriviste social climber."

Edie, too, had begun to rethink her relationship with Warhol and whether it was doing her any good. One day in July 1965, she talked with Ondine, her favorite A-head, on the terrace at Persky's penthouse.

"Why do I keep it, why do I keep hanging on about Drella?" Edie asked, using Warhol's nickname.

"Because you're so young," Ondine said.

"I guess it's true. And it's habit. It's also that I . . ."

"You can't help it," Ondine said.

<div style="text-align:center">||||||||||||||||||||||</div>

While driving out to the Hamptons with Warhol that summer, Edie told him about her theory that each person lived within an inner and outer universe. Her idea was likely a drug reverie, but the fact that her musings were hard to understand made them inviting to Warhol as a movie idea.

Warhol wanted a new camera to shoot the film. This time, Warhol asked his tape source Ekstract for help getting hold of a video camera. "He wasn't going to pay for it because he was so cheap," said the magazine publisher.

The device was not on the market yet, but Ekstract convinced Norelco to loan Warhol a prototype of Norelco's new video camera. The equipment was expensive, retailing for about $3,500. Warhol was supposed to show it off to his rich friends, who would buy their own cameras, an eventuality that never happened.

Warhol used the camera in the making of *Outer and Inner Space*, one of the first films employing video. Warhol shot footage of Edie discussing her personal life and feelings. Then he shot two thirty-three-minute, 16mm reels of the video footage being played back while Edie watched and reacted. The completed film comprised the two 16mm reels projected onto a screen side by side. The four Edies

are seen at the same time, Edie watching Edie on the left side and Edie watching Edie on the right side. The Edies talk over each other, a discordance of sound. It is the Tower of Babel come to the Factory, a studious disregard for language as meaning.

Outer and Inner Space explores the difference between image and reality. Whatever Warhol's artistic vision, the film exploited Edie's emotional vulnerabilities. "I can't stand it," she said as Warhol filmed her watching herself. "It's stupid. It's stupid, have to stop it. I never dreamt I was so pathetic." But the video played on.

Edie had laid herself bare for the viewer—and she hated what she saw. The psychic rawness of her life was out there for all to behold. Who was Edie? Was she the woman on the video or the woman commenting on the image on the video? Or was she the woman watching the film of the two women? Or was she some mixture of all of them? Whatever the truth, what psychic price did Edie pay to be so exposed, and how would those wounds heal?

The critic Amy Taubin wrote that Warhol was "attempting to shatter Sedgwick's fragile psyche (and her upper-class social veneer) by splintering her attention and using her wounded narcissism against her."

Having helped Warhol to make an underground film, Ekstract figured it was only fitting to have an underground party to celebrate it. And what could be more underground than the abandoned railway platform that had once been used to bring wealthy guests in their private railcars to the Waldorf Astoria Hotel? That was an era when the rich could isolate themselves almost totally from common humanity, not even having to enter Grand Central Station with its hordes of passengers. The space had been abandoned for decades and was beyond filthy. But an invitation to a Warhol film debut was a *happening*, and the crème de la crème descended into the event in their finery that September 1965 evening.

As the guests entered, Edie's image in *Outer and Inner Space* was projected on the scarred walls of the dusty underground space. Edie and Warhol showed up unfashionably late, after most guests had left. But as soon as Edie stood along the rails in her stark black outfit and dangling earrings, she was the center of what was left of the evening.

That month, Nora Ephron profiled Edie in the *New York Post*. Ephron, who would go on to become a noted author and screenwriter, was at that time one of the hottest feature writers in the city, and she turned her gimlet eye toward Warhol's latest It girl. She wrote that some people said Edie was a little like Lady Brett Ashley, the robust and unhappy character in Hemingway's *The Sun Also Rises*, only Edie "hangs around with boys instead of with men."

Talking to Ephron, Edie seemed to understand the psychological burden of her young life and how she would have to move beyond her family and Warhol. She discussed the suicides of her two brothers and how she was going to free herself from the bondage of her parents.

It was clear Edie believed she had journeyed with Warhol about as far as she could go, but nothing would be easy. "I lived a very isolated life," she told Ephron. "When you start at 2 you have a lot of nonsense to work out of your system." As candid as Edie was, she did not mention that she had blown through her grandmother's inheritance in less than a year and depended on her parents for her rent and a $500 monthly stipend.

One evening over dinner at the Russian Tea Room, Warhol told Edie he wanted to do a retrospective of her films at the Film-Makers' Cinematheque. Edie was appalled at the idea. "Everybody in New York is laughing at me," she said. "I'm too embarrassed even to leave my apartment. These movies are making a complete fool out of me! Everybody knows I just stand around in them doing nothing, and

you film it, and what kind of talent is that? Try to imagine how I feel!"

||||||||||||||||||||

A lot had changed in a little over a year. Warhol's fall 1964 show at New York's Castelli Gallery had been as triumphant as had his show the following spring in Paris. Andy Warhol was at the white-hot cultural center of this new, changing moment. And everyone wanted to be in his orbit.

That notoriety drew the local gentry to the opening of the Warhol show at Philadelphia's Institute of Contemporary Art in October 1965. This was different from the kind of event they normally attended, to be sure. But many were tired of the staid, formalized pattern of their social lives—stuffy dinners and formal receptions with the same old people. No one knew what kind of crowd would attend an Andy Warhol art show. And that was the whole point.

It wasn't just the Philly elite, either; college students came out, too. They were excited by not just the art show but also the mobile disco playing the latest rock and roll—not what you'd see at most upscale cultural events. Philadelphia's art establishment was normally a rather unadventurous group, but they were expecting something different.

At the press conference beforehand, an unusual occurrence for an art show, a light stand from one of the television stations sliced through one of the Warhol paintings. That led the ICA's director, Sam Green, to pack away the other Warhols and leave the walls bare. The opening night of the art show would continue—with no art.

As three or four thousand people eventually entered a venue fit for no more than four hundred, Green realized he might have outdone the pre-publicity. The multitudes stood so pressed together

that one could hardly dance. And that was before Warhol, Edie, and their entourage arrived at 10:40.

Warhol dressed in his newfound cool, all sleek black lines and sunglasses. Edie had been slowly trying to distance herself from Warhol for a while now, but he was such a dominant force that he had drawn her here as if through sheer will. She was in attendance this evening wearing a long pink Rudi Gernreich sheath dress. Almost everyone seemed to want to touch Warhol, and he did not like being touched. "Edie and Andy! Edie and Andy!" the crowd shouted like a football cheer.

Warhol had wanted to be famous for so long. He had not cared how he got there: art, movies, public proclamations. Now he *was* there, and he could have been trampled to a bloody pulp or squeezed to death with faux love. The crowd was like a single being, writhing recklessly, pushing three people out a window, their injuries severe enough to send them to a hospital.

Warhol and the others needed some measure of protection. The only possibility was to get up on a wrought-iron staircase that led nowhere. The group climbed up the stairs, standing above the crowd that was still straining and struggling to get close to them. Warhol stood toward the back of the group, protected by his minions. Some interpreted that look on his face as pure, unmitigated fear at the monster he had created. Others thought it was a self-satisfied smirk because he had finally pulled it off, turning himself into the emblematic artist of the age.

Warhol could not believe the way these people were shouting. It was as if he were Mick Jagger. He did not care that his art was taken off the walls. That wasn't the real art, anyway. "We *were* the art exhibit, we were the art incarnate," he said.

Edie leaned down from the staircase, provoking the crowd with

her presence. When the overlong sleeve on her dress started to unravel, she lowered the cloth into the crowd like an extension of her arm. At one point, Edie pulled a mike up and became the impresario of the evening. "Oh, I'm so glad you all came tonight," she said. "And aren't we all having a wonderful time? And isn't Andy Warhol the most wonderful artist!"

The crowd wanted a tiny piece of Warhol. They passed up commuter rail tickets, cans of Campbell's soup, and scraps of paper for his autograph. Often, Edie signed Warhol's name, a distinction that seemed hardly to matter.

The crowd showed no sign of abating. The firefighters finally arrived and opened a trapdoor in the ceiling at the top of the staircase to nowhere, allowing Warhol, Edie, and the others to leave the premises without passing through the hordes.

Now that they were out of it, Warhol and Edie could look back on what had been a landmark evening. Warhol had received the kind of public accolades he had dreamed of receiving and the prospects of a level of fame known only to a few. Edie had been tantalizing in her allure as she milked every moment.

The event did not change Andy and Edie. Even as Warhol stood among the adoring masses, he was forever alone, lost within his private world. As for Edie, she wore makeup not only on her face but on her being, pretending to frivolous pleasure when she was never far from darkness.

That same month, Merv Griffin had Edie and Warhol on his popular talk show, which was viewed each week by millions of viewers. She also appeared on David Susskind's more serious *Open End* program, where she sat next to Gloria Steinem to discuss the three assets of "In" people: genius, money, and wit. In November, *Life* featured five pictures of Edie in tights, various T-shirts, and turtlenecks.

For young women, it was an irresistibly inviting image. "Her style may not be for everybody," *Life* wrote, "but the spirited wackiness is just right for live girls with legs like Edie's."

⫼⫼⫼⫼⫼⫼⫼⫼⫼⫼

In December 1965, Edie took a limousine to meet Bob Dylan. The singer had recently made his controversial transition from acoustic folk music to amplified electric guitars. However he performed, his songs defined the emotional truths of his time. Edie was taken with Dylan and had some measure of involvement with him.

Warhol was so worried that Dylan might spirit her away that he rushed to make her next film. He sensed that things would not end well for Edie. He saw how fast she lived and how out of control she seemed—even more so than usual. He also knew that his star and hers had risen in tandem, and he wanted to continue to capitalize on that dual fame for as long as he could. He asked the playwright Robert Heide to write a script about a woman who commits suicide.

Kenneth Anger's scandalous *Hollywood Babylon* had just been published and quickly banned. In its pages, Heide found the story of Lupe Vélez, a Mexican actress who took her own life in 1944. On her last day, Vélez took a handful of Seconals and went to bed to die. She planned it perfectly, a death worthy of a queen. But she had eaten spicy food that made her nauseated; she had to get up to go to the bathroom. Vélez was found the next morning, dead, with her head in the toilet bowl. Warhol thought it "wonderful" that Vélez hoped "to commit the most beautiful Bird of Paradise suicide ever," but ended in this sordid mess on the bathroom floor.

Heide wrote a screenplay titled *The Death of Lupe Vélez* based on these events, but Warhol dumped most of the script even before shooting the first scene. Despite its title, *Lupe* was, in essence, part two of *Poor Little Rich Girl*, the continuing saga of the tragic life

of Edie Sedgwick. The film exploited Edie's life without letting her know. She thought she was playing Lupe, but she was playing herself.

Warhol could tell how sick Edie was. She had become not just slim but positively emaciated, and the camera caught a beauty no longer evident in real life. She was nervous and endlessly vulnerable; her emotions were open and raw. Edie needed a friend, but just as he had with de Antonio filming *Drunk*, Warhol stood behind the camera, documenting her sad decline.

Shot in a classy apartment at the Dakota on Central Park West one night in December 1965, *Lupe* begins with a three-minute-long shot of Edie sleeping. When she finally wakes up, we see a young woman in a mauve nightgown luxuriating on ornate pillows fit for a pasha's boudoir. She lights a cigarette and pops a stick of chewing gum in her mouth.

Edie does little for the next half hour but look in the mirror and apply makeup. By all measures, she seems a narcissistic, self-involved heiress. Then, without any foreshadowing, she lies with her head down a toilet.

For the filmmaker Warhol, death is a minor irritation that can be easily overcome. In the second half of *Lupe*, he brings Edie back to life. As Edie lights cigarette after cigarette in the living room, she appears terminally bored. Then, at the film's end, Edie is back with her head in the toilet. She is supposed to be dead, but is still breathing, another mark of Warhol's unique approach to dramatic filmmaking.

At the end of the shooting of *Lupe*, Edie met the playwright Heide at Kettle of Fish, a popular Greenwich Village hangout. She was distressed at her deteriorating relationship with Warhol. "I just can't get close to him. . . . I try but . . ." she told the playwright. That year, she had probably spent more time with Warhol than anyone, yet nobody was truly close to him.

As Edie expressed her feelings, Warhol arrived. He had just gotten there when a limousine appeared in front of the restaurant and none other than Bob Dylan jumped out. Warhol had nothing but scorn for Dylan. He thought him a talentless hustler. Now the singer-songwriter wanted Edie's attention, but Warhol thought Edie was his and his alone.

Dylan rushed into the restaurant and stood at the table, saying nothing. Then he turned to Edie and said, "Let's split," and they departed.

Warhol was silent. Then he asked Heide to take him to 5 Cornelia Street to see where Freddie Herko, the ballet dancer, had died after jumping off the roof more than a year earlier. He obviously recognized some of the same self-destructive qualities he'd seen in Herko again in Edie. But rather than reach out a hand to help her, Warhol quietly observed the situation. Just as he had with Herko. He pondered. He watched. He waited.

That was Warhol, the omnipresent chronicler memorializing everything, including life's tragic moments. If he saw someone drowning, instead of reaching out to try to save them, he likely would have picked up his camera and filmed them as they sank under the enveloping waters.

As Warhol stood looking up at the fifth-floor window from which Herko jumped to his death, he said, "I wonder when Edie will kill herself. I hope she will let me know so I can at least film that."

Nights of Amphetamine Dreams

Soon after Brigid Berlin entered the Factory for the first time in the summer of 1965, Warhol brought her into the Factory fold as one of his closest friends and allies. As an amphetamine addict, she fit in perfectly. Some people called Berlin the Duchess, an appropriate nickname for a woman who, wherever she walked, acted as if she owned the land beneath her feet.

Warhol loved to talk to Brigid—though for the most part, that meant she spoke, and he listened. Brigid hated music; the intrusive sound interrupted her endless soliloquies. She often told tales of her early years, and all the injustices inflicted upon her. Warhol loved it. Like a child wanting to hear his favorite fairy tale before falling asleep, he had her tell the same story repeatedly.

Again and again, it came back to Brigid's mother. In the thirties, Muriel "Honey" Johnson was featured in the gossip columns, as she dated many of the most eligible young men in Manhattan. The conservative Catholic finally settled on a bachelor two decades her

senior, Richard E. Berlin, who in 1942 became the chairman of the Hearst Corporation, one of America's most influential media executives.

Berlin was so close to the company's founder, William Randolph Hearst, that he was at the mogul's bedside when he died. Like Hearst, Berlin was a man of right-wing political sentiments, abhorring the policies and administration of Democratic president Franklin D. Roosevelt. In 1947, when Richard Berlin was recuperating from an operation in New York's Roosevelt Hospital, he was visited by former Kansas governor Alfred Landon, who quipped, "Dick, I never thought I'd live to see you in a Roosevelt bed."

Overseeing life in a palatial Fifth Avenue apartment and a Westchester estate, Honey dominated the family. Her four children hardly dented her youthfulness. Honey was a vision of fifties upscale elegance in her pearls and white gloves as she and her husband frequented New York's café society. They sat at the best tables in the finest restaurants and were honored guests at exclusive parties. It was obvious to Honey that some people mattered and others did not. One stepped around the outcasts to enter the homes and dine at the tables of those worthy of one's company.

Those same rigid standards extended to her children as well. Honey sought to control everything in Brigid's life. Her daughter had to be pure. One day, she came upon her firstborn playing with herself in the crib. To stop the child's sinning, Honey tied her hands down to the sides of the bed.

Brigid's mother raised her children with conservative, upper-class values, beginning by bringing them up to be thin, one of the defining characteristics of her world. When Honey met someone new, she did not always have to learn their home address or the names of their clubs. She just had to look at them. If they were lean, they might well be worthy of her friendship.

Brigid did not want to take the pathway her mother had set out for her. She defied her mother from an early age in visible, menacing ways. Brigid's only weapon was food. She ate almost uncontrollably, attacking her mother with every bite.

As Brigid ate to upset her mother, she paid a price that affected her entire life. Even before she entered kindergarten, she became a compulsive binge eater. Once she got on this manic ride, she could not get off. As an adult, much of her life focused on eating and dieting, eating and dieting, eating and dieting. Over a few months, her weight might fluctuate a hundred pounds or more.

When her parents went out in the evenings, Brigid rushed into the kitchen and grabbed whatever food she could find, from fish to desserts, brought it to her bedroom, stuffed it down, and left the plates under her bed.

In the morning, Brigid's mother weighed her in the bedroom. If she lost a pound, she received five dollars. To motivate his daughter, her father set the bills in a money clip on the table before her.

If Brigid knew she had gained weight, she told her mother she had drunk lots of water, and the reading would be off. That ruse could only be used so many times. No problem. Brigid figured out how to put her elbow on a cabinet next to the bed to make the scale weigh precisely what she wanted. As often as not, she went out the door with five dollars in her pocket. Walking to school, Brigid stopped at various stores, buying candy.

Brigid's parents told her she had diabetes. They explained to their daughter that meant she had sugar in her urine and must change her diet. Brigid felt fine and would not give up her sweets. But, worried that perhaps she did have the disease and knowing little about it, she looked for sugar cubes in the toilet water when she went to the bathroom.

Brigid's mother told her eleven-year-old daughter she could

roller-skate around the block, but warned her never to cross over to the other side of Madison Avenue. Honey did not say why, as if the possibilities of evil and harm beyond their privileged haven were so extreme that they must not be mentioned.

Once, when the Berlins went off to a weekend wedding, they left Brigid and her younger sister, Richie, in the care of a nanny. The girls got on their roller skates and rolled across to the forbidden side of Madison Avenue. The sisters discovered the east side was like the west side. There was one happy addition: a Whelan's drugstore. The girls sat at the counter enjoying chocolate malteds topped off with jelly donuts.

Soon after the sisters arrived home, the doorbell rang. It was Father Hart, who had baptized Brigid. Sometimes, priests had a seeming omniscience that could be scary. Fearing the priest might be onto her, she lied to Father Hart with the same certitude as to lesser mortals. He had not asked, but she told the priest that she and her sister had gone roller-skating, but had not crossed Madison Avenue.

Brigid's fib was impeccably told, but the nanny had a friend who had been in Whelan's at the same time as the Berlin sisters and watched them devouring malteds and donuts. When the nanny told their parents, unholy wrath came down on Brigid. Not only had she led her younger sister in doing what they were not supposed to do, but she lied about it to a man of God. As punishment, her parents deposited a bar of Kirkman's Borax soap in Brigid's mouth and forced her to chew on it.

Brigid's parents tried to control what their daughter was eating, but she found ways around them. Once, at the summerhouse, she did not sneak her peanut butter sandwich upstairs, but ate it downstairs, where her mother discovered her. Honey shoved the sandwich in Brigid's face. Brigid ran upstairs, ready to ingest enough tranquil-

izers to kill herself. When her father ran after her, she threw a priceless Spanish lamp through the window, vowing to kill him.

The Berlins were desperate to control their daughter's weight and decided a doctor might help. Her parents took the thirteen-year-old to a physician, who prescribed Dexedrine for weight loss. Dextroamphetamine, as it is formally called, is a habit-forming stimulant. The drug set Brigid on a road that ended a decade later with her injecting herself with massive doses of amphetamine.

Brigid's mother read in *Life* about a celebrated hypnotist who, in one session, could change human conduct forever. Honey took Brigid to the man, who had her lie down and hypnotized her. He asked her if there was any food she despised. That was an easy one—cod cakes. He told her that from that day forth, everything she ate would taste like cod cakes. Then he awakened Bridget from her trance and sent her on her way a new person.

Brigid went to a candy store on Madison Avenue. She bought all her favorites: Mars bars, Clark bars, Almond Joys, Butterfingers, Reese's peanut butter cups, and 5th Avenues. Once she paid and left the store, she ate them one after another. It was only fair to test them all. From the first to the last, they tasted just as delicious as before, without a hint of cod cakes.

In the summer of Brigid's fourteenth year, she and her sister stayed at the family country house. When her parents went on a short trip to Canada, they told their daughters not to invite anyone to the house. As soon as the Berlins went out the door, Brigid ordered a beer keg for her party guests. It was hardly enough for all the teenagers who showed up, but those who went down to the beach house to have sex hardly missed a full measure of beer. When Richard and Honey returned, her father accused Brigid of turning their house into a brothel, an accusation that bothered him far more than

it did his daughter. Richard grounded his daughters for the rest of the summer, doing everything but placing them in chains.

In the summer of 1955, the Berlins put their teenage daughters in Manhattan's John J. Residence for Girls. The Catholic institution was primarily for orphans between fourteen and eighteen years old, and it was a much more austere existence than they'd been used to on Park Avenue. There, Brigid and Richie could see what it was like to have a life without parents. Honey wanted to punish her daughters, but they got what they'd been wanting for so many years: a measure of freedom without the dominating presence of their mother.

Their father had another way to teach his daughters about what he considered the real world. The following summer he got them jobs within the vast Hearst empire. Sixteen-year-old Brigid had an entry-level position at *Harper's Bazaar*. On her first day, Brigid appeared in a black dress and pearls, the perfect outfit for a gig at the influential fashion magazine. She placed a framed picture of her father on her desk, put her feet up, and proceeded to do nothing but talk to her friends on the phone and order food to be delivered. She did that all summer, and nobody dared to criticize her.

Brigid had crushes on older men. She knew that was inappropriate but would not let anyone tell her what to do. Brigid was enamored with her mother's friend, a divine gentleman who looked like a young Cary Grant. He was married to an older woman, and they had a young daughter, Janie.

To cozy up to her would-be beau, Brigid took Janie ice-skating. As they sat around the rink, she plied the child with every kind of goody, from candy and popcorn to pizza. Janie went home and said she preferred "Aunt Brigy" to her mother. That did not go over well. It ended the child's supply of snacks and Brigid's dreams of life with her Cary Grant look-alike.

Brigid had sex for the first time when she was seventeen, though she was so drunk she had no recollection of the event. She only knew she was no longer a virgin when she realized she was pregnant. Her mother's shame was such that she canceled Brigid's appointment with her regular doctor and shuttled her off to a physician newly arrived from Budapest. He performed the abortion right then in his office. Before beginning, he warned Brigid she must not make any noise. Although the pain was excruciating, and the doctor had not even given her a tranquilizer, Brigid made not a whimper.

Brigid's mother made it clear that decent men kept their hands off the young women they married and did what they wanted with the other sort. Thanks to the secretiveness of the abortion, Brigid could still parade herself as unblemished and marry a proper young man.

But Brigid wanted nothing of what she considered the falseness of her parents' lives. She was not going to please them by going off to college. With a $150,000 inheritance from a family friend, Brigid proceeded to live in a manner every bit equal to her mother's, quickly running through the money.

To further spite her parents, in 1960, at age twenty, Brigid married John Parker, a gay man who worked as a window dresser at the Tailored Woman on 57th Street and Fifth Avenue. When Brigid brought her fiancé to meet her parents, Honey would not let John enter the apartment. She gave her daughter a wedding gift: a check for $100 to buy underwear. "Good luck with that fairy," Honey said as her daughter left.

The newlyweds went out almost every night, hopping from club to club, drinking to forgetfulness, and dancing until the music stopped. At some point, they had to come home to Brigid's apartment, where they could not hide how little they had in common. That became even clearer as the money ran out. John loved opera

and played his albums constantly. Brigid got so sick of the music that she broke the records. John ripped off her pearl necklace, the pieces falling all over the floor, and flew off to California.

Brigid invited over a new friend. Ruth was married and had two sons and a seven-year-old daughter. Brigid had never slept with a woman before. They got into bed and got up the following afternoon. Ruth came back on other occasions, bringing her daughter with her. The child sat in the living room while the two women returned to Brigid's bedroom.

One day, Brigid was returning from her latest tryst when she found John standing naked in the living room. He was so angry that he beat his wife with a rolling pin, hitting her so strenuously that the handle came off.

"I gotta leave," Brigid moaned. "I gotta meet Ruthie."

"I'm going to fuckin' ruin your life," Parker said.

Warhol loved to hear Brigid's stories, recording them as she spoke. He had a sweetly ingratiating way of seducing Brigid into telling him intimate, personal details, from the shape of the stirrups for her abortion to the way Ruth fingered Brigid's clitoris. Warhol wanted it all, no holding back.

Brigid often said she loved herself from her neck up. Her well-wrought features were unquestionably attractive. But by saying she cared only about her face, she was also saying she hated 90 percent of her body. That was an accurate measure of her self-hatred.

As Brigid described how she stumbled through life, she turned it all into an endless string of amusing anecdotes. Warhol had what he wanted: hours of entertainment from a woman telling tales of her wealthy upbringing. Despite all the time they spent talking, he never pushed her to reach deeper into the truths of her life in ways that might help her. No matter how long her soliloquies or how often she told her tales, she was this comic entertainer doing pratfalls.

Having to survive on a modest allowance and not wanting to work, Brigid took a room at the George Washington Hotel, a Gramercy Park establishment with dirty carpets and a reeking odor. As neglected as the hotel was, her apartment was pristine, with everything in perfect order. Incredible attention to detail is one of the marks of an amphetamine addict, and Brigid rooted out dust that nobody else even saw.

Brigid did not dress in the downscale manner favored by most people at the Factory. She liked to wear a Battaglia blazer, a polka-dot ascot, a Dunhill shirt, tapered khaki pants, and polished loafers. Every Friday, Brigid took a taxi uptown to a bank to pick up her weekly stipend from her parents. As much as she disdained them, she felt they had an obligation to fund a lifestyle that did not involve a job. She took from them a sense of entitlement made infinitely stronger because she did not realize she had it.

Brigid's life was consumed by shooting up speed. When she met the drug dealer Rotten Rita, she was mesmerized. Rotten's real name was Kenneth C. Rapp, but the tall amphetamine junkie with a missing front tooth was known by a nickname that conveyed a unique, almost magical quality.

Rotten worked in a fabric showroom during the day. At night, he dealt drugs, moving stealthily through the city, delivering what must be delivered. Although sometimes Rotten stiffed his customers with inferior goods, for the most part, he was a righteous dealer, often cementing the deal by shooting his customers up in a powerful ritual.

Enchanted with Rotten's world, Brigid started showing up at his apartment in the West Eighties and staying for days. When she arrived, he sometimes was in underpants, endlessly cleaning the rooms. She understood Rotten the way nobody could who was not an A-head.

While Rotten Rita did his thing, Brigid pulled out her Magic Markers and started filling out her trip book. She drew circles within circles, the details as minute as they were precise, hour after hour after hour, stopping only to shoot up and swig Majorska vodka.

Brigid became something of a legend in the drug community. She merited another nickname, Brigid "Polk," because she took such pleasure in shooting herself and others up. In this world, Brigid was not a privileged heiress but just another speed freak looking for a hit.

That summer, when Brigid went to see her dentist, he noticed black-and-blue marks all over her body. She was so "bruised and demented" that he had her admitted to Roosevelt Hospital. Brigid's parents were still there for her on matters of consequence, and they set her up in a VIP room with gourmet dining.

Just because Brigid was in the hospital did not mean she stayed sober when she could secret away bottles of her beloved Majorska vodka. Maybe she could not risk shooting up amphetamine, but in the short term, pills and vodka worked almost as well.

As much as Brigid joked about her condition, she had the bruises because her capillaries were hemorrhaging. It was a serious matter, and she was told she needed an immediate operation. As she realized, part of her problem likely was malnutrition. One of the few A-heads who was also an alcoholic, she did not eat regular meals.

Brigid had a private phone in her hospital room and was constantly talking. Distraught at missing the action, Brigid called Rotten Rita. It so happened that Warhol, Ondine, and others from the Factory were in his apartment.

Shooting up is the crucial moment in an addict's life, and Brigid thought that she should be the one to perform the task. That's why something Ondine said distressed her beyond measure.

"I was just in the bathroom, and Rotten gave himself the most perfect poke I've ever seen," Ondine said.

"Oh, that makes my heart sink," Brigid said.

"What makes your heart sink?" Ondine asked.

"Oh, I want him to give it to himself perfectly, my dear, but don't advertise it because I do like to give people pokes."

"I know, but Rotten gave himself," Ondine said.

"I don't like everyone giving themself a poke. Then who will I have left to poke? And that's my hang up. Not the poke, but the pokee."

For Brigid, Christmas was a melancholy time. Her parents were at the Lake Placid Club in upstate New York, where the family always went for the year-end holidays. She could visualize it. Afternoon tea with the ladies dressed as for their clubs in New York. The jigsaw puzzle sitting on the card table in the lobby. People passing by, stopping and adding a piece or two. And her father, walking out in his stylish ski outfit for a run or two down the slopes. And here she was, sitting and talking to Warhol, something she did every day of the year.

Brigid always harbored anger, but she was furious on this day. She had chronic hepatitis for a year, and her father would not pay for her medicine. He said she had gotten the disease by shooting drugs, and she was on her own. She needed money. She still had the keys to the family residence. She went back there and took almost all her mother's rubies. The maid spent her day off in the residence cleaning doorknobs, making it difficult for Brigid to slip in surreptitiously to take more of what she needed.

Warhol said almost nothing as Brigid went on with her wrathful soliloquy. Words had their limits, and she finally decided there was only one thing to do—call her parents, not to wish them Merry Christmas but to hit them up for money. She was tired of the measly amount they doled out to her weekly. Brigid wanted real money. Nothing less than $50,000 would do. It was late, but that didn't matter.

Brigid picked up the phone. "Operator, I'd like to make a collect call to Mr. and Mrs. Berlin at the Lake Placid Club in Lake Placid, New York."

"I'll have to put you on hold," the operator said.

"No problem," Brigid said, but soon felt otherwise. "If this goes on much longer, I'm going to have my period."

"Do you think maybe your mother doesn't want to talk to you?" Warhol asked.

"Are you kidding?" Brigid said. "My mother has a sentimental, maudlin streak a mile wide. She's lying in bed awake, wondering where her first-born daughter is this Christmas."

The Berlins never took the call.

9.

The Long Goodbye

DECEMBER 1965

In December 1965, Warhol and his entourage showed up at Café Bizarre in Greenwich Village to hear a new band, the Velvet Underground. Warhol was always hunting, questing, on the lookout for something new. The world was changing fast, and tastes were evolving faster. The pop art he'd adopted was radically different from the art that had come before. His films, too, challenged convention and ushered in a bizarre new aspect to a well-worn genre. He was determined to stay ahead of the curve in music as well.

But Café Bizarre was an unlikely spot to hear anything new. The clientele was primarily tourists. They came hoping to get a glimpse of some of the storied Village weirdos and freaks—this was the capital of bohemian America, after all. But mostly, the visitors ended up looking at each other across the half-empty room.

The Velvet Underground, though—they were something different. The lead singer, Lou Reed, wrote memorable lyrics, including depressing songs about drug use and death that were unlikely to get

the band on Dick Clark's *American Bandstand*, the popular music performance and dance television show. But the band played so loud it was nearly impossible to hear the words.

Reed's musical partner, John Cale, was a classically trained viola player, but his amplified playing was drowned out in an explosion of sound. Sterling Morrison played a mean guitar. The percussionist, Maureen "Moe" Tucker, looked so slight that it was amazing she could even lift her sticks, but she played drums with a bold and strong beat that was as good as any man. But not this evening. There was no room for her complete set of drums on the minute stage, and she was the only band member whose performance was subdued. Malanga danced by himself before the tiny stage, wielding his bullwhip.

The Velvet Underground played dark, dangerous music, a threat to civility. One of the songs Reed would write later was "Vicious." And then there was "Walk on the Wild Side," an anthem for the age. The band meshed perfectly with what Warhol was doing with his films—presenting, unvarnished, the seamy side of life in the city in all its grimy glory, replete with sex, drug use, and S&M overtones— and he decided he wanted to manage the group. For 25 percent of their overall take, of course. The fact that he would want anything to do with this jarring, marginal band suggested his widening interests. He was no longer primarily an artist; he was moving into the role of a cultural entrepreneur, his nose sniffing out popular culture's cutting edge.

The Velvet Underground had no record label or notable producer vying for their services. Initially, Warhol appeared a savior in a wig to Reed and his mates in the band, promising to take them out of such gigs as Café Bizarre. To help Warhol, a new associate, underground filmmaker Paul Morrissey, was there that evening. Like most of those around Warhol, Morrissey was a Catholic—not a

fallen Catholic, but a deep, conservative believer. He had enlisted in the army and risen to first lieutenant. That was a unique credential at the Factory and not one universally admired.

Morrissey did not take drugs and was full of something else the others did not have: unabashed middle-class ambition. He had a way of leaning forward as if he were about to pounce on his prey. Talented at the games of power, he was dismissive of what he considered the silly business of the counterculture. He kept a keen eye on the others in Warhol's orbit and stealthily pushed out anyone he thought might threaten him. Most of the others were no match for Morrissey, who worked with Warhol trying to figure out how to promote the Velvet Underground.

One evening Malanga received a call from Nico, saying she was in town and having dinner at a Mexican restaurant. Warhol, Malanga, and Morrissey grabbed a taxi and arrived in time to find her sitting in front of a pitcher of sangria.

Nico still dreamed of becoming a famous singer. To get there, she began shrewdly cultivating the managers, the moneymen, and the stars who might help her in her quest. Whether she was having dinner, sex, or a business meeting, she was always auditioning, playing the role each man in front of her wanted her to play.

From her teenage years, Nico learned men were so easy to manipulate. These days, she wanted a different kind of prize, musical fame, and men would help her get it. Once she achieved success, she could finally be herself, or so she believed. Until then, she'd be whoever they wanted her to be.

After that evening with Warhol and his entourage at Castel in Paris back in May 1965, Nico had gone to London to meet the Rolling Stones' manager, Andrew Loog Oldham. He signed Nico to a contract and took her to a Soho studio to cut her first single. Nico sang "I'm Not Sayin'" in the deep, haunting contralto voice that became

her signature. One critic said her voice was "like a cello getting up in the morning," but others found it intriguing. The record did not make her a star, but it got her on the popular weekly TV show *Ready Steady Go!* to give her visibility in the British pop music world.

The twenty-seven-year-old woman who had dinner with Warhol and the group that evening in New York was obsessed with her career and wonderfully well-connected . . . but she also had no significant savings, and a young son back in Europe. (Despite her old boyfriend Alain Delon's denial of paternity, Delon's mother and her new husband were watching over the child, Ari, in Paris.) Neither Warhol nor the others sitting at the table had or would have children, so there was no reason to think Warhol would understand her maternal feelings and yearnings. Yet Ari was never far from her mind.

When Warhol and the group sat down, Nico had her long fingers in the sangria, plucking out slices of orange. It was not something that was done in hygiene-obsessed America. "I only like the fooood that floooats in the wine," she said.

Warhol could not decide what to make of this strange woman. Nico spoke English, French, German, and a smattering of Spanish. Although her formal education was limited, she made a school from her experiences. Unlike Warhol, she was comfortable traveling alone as she moved from one life to the next. But like him, she was just as at home sitting in silence, observing.

This was a novel experience for Warhol. He was used to his Superstars, Baby Jane, Edie, and Brigid, who talked incessantly and were nothing if not exhibitionists. He asked Nico a question, and she ruminated endlessly before a strange, largely incomprehensive sentence came painfully out of her mouth. Then she'd look at Warhol with that gorgeous face and those expressive eyes. She was utterly, completely different. Mesmerizing.

"She was mysterious and European, a real moon goddess type," Warhol recalled of that first evening.

Nico was also smart. She knew she had come to the land of hustlers, and she played the game well. In an offhand, disarming way, she gently dropped that she had appeared on the hot music program in London and took out a 45 of her song.

Nico was as beautiful a woman as Morrissey had ever seen. Immediately, he envisioned her singing in front of the Velvet Underground, elevating the scruffy lot with her presence. Of course she'd be gorgeous onstage. But in all sorts of ways, she was not an obvious choice. The Velvets were many things, but first and foremost they were *loud*. Powerful singers like Grace Slick or Janis Joplin, who would soon emerge, had voices that rang out above the deafening music of any band. But Nico was a singer of poignant ballads. Wouldn't she be overwhelmed by the overwhelming sound of the Velvet Underground?

Her whole life, Nico's beauty had opened doors and given her rides to places she otherwise might not have been admitted. But beneath those gorgeous looks was a complex woman with a singular talent. On the songs that touched her, every syllable of her singing rang with the gravitas of truth. She could stand up in front of the Velvet Underground and sing out alongside them . . . if they would just give her the chance. Warhol was certainly up for it. He started promoting her as the "1966 Girl of the Year" and positioning Nico as his Next Big Thing.

The band members, however, were not amused to have this blond *thing* imposed upon them. And no one was more upset than Reed. The singer-songwriter abhorred the idea of standing in Nico's shadow. He'd been in shadows for too long. He didn't have much stage presence, but he was finally ready to stand in the spotlight.

And he wasn't keen on the idea of sharing it with this German goddess.

Reed had grown up in Freeport, Long Island, just outside New York City, the son of an accountant. The teenager played in a rock band and wrote songs. As a freshman at New York University, he had a nervous breakdown, and as a result his father agreed to have him subjected to electroshock therapy. Reed believed it was done to cure him of his homosexual urges. It did not work. Nor did it diminish his creativity or musical drive.

After graduating from Syracuse University, Reed moved to New York City, where he worked as a songwriter and put together the Velvet Underground. He spent time at the Factory and other underground spots, and developed a heroin habit that almost killed him and—astonishingly—also produced some of the defining pop music of the sixties. Like his bandmates, he said yes to the idea of Nico joining the band. But he was dragging his feet all the while.

|||||||||||||||||||||||

New York's psychiatrists wanted to be hip—or at least *understand* hipness and assure themselves that they were not hopelessly out of it. That's why the New York Society for Clinical Psychiatry invited Warhol to entertain at their forty-third annual dinner at the upscale Delmonico Hotel in January 1966. That the shrinks expected Warhol to speak showed how little they understood him and how out of it they truly were. Having no idea what was about to happen, they invited a *New York Times* reporter to cover the event.

The evening began in the white-and-gold Colonnade and Grand Ballroom. The psychiatrists arrived in black tie, their wives in long formal gowns. They had time for professional chitchat over cocktails in the resplendent ballroom. As the psychiatrists kibitzed,

screens showed Warhol's underground movies. The therapists regularly discussed all aspects of sexual life in their private sessions with clients, but few of them had seen shots like these in real life.

As the images from such Warhol epics as *Couch* played on the screen, Warhol and his entourage entered the ballroom. They looked positively freakish to the gathered attendees. In a few years couplings such as jeans and a sports coat would become their own style, but Warhol's combination of formal dinner jacket and black corduroy work pants looked like a hapless mishmash. His entourage followed his lead, giving their distinct interpretations of formal dress. John Cale wore a black suit emblazoned with rhinestones affixed to his collar. Nico wore a white slack suit highlighting her long blond hair. Edie looked surprisingly déclassé, chewing gum and downing martinis.

The shrinks were dutifully working their way through roast beef and small potatoes when the thunderous sounds of the Velvet Underground rose across the ballroom. The band had never played before such a large, distinguished crowd, and their sounds rang out as if they were playing on the tarmac at LaGuardia Airport. One of the shrinks described the sound as "a short-lived torture of cacophony."

As Nico sang, Gerard and Edie got up onstage in front of the amazed doctors and their wives. Malanga pulled out his trusty bullwhip, cracking it across the crowd as he danced with Edie and twirled maniacally.

While the psychiatrists tried to make sense of all this, the underground filmmaker Jonas Mekas entered the ballroom with a crew. Pushing forward with lights and a camera, he filmed the shrinks as he asked them questions about the size of their penises and, pointing at their wives, queried, "Do you eat her out?"

The psychiatrists, who typically worked in an atmosphere of

discreet decorum, were shocked and appalled. Their job was to bring sanity to a troubled world. But now these troubadours of madness had been invited into their midst.

Some therapists were so disturbed that they jumped up from their seats and left well before the evening ended. "You want to do something for mental health?" a fleeing psychiatrist asked the *New York Times* reporter. "Kill the story."

The journalist did not follow the shrink's advice. When Warhol read about the event in the *New York Times* the next day, it was one devastating comment after another. "Why are they exposing us to these nuts?" one shrink asked. "It seemed like a whole prison ward had escaped," said another.

The sheer savagery of the attack delighted Warhol. This was not some prissy lukewarm review, but an attention-getting assault. He had pulled it off. This was the real thing. The fact that the reporter made fun of the event and treated him as a cultural bomb thrower made it even better.

There had been only one bad thing about the evening. Edie had been unhappy. Almost always before, wherever she had been with Warhol, she had been the center of attention. But Nico's presence as she stood in front of the Velvet Underground illuminated the ballroom—she was a star. Her haunting voice, too, played to great effect as it melded with the band's bold, noisy sounds.

Not wanting to be left out, Edie had also tried to sing with the Velvets for a song or two. But, emaciated and exhausted, she had no voice, and soon, she grew quiet.

<center>‖‖‖‖‖‖‖‖‖‖‖‖‖‖</center>

Edie met with Warhol and his entourage of about eight people at the Ginger Man on West 64th Street the following month. Over

dinner, Warhol talked about making a movie chronicling a day in Edie's life. He had taken her tortured personal life and used it as fodder for his underground films for nearly a year at this point. Now he wanted to do it again, even more directly. She wasn't interested.

"I'm broke," Edie said. "I have no money. Why am I not getting paid?" She felt she deserved recompense for the films she'd already starred in, let alone for making more.

"Oh, I'm not making any money on the movies," Warhol said in that whining woe-is-me voice that he could turn off and on like a switch. "You gotta be patient."

"I can't be patient. I just have nothing to live on."

Edie had a secret she probably should not have divulged this evening, but Warhol's rejection of her request for payment raised her ire. She told him she had something going for her that would lift her out of Warhol's world. Bob Dylan's manager, Albert Grossman, had signed her to a contract.

"They're going to make a film, and I'm supposed to star in it with Bobby," Edie said.

There would be no room for the sordid little films she had made at the Factory in the glamorous new world Edie would be inhabiting. In fact, she told Warhol that Grossman did not want his films with her shown any longer, either. Beyond that, her new manager did not want her to spend much time with Warhol—that was not the kind of publicity they wanted for Edie.

Warhol listened quietly as Edie dismissed everything he believed he had done for her. Tired of hearing this, in a soft voice of ersatz innocence, Warhol told her, "Did you know, Edie, that Bob Dylan has gotten married?"

"What?" she said, shuddering in disbelief. "I don't believe it. What?"

It was true. Dylan had gotten secretly married to the model/actress Sara Lownds the previous November. If Edie did not even know that, then how much of her story was true?

Edie was crushed. She needed to leave this restaurant. Now.

In the old days Edie would have footed the bill for a big group like this without thinking twice. But now she had no money left for indulgences. She couldn't even get a ride around town; she had so many unpaid bills with limousine companies up and down Manhattan that they turned down her service requests. So, Edie asked Warhol to pay. He said no. Edie got up and hurried to the basement to the phone and probably called Dylan.

When she returned, she stood at the table and said, "I'm leaving. Goodbye." She walked out the door and did not look back.

Chuck Wein, Edie's friend from her Cambridge days, was at the Ginger Man that evening, too—and he was as disgusted with her "betrayal" as Warhol was. He had come with her from Boston back in 1964 to manage her advance in the artistic world. As far as he was concerned, she had stiffed him. He had been as taken with her as Warhol had been, but that was over. He wanted nothing more to do with Edie, either.

Wein was a vengeful sort who sought some way to get even. After seeing a movie in one of the sleazy theaters on 42nd Street, Wein and a friend entered a bar for a drink. There sat a thin young woman they took to be a prostitute, who looked like a downscale version of Edie. That gave Wein the idea of turning this woman into Edie's replacement.

Warhol thought the woman "looked like a piece of trash," and he liked the idea. Unlike Wein, he was not vindictive. He usually just went forward, refusing to look back. But he was not used to someone walking away from him, especially the woman he cared about more than any other.

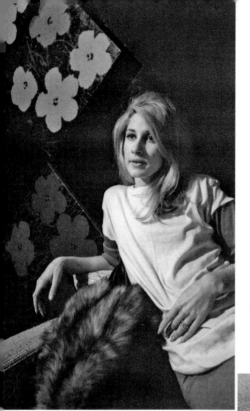

Andy Warhol's first Superstar, Baby Jane Holzer, posed in front of one of the artist's celebrated flower paintings.

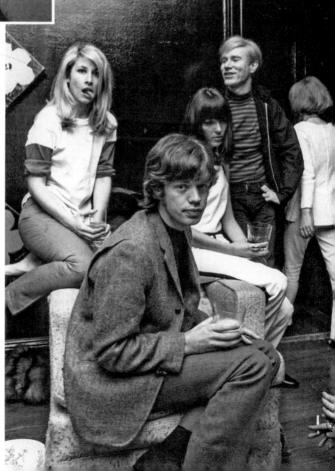

The insouciant Baby Jane Holzer with the Rolling Stones' Mick Jagger and Andy Warhol.

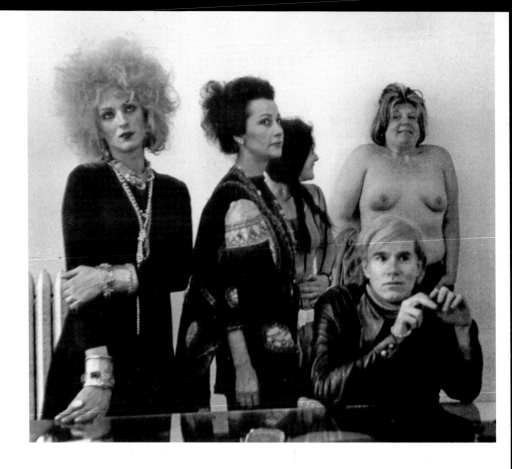

TOP:
Andy Warhol (seated) with
Candy Darling (left),
Ultra Violet (second from left),
and Brigid Berlin (right).

RIGHT:
Andy Warhol's Superstar
Brigid Berlin had an
in-your-face attitude.

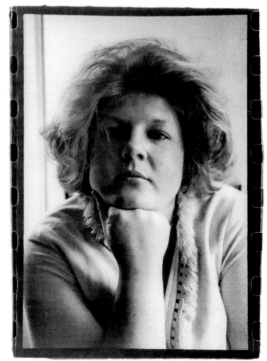

Andy Warhol and Superstar Edie Sedgwick
stand as tall as the Empire State Building.

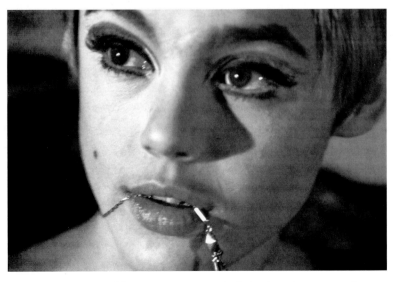

There was an overwhelmingly poignant quality
to Edie Sedgwick.

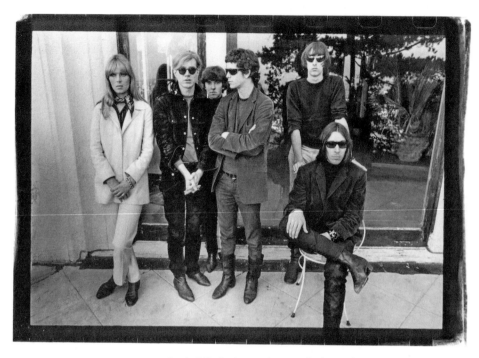

Andy Warhol standing with the Velvet Underground, including Nico, Moe Tucker, Lou Reed, Sterling Morrison, and John Cale.

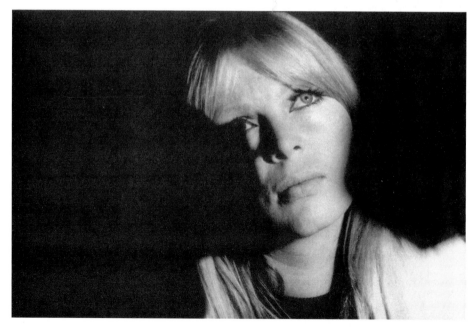

The singer Nico was a woman of mesmerizing beauty, which she believed hindered her career.

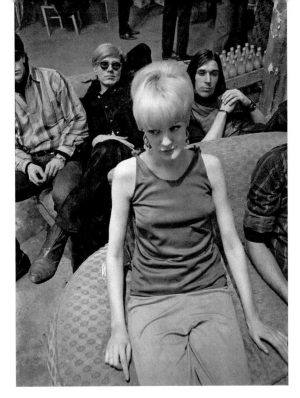

There was a sadness about Ingrid Superstar as she sat in front of Andy Warhol and John Cale.

Andy Warhol with Superstars Ultra Violet (left) and Viva.

The feminist radical Valerie Solanas achieved notoriety by shooting Andy Warhol on June 3, 1968.

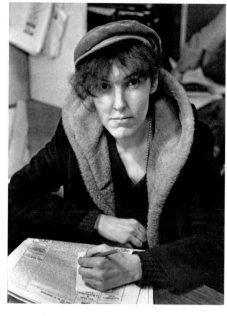

LEFT:
Andy Warhol's assistant Gerard Malanga with Superstar International Velvet in Malanga's photobooth shot.

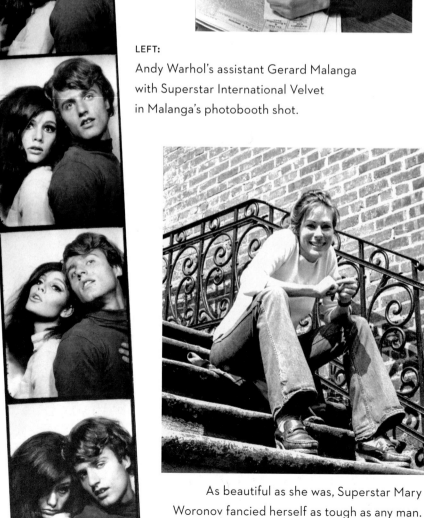

As beautiful as she was, Superstar Mary Woronov fancied herself as tough as any man.

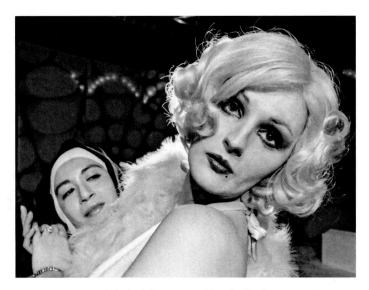

Warhol Superstar Candy Darling starring
in Tom Eyen's *The White Whore and the Bit Player*
at La Mama Experimental Theatre Club
in New York City, 1973.

The classic deathbed photo
of Candy Darling by Peter Hujar.

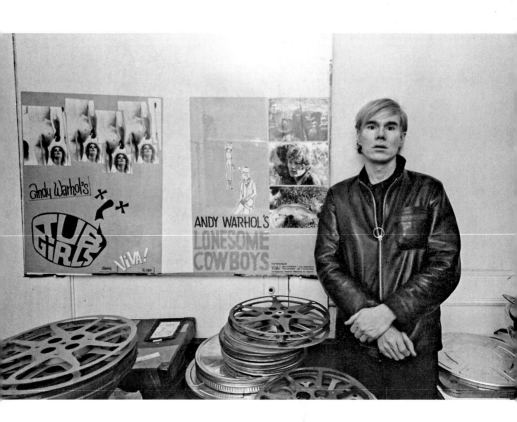

TOP:
Andy Warhol at the Factory standing alongside movie theater posters designed by George Abagnalo.

RIGHT:
Alice Neel's classic painting of Andy Warhol after he was shot and left profoundly damaged.

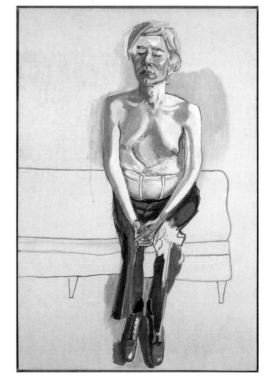

It did not matter who this new woman was, or *what* she was, as long as he could feature her in his films, make her a Superstar, and get the media to pick up on it. That's what celebrity was all about. You could take anyone, raise them out of anonymity, leave them up there for a while, and then watch as they toppled back into obscurity. The more unlikely they were, the greater a triumph for Warhol. And what a delicious way to stick it to Edie.

The woman's name was Ingrid von Scheven. When she met Wein, she lived in a rooming house in Hackensack, New Jersey, and worked as a secretary. Her biggest excitement was taking the bus into the city for an evening in the bars and clubs. No single woman concerned with her reputation would think of entering a 42nd Street bar, and Ingrid was earning extra money turning a few tricks.

Ingrid had never heard Warhol's name or visited the underground world of Lower Manhattan. For the unsophisticated young woman, it was as exotic a setting as the outer reaches of Tibet. Despite their egalitarian pretensions, the dwellers of the Factory had snobbish disdain for those like Ingrid who did not pass muster. It was not just that Ingrid was ignorant of their world; they deemed her stupid.

When Ingrid first arrived at the Factory, she was named "Ingrid Superstar." Whatever her detractors thought, Ingrid Superstar was smart enough to realize her best chance to survive was to turn herself into Edie's clone. She was far from beautiful, but she could be attractive with the right makeup, hairstyle, and clothes. Under Wein and Warhol's direction, she cut her hair short just like Edie's and learned to dress and speak like her. Ultimately, it was a painful comparison. Everything she said and everywhere she went made it even clearer she was not Edie.

Ingrid's rite of passage never fully ended. "We treat her like dirt, and that's the way she likes to be treated," said Morrissey at the time.

In the growing S&M world at the Factory, some people liked to be pummeled and hurt, but no one enjoyed ugly dismissals and put-downs. Warhol said he liked Ingrid but enjoyed insulting her as much as anyone. "Is it true you're slightly retarded, Ingrid?" he asked, though it was clear he thought he knew the answer.

Ingrid Superstar had hardly arrived at the Factory when she went off with Nico and the Velvet Underground in March 1966 to present the "new wave" at the Ann Arbor Film Festival. Eleven people piled into the rented RV for the 650-mile trip to the Michigan college town. Warhol was not going to pay for a professional driver. So, of all people, Nico got behind the wheel. Her primary experience had been driving in Great Britain; it was a concerted effort to stay on the right side of the road, but she barreled on with perfect confidence. Warhol and the others felt right at home. The RV was as foul as the Factory. In both, the toilet often did not work, leading to some unintended stops and unintentional comedy.

This was a chance for Warhol and the Factory inhabitants to step outside the confines of Manhattan and see what was happening in the rest of the USA. While the 1960s were blossoming into full bloom in New York—a period of cultural, social, and political up-heaval was spreading ever outward from Manhattan, San Francisco, and a few other enclaves—their impact had only begun in the broad swaths of territory that Warhol and the others were traversing. At times, it felt more like 1956 than 1966 in the American heartland.

Everything about the RV and its passengers seemed foreign and dangerous to many of those living along the route. Dressed in black and wearing dark glasses, the Factory sojourners appeared like aliens to the townsfolk they encountered. Twice, police stopped the vehicle, perplexed at the odd assortment of characters they found inside and shooing them along on their way. When the New York

contingent arrived in Ann Arbor, Nico bounced the RV up and down the curb, but they finally reached the venue safely.

Everyone had shared the same bumpy ride and miserable food on the trip, but Warhol stood far above the others. He paid them what he wanted to pay them when he wanted to pay them, based on a formula known only to him. For the Ann Arbor gig, Nico got $100, and Malanga and Maureen Tucker got $25 apiece. For Tucker, this was big bucks. Back at the Factory, she had to follow Warhol around, begging for gas money to get back and forth from her parents' suburban home; as she pursued him, he flitted away, keeping his wallet tightly encased in his pocket.

Warhol began the evening's performance at the Ann Arbor Film Festival by showing *Vinyl* and *Lupe*. This was the first time he had shown his films to almost anyone other than such bohemian true believers as Mailer and Mekas. The audience's disdainful, desultory reaction made it clear these films would never have a general audience.

"Both of the films were about as interesting in technique and dialog as home movies of a trip down the Grand Canyon," wrote the *Detroit Free Press*. "The only unforgettable impression of these two films were of the strong undercurrents of homosexuality and sadomasochism."

The final third of the program, featuring the Velvet Underground and Nico, saved the evening. It was a scream in the night, thunderously loud and overwhelming in intensity. Reed's songs, whatever part of them one could hear, spoke to the anxieties and dreams of the youthful generation filling the auditorium. The lyrics and iconoclastic attitude directly attacked whatever was left of self-satisfied 1950s Eisenhower America.

Then there were the lights managed deftly by Danny Williams. The 1961 Harvard graduate had been working as a soundman and

editor on several Factory films and was a natural for Warhol's scene. He was tall with a long, lean, vulnerable face, and Warhol had been taken with him. It was only a short time before twenty-five-year-old Williams moved in with thirty-seven-year-old Warhol. The couple were affectionate in public, kissing and embracing in a way Warhol had not previously been known to do.

Nothing lasted with Warhol. Williams left Andy's house and bed after no more than two months. Despite that loss, Williams was still so excited about editing films that he moved into the Factory. There Williams was amid a scene full of broken people. Warhol paid no one beyond a pittance, and people fought over other kinds of remuneration, primarily seeking to get as close as possible to Warhol. "Everybody was trying to be the first person in Andy's life, the king or queen of the court," said Malanga. "Andy allowed these situations because he maintained a kind of power."

Drugs were everywhere, and Williams soon became not simply an alcoholic but a heavy amphetamine addict. He no longer combed his increasingly disheveled hair. Nor did he bother brushing off the silver specks on his clothes that had fallen from the Factory walls. And when his glasses broke, he taped them together instead of buying a new pair.

That evening in Ann Arbor, Williams worked with detailed intensity on the light show. He took strobe lights and other lights and played them across the crowd. As modest an element as the lights may have been, it wasn't something that was typically part of rock shows at that time, and it wowed the audience. Dissipated by amphetamine, Williams found salvation in developing startling light shows. He worked endlessly, almost always in the shadows, creating an atmosphere that was positively transformative.

Amid all this, Malanga danced with Ingrid, wielding his whip as he twirled. As long as the light shone on him, he danced on and on.

The Velvet Underground performance ended with "The Nothing Song." It was not a song with music and words, but a discordance of sound, the amplifiers revved up so high they risked blowing out the system, the deafening feedback overwhelming everyone and everything. And then silence. The performance was a virtual acid trip, an experience that took a person out of themselves, beyond comprehension, leaving their ears ringing like a tuning fork, uncertain of what they had just seen and heard.

By the time Warhol arrived at the Ann Arbor Film Festival, he had fully worked out his public persona, creating one of the most memorable characters of the age. His silver mop was even more pronounced than ever. His dark sunglasses were omnipresent. He wore dark clothes, often topped by a leather jacket. He rarely smiled. Though he often appeared shy, it was in fact largely a calculated remove that was, again, integral to his image. He loved putting reporters on, saying one thing one day, the opposite the next, refusing to take anything seriously. He was hidden behind a shield of mockery; nobody got through to him.

As his public persona grew more established, photographers took Warhol's picture more and more often. David Bailey shot him at least twenty times. A great photographer waits until his subject is unguarded and the underpinnings of his soul are exposed. But with Warhol, that moment never came, no matter what Bailey did or how long he waited. "It felt like I was going after smoke," said Bailey. "He'd just disappear right in front of you. Boom! You'd try to touch him, and he'd just evaporate in front of you. I'm not sure I ever properly knew him. I'm not sure he was ever actually there, not really. I'm not sure he was there for anyone."

That summer of 1966, Warhol talked to Gretchen Berg, a young writer for the *East Village Other*. Berg was twenty-three and had no agenda, and he disclosed to her an Andy Warhol nothing like his

public image. He told her, "I prefer to remain a mystery" and "I never have time to think about the real Andy Warhol."

The Andy Warhol character he had created said fine art was dead, nothing but a gigantic joke of which pop art was little more than a funeral lament. *This* Andy Warhol did not scoff at his predecessors but said he had learned from such twentieth-century realist artists as Andrew Wyeth and John Sloan. *This* Andy Warhol was a serious, thoughtful artist, but his remarks did not jump provocatively off the page, setting him apart from his peers, and Warhol rarely allowed him out again. Did he fear that if people saw what he was, they would walk away, and everything would collapse around him?

10.

The Bone Crusher

Gerard Malanga was a pied piper who led women to Warhol and life in the Factory. A poet with sensuous, handsome features, he had a pitch that was almost irresistible: he promised them they would be in the master's films.

No matter that almost no one had seen Warhol's infamous movies. They knew *of* him—he was, by 1966, a nationally recognized figure. A pioneering pop artist, written about in magazines and talked about in the same breath as tastemakers like Norman Mailer and Truman Capote. He was *famous*.

And what's more, he *made* people famous.

On a visit to Cornell in upstate New York to give a poetry reading, the gorgeous blond-haired Malanga met the handsome Mary Woronov, a striking twenty-two-year-old art student whose long hair, high cheekbones, and wide, knowing smile were irresistible to him. The dark-haired, sinewy Woronov was six feet tall and a

presence wherever she went. She stopped Malanga in his tracks—and she found him attractive as well.

Malanga had brought a Bolex camera with him to Ithaca that he used to make a short film of Woronov as she walked across Trip-hammer Bridge. That was his favored aphrodisiac—filmmaking. "I thought it was hot, and you know I got even hotter, you know, while he did his little films of me," Woronov said.

Woronov was born in 1943 at the exclusive Breakers Hotel in Palm Beach, which, during the war years, had been transformed into a hospital. When she was born prematurely, with a cyst resembling a tail and dark hair, her grandmother suggested she be returned.

Things were lean until her mother married a cancer surgeon in Brooklyn. From then on, Woronov had an upscale lifestyle. At the all-girls Packer Collegiate Institute, the upscale private school she attended, she did not have to worry about boys pushing to the front of the class. She acted in student plays and painted and thought there was little she could not do.

Woronov was a sadist. In front of her aghast junior high school geography teacher in what she considered one of the most wonderful moments of her childhood, Woronov beat up a fellow student until she was a whimpering heap on the floor. Years later, Woronov remembered the sound of the teenager's "bones cracking, the thud of her head hitting the blackboard, that weird bleating noise she made which made me hit her even harder."

Life was weird. The student loved her beating so much that she lured other girls into the bathroom, where Woronov could attack them. In the end, Woronov had enough of the pathetic young woman. To get rid of her for good, she did not hold back this time, leaving her with cracked ribs and a broken finger. But how could there be any justice when the girl was ecstatic?

Woronov's stepfather had married the tall, beautiful woman of

his dreams, but as he saw it, his wife was distressingly slow at everything she did—making the beds, doing his accounting, cooking meals. It was a simple matter of putting her on amphetamine, which revved her up considerably. But this was no honest answer for her mother's malaise, and Woronov saw darkness in this marriage.

By the time she escaped to Cornell University in Ithaca, New York, for college, Woronov was ready for something new. Although the school had a serious academic reputation, in the 1960s Ithaca was also an enclave of the hip and the radically disenchanted. Hippies and drug dealers who had no connection with the college hung out with students and ex-students who sought a different kind of life. As an art major who also acted in college theater, Woronov gravitated to this intriguing counterculture. She also liked to hang out around gay men. They were witty, glamorous, and did not make inept attempts to woo her. She'd had to deal with too much of that already.

Woronov had given up her virginity while in college to a busboy who served her family's table at Grossinger's, the Catskills resort where her family had gone on spring vacation. It had been little more than desperate grasping in the night, made worse when she learned the young man's job was not just to clear tables; he was also expected to have sex with the bored wives who flocked to the hotel. But Woronov had gotten what she wanted—"the mark that said I was a woman"—and had no interest in going down that road again anytime soon. She was so disinterested in sex and so subtly manipulative that when men came around her (and they often did—she was strikingly beautiful) she got her girlfriends to sleep with her suitors instead.

When Woronov's art class traveled to Manhattan to visit various artists, they first went to artist Robert Rauschenberg's studio, located in a building that had been a Catholic orphanage. Rauschenberg was a hugely successful artist. Since the fifties the Texas-born

painter had been making art out of junk from the streets and news-papers in a way that predated pop art. Rauschenberg's studio was bustling, with hip young people running around, talking about and making art. Everything was white, pristine, and impeccable—in dramatic contrast to the world of discord that the artist saw all around him and tried to capture in his work. The critic and biographer John Richardson visited both Rauschenberg's and Warhol's studios and saw a vivid contrast: "In my experience, people seldom discussed art at the Factory, whereas in Rauschenberg's kitchen, people seldom talked about anything else."

Woronov and her classmates then traveled uptown to Warhol's studio. They, too, immediately clocked the contrast between the two spaces. At the Factory, the discord was not just in the art but also in the surroundings. The silvered walls had begun to look tarnished. The atmosphere was dark and louche. Two drag queens sat on the infamous sofa mocking everything around them as the group of Cornell students arrived.

Woronov had hardly entered the Factory when Malanga came sweeping toward her. He had fond memories of meeting her at Cornell and wanted to reconnect. What better way than through a film? "Warhol's going to do a movie," Malanga said. "I think you should stay around because I think he'll want to shoot you." Something was happening at Warhol's studio amid the grubbiness that, to those susceptible, was irresistible. Woronov agreed to stay for a screen test as her classmates left to visit other artists.

Warhol constantly tested people, and the test never ended. With his hundreds of "screen tests," he was not just looking to see if a subject projected well on-screen. It was equally a test of personality. Across the room sat a stool, with a camera a few feet away. Woronov was told to sit on the stool. When she did, everyone walked away. Woronov did not know if the camera was on or if there was even film

in it. She could have gotten up, refusing to play their little games. Instead, she stared the camera down, never flinching, looking at it minute after minute.

If this was a test (and it was), she'd passed with high honors.

In short order, Warhol invited Woronov back to the Factory. That was all she needed to hear. This was her kind of place—risky, boundary breaking. She packed up and moved to New York City, where she initially stayed in Brooklyn with her mother and stepfather.

||||||||||||||||||||||||

Woronov had hardly arrived when Warhol cast her in a small role as a police officer in *Hedy*, his film about the actress Hedy Lamarr's travails as a shoplifter. Always looking to brand his Superstars in his own image, Warhol rechristened Woronov with the name "Mary Might." It didn't last long. Unlike other Superstars before and after her, Woronov refused to let Warhol slap some new name on top of her. She was born Mary Woronov and so she would be when she died.

Everyone at the Factory was trying to find a unique place or role in the never-ending circus that made up daily life in Warhol's orbit— some characteristic or "bit" that would make them irreplaceable. Malanga had been attempting to do that by dancing with his whip during the Velvet Underground performances, and by getting cast in indispensable roles in Warhol's films. In the newly arrived Woronov—stunning, anxious—he saw someone who could help him achieve his ends. He came up with a duo act for the two of them, dressing her in black pants and giving her a whip so they looked like twins.

Woronov believed Malanga had sought her out at Cornell because he needed a partner to team up with him in Warhol's films.

She saw the utility in the collaboration and entered it willingly. They didn't sleep together—not yet, anyway. But they both realized their artistic fortunes at the Factory were brighter if they joined together.

Malanga wanted to share the screen with Woronov, but much of his interest was romantic. Love was his addiction, and when he was mainlining it, nothing else existed until it all came tumbling down. He became obsessed with Woronov. She was unlike any woman Malanga had previously known (and he had known a lot). She had a tough, aggressive side. "I acted like a guy," she said. "I was masculine and I fitted really well with all the guys who were being very, very feminine."

Malanga and Woronov went down to the East Village one evening early in April. They entered a building with a sign identifying it as the Polski Dom Narodowy, the Polish National Home. Most people knew it simply as the Dom. Downstairs, a restaurant bar featured Polish food. The upstairs was a dance hall for weddings and other events.

Warhol had rented the dance hall for a month for the *Exploding Plastic Inevitable*, a multimedia event featuring the Velvet Underground and Nico. Warhol was never first in anything. Dancer and choreographer Elaine Summers had put on her *Fantastic Gardens* mixed-media event at Judson Memorial Church two years before. The evening combined film, music, dance, and sculpture in a mesmerizing presentation. Mekas called it "by far the most successful and most ambitious attempt to use the many possible combinations of film and live action to create an aesthetic experience." In the Greenwich Village world, the event was a sensation. Warhol paid attention.

Warhol and his minions decided they wanted to take the multimedia-event concept to a different, even more ambitious place.

In one crazed evening, they assaulted the ears, the eyes, the mind, the soul, and conventional morality. The Factory member who took the lead producing this event was Danny Williams, Warhol's ex-boyfriend-turned-lighting-designer who continued to hang out on the scene . . . even as Warhol had turned on him, treating Williams with disdain that was devastating to such a sensitive soul. But Williams went on doing his job with great originality, the jolts of amphetamine helping him focus in minute detail.

Williams and his associates placed three screens on the walls and set up projectors facing them. Spotlights jutted out from the stage and the balcony. On the front of the stage sat a machine that shot spots of light onto the ceiling. Another machine pulsating with various colors stood on the other end of the stage.

The elements came together with stunning discord. As Warhol's films played, naked bodies writhing juxtaposed with acts of sado-masochism, Malanga and Woronov danced to the Velvet Underground. The strobe lights turned off and on so that the black-garbed couple appeared to be dancing jerkily as if in a silent film. Malanga had not yet bedded Woronov, and his dancing pulsated with sexual energy.

Woronov was the dominatrix towering over Malanga. "He took a passive role and gave me the active role," Woronov said. "He was always on his knees to me with his head bowed, and I was always above him. We were female/male, but I was never hanging on him; the roles were switched." A woman did not lead a man in mid-sixties America. That alone set this evening apart and by itself made the event memorable. Woronov eventually slept a few times with Malanga, more out of a sense of inevitability than a consuming passion.

When the Velvet Underground played Reed's song "Heroin," Malanga took out a large fake syringe and pretended to inject himself. He did not do the drug, but Reed and other members of the

band had heroin habits. Warhol bought the drug for the group, daily listing in his expense account, "$10 for H, for John's toothache." For those who wanted to get stoned on marijuana, there was a room in the back of the dance hall set up with mattresses.

New Yorkers have an irresistible impulse to seek out the latest thing. In the spring of 1966, anyone in the city who thought they were with it headed down to the Dom for a wild, indescribable evening. It was not just the artistic and musical avant-garde who made their way to the Dom, but members of the social elite arriving by limousine to see and be seen. One evening, Walter Cronkite walked up the stairs after anchoring the *CBS Evening News*. Another night, Jackie Kennedy, then the most revered woman in America, made the trip down to the East Village.

Woronov soon grew tired of Malanga and his endless romantic musings. She far preferred Ondine and, in her way, loved him. Ondine was gay, but that was no problem, since Woronov had little interest in sex. He was a man of surprising erudition, quoting from classic Greek plays and singing parts of *Tosca* from memory. Ondine fascinated her, and the two gravitated toward each other.

One evening, dressed in a cloak that made him look like a gangly monk, Ondine played a record of the opera singer Maria Callas, the background music to his life. Higher than high, he ran around his apartment, jumping up and down on a table. Stoned herself, Woronov wrote what she had seen and felt and understood:

"I composed my first rigid speed concerto in logic, which I will now play for you: Order=Fear of Death; Chaos=True Reality. We took drugs to battle the cages of order, in order to embrace the chaos of the divine order. I+Order+Ondine=Chaos−Andy+the black primal creative negative."

It must have seemed to Woronov like an extraordinary epiphany, a key to the secret knowledge of the universe. Sober, she would

have seen it for what it was: a mindless drug reverie signifying nothing. But Woronov wasn't sober.

As Woronov took more and more amphetamine, she became one of the moles. It was a swift descent into a dark, insular world. Only an A-head could understand how once a person entered their drug-fueled existence, that world became the entire universe and must never be traversed. As Woronov expressed it, anything was better than "the unbearable emptiness that the outside held for us."

Death was always somewhere lurking among the A-heads in New York, ready to take the unaware or the unfortunate. When someone OD'd and died, there was no elaborate mourning, no soliloquy before the casket was lowered into the grave. The body had to be disposed of quickly. When one of Woronov's acquaintances died one night, his body was carried down into the street and left there.

The Factory culture had a startling disregard for the value of individual human lives. It was the worst thing about Warhol's world, and that sentiment spilled over everything. One day when Woronov was there, a drug dealer came up the elevator and shot up a young woman in the bathtub. She disappeared under the water, and when they pulled her out, she appeared to be dead. That would have been the time to call for an ambulance, but that would have meant the cops and embarrassing questions, and nobody wanted that.

Then one of them came up with an inspired idea: "We should send her down the mail chute." That lightened things up considerably. People licked stamps and pasted them on her forehead and wrote little notes and placed them on her body. Then, as they were about to try to stuff her down the mail chute, she woke up and they went on to other things.

Woronov was a fine dancer, but as her other interests developed, she stayed home when the *Exploding Plastic Inevitable* went on a weeklong tour to Chicago. A diminished crew flew off in June 1966

to the Midwest. Warhol was busy with his new film and could not be bothered, though he was supposed to be the main draw.

Lou Reed had a better excuse for staying home. The Velvet Underground's lead singer was in the hospital recovering from hepatitis, likely brought on by using dirty needles when he was shooting up heroin. Nico was not even in the country. She was in Ibiza visiting her mother.

The tour continued, if reduced. Malanga danced with Ingrid Superstar, and the loquacious Brigid handled the interviews Warhol would have done. Williams's light show at Poor Richard's in Old Town Chicago took on even greater importance with so many people missing. In its review, *Variety* called Williams the "mastermind" of the show, giving extraordinary praise to one whose work was hardly ever mentioned.

This did not sit well with Paul Morrissey, who started tinkering with Williams's lights, moving some and diminishing others with no purpose other than to get at his supposed competitor. Williams felt Morrissey was devoid of creativity but was an adversary of relentless force. Williams was a gentle person not prone to arguments, but one evening during the performance, he and Morrissey had a fistfight on the catwalk high above the stage.

Warhol could have stepped in to settle things down, but he was not about to do that. He saw that "Paul's relationship with Danny Williams was really sadistic," but he wasn't any better. He kept sniping at Williams, belittling him in that passive-aggressive mode of his. Despite putting Williams down, he went back to having sex with him occasionally, including one night in a motel.

Everyone followed Warhol's lead at the Factory. The others mocked Williams when they were not ostracizing him. He was a wreck, his amphetamine use out of control. One day, he fell asleep with a cigarette in his hand, setting a piece of furniture ablaze. Di-

sheveled and distressed, Williams needed help, but nobody appeared to care.

Twenty-seven-year-old Williams returned to his home in Rockport, Massachusetts, on the Atlantic Ocean at the tip of Cape Ann. Everything was the same, his room much as he left it, his mother overwhelming in her dominance. The only thing different was Williams. One evening after dinner, he borrowed his mother's car, drove to a lonely cove, parked at the breakwater above the rocks, took off his clothes, neatly folded them, and walked into the sea.

When Williams's mother learned what happened, she went to his bedroom and flushed his drugs down the toilet, but she did not want to believe her son was gone. Maybe he had a confidant there on the beach, and they had gone off to start a new life. So many things could have happened. She called Warhol to see if he had any ideas where Williams might have gone. Warhol refused to take her call. "Oh, what a pain," Warhol said in exasperation. "I don't care where he is. He is just an amphetamine addict."

Williams's body was never found. Eleven months after his son's disappearance, Danny's father killed himself. Warhol was emotionally disengaged from the whole situation. He never wrote a condolence letter. He did not *feel* what most people felt.

In 1980, when *Popism*, Warhol's story of his life in the sixties, was published, he did not write about his love affair with Williams, his friend's accomplishments, or his tragic death. He mentioned him as "a Harvard kid named Danny Williams [who] would take turns operating the spotlights."

||||||||||||||||||||||

When Nico walked into a Manhattan studio with her bandmates to record the Velvet Underground's first album, she had other things to consider besides her career. On her way back

from visiting her mother in Ibiza, she stopped in Paris to pick up her young son, Ari. She brought him up like a hippie child, conversant with all kinds of adult activity, and allowed to roam as free as a beast of the woods.

Nico was still consumed by the idea of becoming a famous singer. Not many in her orbit shared her vision. Reed did not try to hide his disdain for her—he saw her as a talentless pretender, standing on the stage with a model's posturing when she was not singing out of key. That she was deaf in one ear might have had something to do with it. But it was the cause of great merriment among her Velvet Underground bandmates, who mocked her mercilessly. Even those who supported her, like Morrissey, did so not because they thought she was a notable talent but because, as a beautiful adornment, she would increase the commercial viability of an otherwise unappealing band.

Lou Reed was not an enemy to have. An artist of singular talent, he saw no limits to what a song could be or where it could journey. He wanted to do with lyrics what the novelist Hubert Selby Jr. was doing with fiction, exploring the unspoken parts of American life. Anyone who read Selby's 1964 novel *Last Exit to Brooklyn* would forever remember his portrait of gay men, trans people, and working-class stiffs occupying the edges of society, a book that seemed not so much written as retrieved from the depths of darkness. This was where Reed felt most comfortable, and it was the world he sought to portray in his lyrics.

Warhol, still trying to drum up interest in "his" house band, created the provocative cover image for the band's first studio album. The oversized banana peeled back to reveal a flesh-colored shaft that looked more like a penis than tropical fruit. It was audacious and instantly iconic. Although *The Velvet Underground & Nico* sold only about thirty thousand copies, it was a seminal album, a lesson book

to succeeding generations of rock musicians. Reed wrote most of the songs, each one more unsettling than the last. Unlike at so many of their public appearances, the lyrics are everything on the album, and the words are clear.

The melancholy tone was there from the first note. Cale's viola could make "The Star-Spangled Banner" sound like a dirge, and the bohemian scene that Lou was so brilliantly chronicling was full of sadness and despair. The song "Sunday Morning" was about that predawn hour when little is left of the evening but a bad taste in the mouth. On "Heroin," he sang about how shooting up made one feel like Jesus's son, in the telling giving the junkie's world a measure of dignity.

Nico's first song on the album was "Femme Fatale." Reed wrote it about Edie, this irresistible tease of a woman playing the world for a fool. Only, these days, Edie was a depressed, emaciated drug addict, and Nico was singing with poignancy about a world that once was and nevermore would be.

Reed wrote "I'll Be Your Mirror" for Nico. The song is as much a lament as a ballad. Nico sang lyrics as testaments of truth. A woman sings to a man, promising him she will be everything for him, but there is no response. Nico had made that promise to Delon, Dylan, and others, and it had all come to naught. No wonder she had a hard time singing the song.

11.

A Fallen Debutante

Gerard Malanga took the train to Boston to spend a few days visiting the city. There, he met Susan Bottomly, a debutante who had been on the cover of *Mademoiselle* the previous December. She was dressed all in white, with a thick wreath of white coq feathers around her head, and her dark hair and eyes showed in dramatic contrast.

Bottomly's hair color was the result of an experiment gone wrong. She had been playing with putting peroxide in her hair. It was such a disaster that she dyed her locks with brown coloring, but left it on too long, and her long mane ended up ebony black. The effect, however, was mesmerizing. She was far more sensuous in person than on the magazine cover. Malanga thought Bottomly resembled a young Elizabeth Taylor.

Malanga had hardly met Bottomly when he employed his favorite sexual ploy, filming the intended subject. He and Bottomly went

to her friends' house in Milton, where he shot her putting on makeup while drinking vodka and orange juice. The thirty-three-minute film did the trick of ingratiating him with Bottomly. There was one problem. Bottomly was just seventeen years old, while Malanga was almost six years older. But as Malanga saw it, some things were worth the risk.

Bottomly spoke in a Boston Brahmin accent gently touched by old England. By rights, she should have grown up a proper Bostonian like her blue-blooded mother, Mary Bottomly. But she identified more with her father, John S. Bottomly, who came from a more modest background. He left his lucrative private practice to become Massachusetts's assistant attorney, where he prosecuted the notorious serial killer the Boston Strangler.

His daughter Susan had a similar brash spirit. By the time she'd turned thirteen, Bottomly was already sneaking out of her Wellesley house to meet boys and stealing whatever she needed from her parents. She was kicked out of private school after private school as she broke all the rules and did whatever she wanted.

The Bottomlys had five younger children who needed attention, and Susan was nothing but trouble. They had no idea what made her so intractable, but they were too busy and preoccupied to put up much of a fight. When their teenage daughter said she was taking the train to New York with Malanga to pursue a modeling career, they shrugged.

The train had hardly pulled out of South Station when Malanga realized there might be more to this pretty girl than he had initially believed. Bottomly, he saw right away, thought the system was there to be conned. When the conductor asked for their tickets, Bottomly said she had lost hers in such a plaintive, beseeching voice that the conductor smiled and allowed her to ride free of charge. That was

the kind of performance many of Malanga's colleagues at the Factory would have appreciated.

When the couple arrived at Grand Central Station, they took a taxi to the Chelsea Hotel, a nondescript residential hotel on West 23rd Street that had been a popular home for artists for decades. Thomas Wolfe and William S. Burroughs had lived there, and Dylan Thomas had died there. Writers, rock musicians, and painters frequently made the hotel their New York residence—along with junkies, drug dealers, and prostitutes. That juxtaposition of different kinds of people doing different things made the hotel fascinating, nerve-racking, and never boring.

Bottomly's father agreed to pay the monthly rent at the Chelsea, and she moved into an apartment with Malanga. Bottomly liked fine clothes and expensive makeup, and she constantly wrote her father for money. Malanga spent much of his time writing love poems to his teenage amour, but he found time to take his lover's letters to the post office and mail them off special delivery. And sure enough, a few days later, the check would arrive.

Bottomly shared a trait with several of Andy's Superstars. As impeccably dressed as she was when she left the hotel, her room was squalid. It bewildered Malanga. "The room never seems to get cleaned," he wrote in his diary, as if that were a woman's natural task and he couldn't fathom how it might get done if she didn't do it for him. "She always throws her garments on the floor, and the sink is always dirty, and the refrigerator has been empty for days." A grown man living with a beautiful teenager was not quite the idyllic existence.

When Malanga brought Bottomly to the Factory, Warhol saw immediately that she was a natural Superstar. He named her International Velvet, a takeoff on Elizabeth Taylor's role in *National*

Velvet—he, too, immediately clocked Bottomly's physical resemblance to the star and calculated how to turn it to his advantage. She soon became a part of Warhol's artistic scene and his growing nightlife entourage.

When International Velvet went out with Warhol on his evening sojourns, she had to compete with his other Superstars for his attention. Andy liked that dynamic just fine. One evening, Warhol and Malanga were having dinner at El Quijote, a restaurant at the Chelsea Hotel, with International Velvet, Woronov, and Edie—who, despite how she had been treated, still occasionally joined the group. Everyone except Warhol was drinking heavily. Well into the evening, Malanga taunted the three women, saying that Nico would supersede them all when she returned from visiting Ibiza. Upset with Malanga's attempt to get the three women clawing at each other, Woronov jumped up and ran to her room in the Chelsea.

Woronov knew she had to do something special to merit Warhol's attention. "When you are with Andy, it was sort of like a circus thing," said Woronov. "You had to think of something to be effective." Warhol was the ringmaster. Edie danced a mesmerizing dance. Woronov exuded a female and male spirit as exotic as the bearded lady. International Velvet played the ingenue, while Ingrid Superstar shouted above the others. As for Brigid, she simply shot herself up and offered to poke anyone else who needed it. And with all of them the action was done to impress Warhol, who looked on primarily with bemusement and seeming disinterest.

They each had their chance to wow Warhol as he embarked on his next film—one that would become the most enduring movie to come out of the Factory scene. That summer of 1966, the Superstars played roles in *The Chelsea Girls*, Warhol's three-and-a-half-hour film about life at the famous hotel. The film consists of twelve thirty-three-minute reels. Warhol had so much footage that he felt

it was too much to edit. So he decided to project two reels at a time, calling the parallel reels "a divine accident." It forced the viewers' eyes to jump back and forth, as if watching a tennis match.

A bohemian *Ship of Fools*, the segments purportedly show life in different rooms at the hotel, though most were shot elsewhere. Although each part exists independently and does not relate to the others, *The Chelsea Girls* is as close to a narrative film as Warhol ever directed. Featuring an array of people who hung around the Factory, he considered "99.9% of them" degenerates, perfect subjects for his film.

International Velvet appears alongside Woronov, Ingrid Superstar, and another Warhol actress, Angelina "Pepper" Davis, in one episode. Ronald Tavel had written a script about Hanoi Hannah, a notorious radio propagandist played by Woronov. She learned her lines, as did Davis, which was a worthless achievement since Ingrid Superstar and International Velvet did not. They set off on a wild segment that included scripted lines and extravagant improvisation.

Warhol did not invent reality programming. Unscripted dramas have existed since the early years of radio. But no one had ever focused the camera on the gritty, often dark realities that he did. In *The Chelsea Girls*, his three Superstars and Davis play versions of themselves. The needy and submissive figures of International Velvet and Davis are perched on the bed in International Velvet's modest room. Above them, squatting on a window ledge, Woronov is the dominating presence. And lying on the floor is Ingrid Superstar, a masochist waiting to be abused.

Before the shooting began, International Velvet fortified herself with vodka from an open bottle, Ingrid took her full quota of pills, and Woronov was on amphetamine.

In the film, the women share insults, speaking in belligerent, insulting tones, but due to the fractured sound it is sometimes difficult

to understand. Like most of the people featured in *The Chelsea Girls*, the four women appear staggeringly self-absorbed, not speaking so much with each other as at each other.

Woronov approached the scene as if she were entering a boxing match—she intended to lay someone out and pummel her competitors, whether with words or fists. International Velvet was her likely opponent. Woronov delighted at the prospect of walloping a woman she thought "a stupid cunt" who had absurd ideas of becoming a Hollywood star.

Woronov considered Ingrid Superstar a worthless piece of trash unworthy of attention. Woronov dealt with her by threatening to pull out her nails. That should have terrified Ingrid, but she delighted at the prospect of pain. "We're the ones who are sadistic," Woronov lectures her. "You're not supposed to like it."

"Oh, I love it," Ingrid Superstar says.

"Shut up!" Woronov shouts.

Ingrid Superstar's voice is so shrill and insistent that Woronov and International Velvet tie her up and place her out of camera range on the floor under the desk. That lets the real battle begin. Woronov reaches across the bed, grabs International Velvet, and beats her. They scratch at each other like alley cats.

"Kill her! Kill her! Kill her! Come on," Ingrid Superstar yells from the floor.

"You shut up, or I'll pull out your nails," Woronov says.

"Oh, no, anything but that!" Ingrid Superstar says. "No, please. I'm a masochist."

Themes of violence and sadomasochism underscore much of the film, and there are glimpses of male nudity. Brigid appears on the screen for the first time with a syringe in her teeth, waiting to shoot up. When she finishes the job with her usual professional acu-

men, she moves on to Ingrid Superstar, poking her in a buttock with such a massive shot that Brigid vows she is "gonna be up for a week."

The Chelsea Girls is a strange, glorious mess—one that glamorizes the darkness while simultaneously exposing its true griminess and depravity. Warhol had created a world where taking drugs had no bad consequences, and his films made shooting up seem lots of fun. Sadly, this didn't reflect the reality of either the outside world or the hermetically sealed environment of Warhol's Factory. Nowhere in the films are there any suggestions this kind of drug use might have darker endings.

The penultimate scene in *The Chelsea Girls* was staged at the Factory itself. It begins with Ondine shooting up, achieving a high that brings out the extremes of his personality. Next to Ondine sits Ronna Page, a midwestern-born woman living with filmmaker Jonas Mekas. She begins talking to Ondine as if he is indeed the pope and she is a humble supplicant needing his guidance. Then she proclaims, "I think you're a phony."

Ondine called himself the pope of Greenwich Village, but he was no pontiff. He was an often-homeless amphetamine addict whose life reached no further than the parameters of the Mole People. Her accusation so enrages him that he warns her to leave and splashes a drink in her face.

"Leave quickly," Ondine tells her. "Leave quickly before I tarnish your, the rest of your filthy image. Get out of here. Get out!"

Not realizing her immediate danger and loving being filmed, Page sits there.

"You're a bore," Ondine says, striking her in the face. "A bore! A bore! A bore!" he shouts, hitting her again and again. The camera, of course, keeps rolling.

Warhol later said he was so upset at the violence that he left the room. If that's true, then it was a strange thing for Warhol to do. His fascination with violence had been evident since Freddie Herko's suicide in 1964, as well as in his paintings, such as *129 Die in Jet!* (1962), *Suicide* (1963), and *Race Riot* (1964), all of which portray scenes of death and violence. If Warhol left the filming that day, someone else got behind the camera, for it followed the action around the set.

Such scenes made *The Chelsea Girls* a phenomenon, rising from the bohemian ghetto to art theaters in major American cities. Critics who appreciated the film saw it as a daringly realistic portrait of life in mid-sixties America. "The film is an image of the total degeneration of American society," Richard Preston wrote in the *East Village Other.* "The air is thick with the stench of corrupted souls."

Establishment reviewers were divided. *Newsweek*'s critic called *The Chelsea Girls* a "fascinating and significant movie event." His colleague over at *Time* was not amused: "There is a place for this sort of thing, and it is definitely underground. Like in a sewer."

Warhol reveled in the controversy and the fact that the film was banned in Boston. Notoriety, in his eyes, was just another word for fame. Controversy simply brought him greater celebrity. Only a few years before, Warhol had stalked Truman Capote on the streets of Brooklyn. Back then, Capote had wanted nothing to do with him. But now Warhol had risen to such prominence that the author of *In Cold Blood* invited Warhol to his celebrated Black and White Ball at the Plaza Hotel in November 1966.

Woronov was the one casualty of *The Chelsea Girls*. Her mother was outraged—not at her daughter's appearance in the film, but at the fact that, despite the film's success, Warhol did not pay the actors. So she sued him. Warhol settled by paying not only Woronov but other actors as well. That was also the last time he featured Woronov in one of his films.

IIIIIIIIIIIIIIIIIIIIIII

I n the summer of 1966, Ondine was sleeping in Central Park. When he woke up, he went for a swim in the lake and headed over to the West Side to a friend's apartment, where he shot up. Then he walked back across the park to Edie's apartment for his new job as her "French maid." Her parents had decided again to support her, and she was living in a level of luxury she had not had access to for several years.

When Ondine arrived at her apartment, Edie was zonked on barbiturates. Speed was Ondine's wonder drug. All it took was some amphetamine in Edie's coffee to get her going. Then they sat around listening to opera and talking. Ondine did not have to do any cleaning. Edie had a *real* maid for that.

Edie liked to place lit candles around the apartment. One evening in October, the drapes caught on fire, and the place quickly filled with flames. She was burned seriously enough to be admitted to Lenox Hill Hospital.

Edie's apartment was unlivable, and she had to find a new place. All kinds of upscale hotels would have been natural residences for her, but she decided to get a room at the Chelsea. It was the unofficial dormitory of Warhol Superstars, and of course drugs were never more than a few doors away.

Edie had been terribly hurt by Dylan. The singer-songwriter was a man of such self-conscious mystery and suspicion that it's unclear just how close they had been, but close enough to leave Edie devastated. The best thing she had going for her now was her relationship with Dylan's close friend Bob Neuwirth, who she had taken up with in the wake of Dylan's apparent betrayal the previous year.

The singer, songwriter, and record producer had nothing like Dylan's talent, but Neuwirth had become a haven in Edie's ever-

more-dangerous life. They also had a special connection. He had taught her the give-and-take of sex; for the first time in her life, she truly enjoyed the act. But with love came jealousy, and she fretted about losing him.

Neuwirth acknowledged Edie's feelings for him, but he believed she was incapable of real love. "I think you have to love yourself—this is such a cliche and so mundane—but I think you do have to have, if not love for yourself, at least self-esteem in order to really love anyone and not be selfish," Neuwirth said. As he saw it, Edie's self-absorption grew out of her inability to love herself, and her obsessive use of drugs was a mark of self-hatred.

That did not mean Neuwirth found Edie devoid of extraordinary qualities. "Edie was one of the most talented people I've ever known, naturally talented," he said. "Her effervescence and charm made it a real entity to deal with. In the body of a single artist's work, she knew good art from bad art instinctively. She knew good dance from bad dance. She knew good music from bad music. In the old days, they would have said she had good taste."

Part of her rapprochement with the Sedgwick clan meant that Edie would go home for Christmas that year. Doing so seemed so right, a journey out of the cold back into the embrace of the family. This was complicated, of course, as everything was, by her addiction. Edie had to calculate just how much speed she needed for her time away from New York. She figured she could not shoot up at the ranch, but she had a prescription for Eskatrol, a form of amphetamine, and she intended to take enough with her so she would feel fine during the trip. This was going to be okay.

It wasn't. When Edie's father saw the pills, Duke called the police, who took her to the psych ward at County Hospital in Santa Barbara for treatment. She called Neuwirth to tell him what had happened, and he called Duke and threatened to throw him in legal hell if he

did not let his daughter go. So she returned to New York, ever more distanced from the Sedgwicks. Neuwirth had done right by Edie, but her jealousy kept growing until it overshadowed everything.

Edie made new friends at the Chelsea Hotel, including International Velvet, whom she had met at the Factory. The younger woman was in awe of Edie and watched her putting on her makeup for hours. When Edie began, she had the face of a newborn, fresh and clean and guileless. But that visage slowly disappeared behind an elaborate mask of cosmetics—beautiful, yes, but also strange and oddly terrifying and alienating. This should have been a cautionary tale, but International Velvet turned it into a tutorial. Soon she was doing the same thing—asking her father to send money for cosmetics and creating theatrical looks that turned her into an entirely new person.

Warhol was taken aback at what this teenager was doing to herself. Watching this young woman, "who had such perfect, full, fine features, doing all this on her face was like watching a beautiful statue painting itself."

When International Velvet traveled with Warhol and other members of his entourage to Boston, a reporter writing about the artist was so startled at her looks that he stepped back from chronicling Warhol's visit to describe International Velvet in detail:

"There was a tall, ominous, conical girl who looked like a chic hangman. She wore a black and white outfit complete with black hood and earrings like black billiard balls. Her face was done in a deathly coffin pallor, her eyes sooted with kohl and fringed with lashes that might easily have been mistaken for the cats' whiskers, if not the cat's meow."

In the evenings, Edie and International Velvet often headed out to parties in limousines ordered by the older woman. When International Velvet told Warhol about the extravagance, he was bewildered at how Edie could do such a thing when she had no money to

pay for it. Edie did not care. Sooner or later, money came from California, and she parceled some of it among her creditors.

The relationship between the defrocked Superstar and her likely successor could have been fraught with envy, but it wasn't. For Edie, life with Warhol was both too much and not enough. She had no desire to return. As for the teenage International Velvet, as much as she sought a place in the spotlight, she could not imagine replacing someone as remarkable as Edie.

One evening, when the two women were higher than a Baked Alaska, they headed down to Neuwirth's loft. He took out his camera and filmed them on his bed as they ripped their clothes off.

Edie and Neuwirth were still much desired guests on the upper levels of the social circuit despite (or perhaps because of) their proximity to the artistic underground scene. They flew to Hyannis Port in September 1966 to attend Joan Kennedy's thirtieth birthday party. The Kennedys were not old money, but in their Massachusetts home they lived like it. The main house had not been renovated, and much of the furniture had been there since the forties.

Edie appreciated the scene and deftly worked her way through the guests, by any measure a social queen. It helped that before she flew up to Cape Cod, she went to see Dr. Roberts, her Dr. Feelgood, who shot her up with an injection that energized her for the rigors of this event. The only problem was that Senator Edward Kennedy kept hitting on her shamelessly. "Oh, he was always telling me that I should have an affair with him, that it was the healthiest thing for me and for him—right in front of Bobby Neuwirth," Edie said.

Edie and Neuwirth's affair ended not with a whimper but a bang. She checked his answering machine and found a message from a model arriving at the airport. That set her off, and later that night at a nightclub, she pressed her cigarette out on his forehead. When they returned to the limousine at the end of the evening,

nearing the Chelsea Hotel, Edie jumped out in front of a truck. Neuwirth grabbed her, pushed her through the slush of a New York winter into the hotel, and dropped her there.

Neuwirth was gone, but Edie found a new friend at the Chelsea. Heroin was always there for her. Heroin did not talk back. Heroin was loyal. And when someone shot her up, that moment was better than sex.

12.

Band-Aids Are Not Just for Wounds

One day in late March 1967, Chuck Wein appeared in Edie's room at the Chelsea with several associates wanting her to star in their movie *Ciao! Manhattan*. Wein had exploited Edie in all kinds of ways and had dismissed her from his life. That should have made her suspicious of what these men said and did not say.

One thing they assuredly did not tell Edie was that their first choice to star had been International Velvet, whose father vetoed the idea for his teenage daughter. It is also unlikely they mentioned Chelly Wilson, the queen of the 42nd Street–area porn theaters, who was a candidate to help fund the film. Or that at least one member of the group, Robert Margouleff, thought of the project as a "skin flick."

The Chelsea Girls had proven the commercial viability of a film about the New York underground laced with sex, salaciousness, and nudity, and that's precisely what Margouleff and his associates intended to produce. Needing more than sex scenes to hold the film

together, they planned to shoot the be-in in Central Park the next day. If Edie was going to star in this movie, she needed to agree immediately so they could put her in the first scenes.

Edie was high when she walked into the fifteen-acre Sheep Meadow and joined the ten thousand revelers on Easter Sunday. Moving beyond Warhol's modest 16mm Bolex camera, the filmmakers employed a professional 35mm camera and a dolly from which they could shoot down on the event.

Everywhere the filmmakers looked, something different was happening. Mixed in with families fresh from walking in all their finery in the Easter parade on Fifth Avenue was a massive gathering of hippies. This was their New York coming-out party. Young women wore flowers in their hair and paint on their faces and dressed in flowing gowns. Hundreds of participants joined hands and formed giant circles and circles within circles. They wrote "love" on their foreheads and chanted, "Love, love, love" as they jumped up and down. Kites danced in the air. Two men stripped naked but put their clothes back on when the police approached.

"Okay, Dave, your responsibility is going to be to watch over Edie," Wein told his colleague David Weisman.

Weisman had just met Edie, and he thought Wein was kidding. "Bullshit," Weisman said. "Come on."

The filmmakers shot Edie standing among the multitude, looking slightly dazed and talking to Allen Ginsberg, a high priest of the counterculture. They would have liked to have filmed more of Edie that afternoon, but she wandered off into the crowd. They could not find their star amid the swirl of humanity, the earliest indication of what it would be like working with her.

Edie's voice-over was written much later, when the radical hope on display that Easter Sunday had turned into something darker.

"That's the revolution of the youth," Edie said over the footage in an emotionally disengaged voice. "It's sort of like a mockery in the way of reality because they think everything is smiles and sweetness and flowers when there is something bitter to taste, and to pretend there isn't is foolish."

The next major scene occurred in and around the pool at the Ansonia Hotel on the West Side. Filming began on a Friday evening and continued for at least a day. The idea was to get the Superstars and others into the pool and out of their clothes—but to do that, they needed help shedding not just their garments but their inhibitions. Luckily, Wein and his colleagues had just the man.

The filmmakers had set up a charge account with Dr. Bishop, who was there before the cameras rolled, shooting up the cast. Dr. Bishop had once been a doctor at the US embassy in Paris and had served as the deputy secretary-general of the World Medical Association. By any measure, he'd had a distinguished career before setting up his unique practice in Manhattan. Now he was known as Dr. Feelgood—the same doc Edie had seen back in 1965. And as he moved from person to person at the Ansonia, adroitly injecting them, in the minds of almost everyone there, he was no junkie doctor but a hip professional giving his patients what they needed or what the producers wanted.

Brigid had brought her younger sister, Richie Berlin. Richie had never been in a movie before and was nervous. "Just carry on and give yourself up to total abandon," they told her. Richie was just as into amphetamine as her big sister was, so while being on a movie set was new, she was comfortable among the drugs. Still, she was edgy as she stood naked on the side of the pool, looking out on the raft. She was given the stage direction to get it on with Edie, who was standing next to her as naked as the truth.

"What do we do in this scene?" Richie asked Edie, though she knew the answer. "You're the star. I'm going to follow you. They're dying for us to sleep together in the film."

That called for more drugs. From a tiny satchel on the gold chain Richie wore around her neck, she removed some pills and gave one to Edie. "My dear, quel hoot that we should sleep together in Chuck Wein's film," Richie said.

Once the two women got on the raft, Edie jumped off and started doing backstrokes in the pool. Edie was a stylish swimmer, and Richie watched her for a while. Then Richie started having sex with an anonymous young man in a scene that did not make it into the movie.

When Edie returned to the raft, another nude woman lay there. She had a breathtaking physical presence. Susan Mary Hoffmann had a face so chiseled and well defined that it was beyond beautiful. Susan's blond hair curled down around her neck. Her eyes looked out on the world with a full measure of mockery. Her thin, pursed lips looked like they belonged on another face. In describing them, the journalist Sally Kempton wrote there was "an Irish Catholic nun in her lips."

Earlier in the year, Wein met Hoffmann one evening at Max's Kansas City, where she hung out in the front room fending off admirers. She was hoping to become a commercial artist, but these men did not have art on their minds. She could wallop her would-be admirer with a solid right fist if they did not back off. Hoffmann made money working as an artist's model, but she was serious about her art.

Wein was impressed with not only Hoffmann's face and body but also her intellect. Once she got revved up in a conversation and latched on to an idea, there was no stopping her. Hoffmann's mouth could not keep up with her brain, and the words piled up on one an-

other, crowding to get out. In all aspects she was a strange juxtaposition—she spoke with an upper-class accent and a truck driver's lingo. In a few sentences, she would go from sounding like Mother Teresa to spouting words so foul they would turn a nun to stone. She had the mind of a PhD candidate and the mouth of a fishwife.

Hoffmann was the eldest of nine children. She had five sisters and three brothers, and she was very close to several of her sisters. One of them, Mary Beth, lived in the city, and Hoffmann had brought her on set that day to take part in *Ciao! Manhattan.* Mary Beth was more sheltered than her older sister and was shocked by the things she saw, especially the out-in-the-open drug use. Dr. Bishop was ever ready to inject the cast and crew. Edie kept pulling a curtain so she could shoot up in a measure of privacy. Brigid had no such reticence as she poked herself in full view of everyone.

Things kept getting darker. The producers were eager to incorporate Susan Hoffmann's pretty sister in the movie. Their idea: Mary Beth would mimic being raped on camera. Susan came to the rescue. She agreed to lie beneath two men, who ravaged her. As the hours went by and the scenes got wilder and wilder, the semi-scripted film disappeared. The camera became a voyeur, recording a marathon orgy that could not be part of a publicly shown film. No matter, the camera kept rolling.

Margouleff's money to invest in *Ciao! Manhattan* came from his wealthy father. Periodically, Mr. and Mrs. Margouleff showed up with an enormous dog, bringing platters of delicacies, smoked salmon, caviar, and fruit punch. When Margouleff's parents arrived, the sexual activities shut down. Everyone acted like guests at a fancy cocktail party for a few minutes. As soon as the couple and their dog left, everything resumed.

Whatever reluctance she had initially, Edie was at the center of it all: "I was already so bombed I don't know how I got there. The

whole place turned into a giant orgy . . . every kind of sex freak, from homosexuals to nymphomaniacs . . . ah, everybody eating each other on the raft, and drinking, guzzling tequila and vodka and bourbon and shooting up every second. . . . Just going on an incredible sexual tailspin. Gobble. Gobble. Gobble. Couldn't get enough of it."

This film was about her, Edie Sedgwick. By going along with the filmmakers this weekend, she was letting this be her life. Nothing was witty or artistic about these scenes, but she let it happen as if it no longer mattered what she did or with whom.

<center>||||||||||||||||||||||</center>

Hoffmann had not seen the rushes and had no idea how she would come out in *Ciao! Manhattan*, but she had gotten the movie bug. She went to the Factory to talk to Warhol about being in one of his films. A man of instant judgment on matters like this, he saw immediately that Hoffmann had a charisma that might translate brilliantly onto the screen. He told her they were shooting *The Loves of Ondine* that day, about a gay man trying to go straight, and she could have a part. "Uh, you have to take your blouse off. . . . Uh . . . if uh . . . you don't want to do it, you can wait for the next," Warhol said.

That was Warhol at his shrewdest, knowing full well Hoffmann would not wait for an opportunity that might never come again. She was not without a measure of cunning herself. Remembering how, as a student in Paris, some young Frenchwomen, instead of wearing bras, covered their nipples with Band-Aids, she decided to do the same.

On the set at Henry Geldzahler's Upper East Side apartment, Hoffmann learned she had just one scene, inevitably a sexual frolic with Ondine. When Warhol asked her to remove her white satin blouse, she asked to be paid $30 a button. Warhol rarely paid his ac-

tors significant money, but believing he had agreed, she took off her blouse, exposing nipples demurely covered with Band-Aids.

Hoffmann told Ondine if he wanted to see the full monte, it would cost $97.82 a nipple. Ondine had no money in his pockets, but he pretended he did, and Hoffmann removed the Band-Aids. The scene was typical Warhol, as erotic as milking a cow.

Morrissey called Hoffmann after seeing the footage to tell her she was a "performing genius on the order of Mick Jagger, a comic Greta Garbo." The lines she spoke extemporaneously were better than anything Warhol's screenwriter devised for her, especially her put-downs—she called men "pathetic . . . creatures that need help." Morrissey loved it.

Hoffmann had a mesmerizing on-screen presence, unlike anyone in a Warhol film since Edie. She was also smart and witty—and completely fearless and uninhibited. This woman was, Warhol realized, a Superstar. All that was missing was a name. Warhol dubbed her Viva. The name was so fitting that she carried it after she left him.

Warhol insisted that Viva go out with him in the evenings. It was work, not play. "Oh, we have to go to this party," he would say. "We have to bring home the bacon."

Warhol called her in the early morning hours; she spoke, and he generally listened, sometimes for upward of two hours. They did not discuss matters such as the war in Vietnam or the plight of the Black man in America. They preferred intimate, personal subjects.

Viva often talked about her upbringing in Syracuse, New York. Her father, Wilfred E. Hoffmann, was a presence. Over six and a half feet tall, he stood over the world. A celebrated defense attorney, he was a performer outside and inside the courtroom. Wilfred Hoffmann also had a fearsome temper that he could not show in front of a judge, but that he let loose at home, emotionally abusing his oldest daughter more than any of her siblings.

The Hoffmanns had a large summer home on Wellesley Island in the Thousand Islands. There, sometimes, Viva flailed out against her father. On occasion, things reached the edge of hysteria. One evening, after a fight with him, Viva set off in her father's favorite boat; he chased his daughter in another boat. To escape, she jumped out of the boat and swam to shore.

In the Hoffmann home, the things that mattered were not said, and the things said often were not true. Viva reflected that "the behavior completely contradicted the spoken word." Viva's mother, Mary McNicholas Hoffmann, lived in her husband's darkening shadow. In Viva's eyes, her mother was a "brilliant woman who was always pregnant, and therefore probably never in her right mind." As her oldest daughter saw it, her mother was little more than a broodmare churning out child after child in deference to the mandates of the Catholic Church. Outside the home, Mrs. Hoffmann's few civic activities advanced the Church, including chairing the dining room committee of the Rosary Society of Most Holy Rosary Church.

In the post–World War II years, American Catholics were starting to shake off the prejudice that for so long held people of their faith down in US society. Catholics were in the ascendancy, and the Hoffmanns were one of Syracuse's leading Catholic families. Viva's father had a five-foot statue of the Virgin Mary in the house, likely to impress the priests who came to dinner.

Viva believed the Church sent the worst of the priests to upstate New York to get them out of the way, including a full measure of drunks and lechers. When one of them asked her to go for a walk in the woods, he pinched her and pushed his tongue into her mouth. But in Viva's young life, the Church was inescapable. She slept with a cross over her bed and went to Catholic schools to be taught by nuns. Viva was a precocious child, trying to make sense of the rigid,

controlling world around her. In school, she and her siblings were forced to sit and watch television as their fellow Catholic, Senator Joseph R. McCarthy, waxed menacingly about communist traitors in the Army-McCarthy hearings.

When Viva's mother left the house to go off to a church social event, she wore a girdle, stockings, and gloves, and her behavior was as self-contained as her dress. She was unfailingly polite, but her voice showed a subtle menace when she told her daughter to be quiet or cross her legs. When Viva had her first period, her mother warned her that she must not use Tampax, for it might give her sexual pleasure. Viva's brothers were another form of trouble. Viva said one of her brothers tried to rape her. She accused another of beating her up so badly in a parking lot that she called the police.

When it came time for college, the religious Hoffmanns were not about to send their oldest daughter off to a secular coed school, where temptation lay behind every door. Instead, they inscribed her at the all-women Marymount College in Tarrytown, New York. Overseen by the Religious of the Sacred Heart of Mary, the nuns taught the elite daughters of the Catholic Church.

The teachers at Marymount were as conservative and controlling as Viva's parents. In the ethics class, the priest posed crucial moral dilemmas. What should a virgin do if a man tries to rape her? Is it better to shoot him or jump out the window to your death? As the erudite priest explained, shooting the man would be a sin, but the Church would allow the young woman to jump out the window to escape him, even if the end was unfortunate. This didn't sit right with the feisty and independent-thinking Susan Hoffmann, but she did not attempt to challenge the precepts she was taught. Yet.

When the twenty-one-year-old college graduate arrived in Manhattan hoping to become an artist, the first thing Viva did was to

scrap her virginity as quickly and efficiently as she could. Then she set out to explore her sexuality with a stream of lovers like a grand buffet set before her. She lived with a photographer twice her age for a while, but when he jealously tried to control her every moment, she tossed him out of her bed.

In short order, Viva threw out her Catholic faith, too, and what she considered its endless hypocrisies. But the knowledge of that world stayed within her, and she was in good company at the Factory. Most of the people around Warhol were also lapsed Catholics.

One day, Brigid suggested she and Viva stage a skit. Viva would play the Reverend Mother, and Brigid would be one of her students at the Sacred Heart convent. Warhol gave Viva a black cape to don, so she looked like a proper nun. Brigid and Viva attacked the skit with verve, mocking the education the Church had given them. They satirized everything from the rituals to the lack of privacy. The longer they spoke, the clearer it became how much their Catholic education had affected them. They may have left the Church, but the Church had not left them.

Warhol was so enthralled by Viva's performance in *The Loves of Ondine* that he made her a regular in his films. He was intrigued by her and enjoyed nothing more than sitting back and watching her antics. Her intellect was dazzling—who else could talk like Churchill and then abruptly segue into a learned discussion of Tampax? And who else roamed the nighttime streets of the city in the strangest of places with the strangest of men and then talked about it in the most exquisite detail?

Mostly, people watched Warhol's films not because they were interested in highbrow art but because they wanted to witness lowbrow sex, and he gave it to them. For her roles, Viva came to work naked or half-naked. Viva did not have the voluptuous body of a

porn queen, but her lithe frame fit in perfectly with the anti-erotic nature of the films Warhol was producing. In certain circles, Viva's body was celebrated, or at least recognized. The magazine *Eye* wrote that Viva possessed "the best-known anatomy in town."

In *Bike Boy*, Viva has her amorous moments with a muscular, working-class motorcyclist played by Joe Spencer. Before stripping naked, she asks the handsome young man about his sexual proclivities. Finding a subject of common interest, she asks him, "Did you ever fuck on a motorcycle? If you can't do it to me on a motorcycle going sixty miles an hour, I don't think I'll do it at all." He seems unsure about the prospect. But life is a matter of small compromises. "What about going fifty-five?" she asks. "Better than nothing."

Since the success of *The Chelsea Girls*, Warhol's films usually opened at sex-exploitation or art theaters, rather than at the Cinematheque. In October 1967, *Bike Boy* opened at the Hudson, a nudie theater that had begun showing Warhol's films. "It opened yesterday at the Hudson Theater," the *New York Times* said. "It belongs in the Hudson River." Other critics were kinder. When the film opened in Los Angeles, it received favorable reviews including from the *Los Angeles Times*, whose review was less about the film than Warhol's "unique, darkly apocalyptic vision of mankind."

In Viva's next film, *The Nude Restaurant*, her comedic talents are in full view. The hour-and-a-half-long movie was shot in one day in October 1967 at the Mad Hatter, a New York restaurant. Everything was the same as on a typical evening, except everyone is naked save for their G-strings. Playing a waitress, Viva dominates the film with dark comedy that chronicles her life in the great city. This bare-breasted Candide picks her way out of one disheartening scene after another.

The *New York Times* reviewer considered *Nude Restaurant* as

miserable a piece of work as *Bike Boy*: "A bare denizen of the 'Restaurant' observes that she loves Warren Beatty but she hastily adds, giggling: 'I hope he never sees me in this film.' She shouldn't limit this just to Mr. Beatty." The *Village Voice* reviewer was gentler, calling Viva "the brightest of Warhol's lady prattlers."

13.

Come On Light My Fire

One day, the singer-songwriter Leonard Cohen visited Edie in her room at the Chelsea, where she was living with her cat, Smoke. Although Edie had already been burned once before in a fire she had caused, she set out lit candles everywhere, including on the mantelpiece. Cohen was into the occult, and he was disturbed. "These candles are arranged in such a way that they are casting a bad spell," said Cohen. "Fire and destruction." Edie had heard enough prophecies of doom. She told Cohen he was speaking nonsense. Cohen left and returned to his room down the hall.

A day or so later, Edie's room erupted in flames. Unable to open the door to escape, she retreated into her closet. When the smoke threatened to asphyxiate her, she grabbed on to the red-hot doorknob and made her way into the hallway, where she collapsed. Smoke the cat lay among the ashes. The doctors affixed Edie with cumbersome mitts over her burned hands.

Meanwhile, *Ciao! Manhattan* was still in production, and the

film's producer, Robert Margouleff, was in a fix. If he could not get Edie back on the set, his film would never get made, and all he would have for his money were some shots of an orgy and the be-in. That's the primary reason he let her stay in his apartment, sleeping on a mattress on the floor. She was taking heroin, amphetamine, and barbiturates, a fierce cocktail. Edie was a chain-smoker; the mattress caught on fire several times.

When Edie's mitts came off, the producers drove her to a mansion in Fort Lee, New Jersey, to shoot the next scene in *Ciao! Manhattan*. The beat guru Allen Ginsberg was back and was running around naked this time, singing Hindu mantras, one of the saner aspects of the day.

Edie was not about to set to work immediately. After insisting on doing her exercises, she wandered off, secreting herself in one of the rooms like a child's game of hide-and-seek. She finally felt ready to act, but made the director shoot her scenes repeatedly. When the moviemakers finally finished, she got in a car driven by the rock promoter Sepp Donahower and set off with him for California. So much for the rest of the movie.

By the time the couple arrived in Los Angeles, Edie was ready to move on from Donahower. She picked up immediately with singer-songwriter Dino Valente, who penned such songs as "Fresh Air" and "Let's Get Together." They stayed in the Castle, a wondrously neglected mansion in the Hollywood Hills often rented out to rock groups who could do little more damage than was already done.

One of the other guests at the Castle was Nico, who had just been summarily dismissed from the Velvet Underground. She had been waiting to go onstage for a performance in Boston when Reed told her she no longer was a group member. He had long taken umbrage that the beautiful, charismatic German actress/model/singer stood on *his* stage generating attention that he felt should have

been his alone. Nico was out. While Reed was at it, he wanted no more to do with Warhol managing the group . . . and come to think of it, he was not delighted with Cale, either. In short order, the Velvets broke up.

In Los Angeles, the rock manager and publicist Danny Fields introduced Nico to Jim Morrison, the lead singer for the psychedelic rock band the Doors. A troubadour of the counterculture, the twenty-three-year-old, long-haired Morrison wrote poetic lyrics that chronicled the lives of his generation. His manly beauty was so startling that people stared at him offstage as much as on. In that regard, he was the female counterpart of Nico, and they locked together in a love of overwhelming intensity. Morrison was the greatest and most profound of all her loves.

A flame that shines brilliantly rarely endures, and their love lasted no more than two months. High on LSD and hashish, they wandered the Castle in all their naked glory. The pleasure and the pain were equally profound, ultimately blending into each other. "We hit each other because we were drunk, and we enjoyed the sensation," Nico said. "We exchanged blood. I carry his blood inside me."

One day, Morrison led Nico to the tower that looked down on the city. He walked out on the narrow parapet in a dance of death. Then he nodded toward Nico and asked his love to join him.

By the end of July, the Doors' psychedelic single "Light My Fire" was *Billboard*'s number one, and fame was about to change Morrison's hippie-like life forever. Morrison fancied himself a seer and drove to the desert to take peyote with Nico. He read from such literary mentors as Blake and Coleridge and told her she had so much more within her and could write her own songs. He talked until the peyote took them somewhere far beyond talk.

Nico recalled the drug trip like a strange movie. "The light of the dawn was a very deep green, and I believed I was upside down and

the sky was the desert which had become a garden and then the ocean," she said. "I do not swim and I was frightened when it was water and more resolved when it was land. I felt embraced by the sky-garden."

Like so much drug reverie, a vision that seemed so profound at its heights made little sense in the merciless glare of the noonday sun. The same was true of their love. It was just too exhausting, and they fled from each other. During their liaison, Nico dyed her hair red to please Morrison. She kept it long after he died in Paris in 1971 of a likely heroin overdose, a legend in death as in life.

||||||||||||||||||||||

Warhol did not think much of the hippies, but they set forth radical promises of a sort unlike anything in American history. These cultural radicals believed that by dropping out, eschewing traditional politics, and living lives of love and freedom, they would change the world. Scott McKenzie's 1967 hit song "San Francisco (Be Sure to Wear Flowers in Your Hair)" was a pied piper. Thousands of young people—idealistic, open-minded, and up for adventure—streamed into the City by the Bay.

But as the hippie movement started moving into the mainstream, their idyllic vision began to darken and be co-opted by others who didn't share their values of peace and love. That summer of 1967, the multitudes who arrived in San Francisco with flowers in their hair discovered a Haight-Ashbury rife with sexual exploitation, drug overdoses, and predators exploiting their idealism.

It wasn't just in San Francisco that things turned dangerous. Riots erupted in Newark and Detroit that long, hot summer, sparked by incidents of police brutality and fueled by decades of inequality and political unrest, as blocks of the cities burned down. At the

same time, some of those in the anti-war movement had begun to question whether nonviolence would ever work to effect real change. Meanwhile, drugs and addiction were starting to move out of the underground and into the mainstream. At first, they may have seemed a way to boldly journey out of banal everyday life. But for many, drugs led to addiction, and the only answer was more. Everywhere, things were moving to extremes.

At downtown hot spot Max's Kansas City, as elsewhere, the atmosphere was changing. It wasn't an underground club anymore; the lines outside of those hoping to appear hip enough to be admitted and to dine near Warhol got even longer. The scene around the Captain's Table was wilder and stranger than ever. Young men stood on the tables, masturbating. Brigid shot up through her jeans, shouting, "I'm up." In a weird turn, Brigid started bringing a stamp pad to Max's to collect penis images from the back-room clientele, a task the anointed performed without leaving their seats.

One evening, Ultra Violet took off her blouse, exposing her braless breasts. To the jaded customers, her actions were met with a big ho-hum. That did not stop another Warhol follower, Andrea Feldman, from joining in with an impromptu performance that became her signature act. Andrea shouted, "It's showtime!" and stripped off her clothes, singing along with the jukebox. "Andy Warhol is my husband!" she yelled as she licked her nipples. That brought a cheer from the patrons.

No velvet rope cordoned off Warhol's table from the rest of the room, but almost everyone knew they were not to approach. Ronna Page was an exception. She thought she'd be welcome—after all, she had played a role in *The Chelsea Girls* and was a longtime hanger-on in the Factory world. But Warhol and his entourage were incredible snobs, and they snubbed her harshly time and time again. Something

was just *off* about Page. She seemed a bit too needy, desperate for acceptance. The Captain's Table had no room for try-hards. Still, Page lingered in their midst.

One evening, when Brigid decided enough was enough, she asked Page, "What are you doing here where you're not wanted?"

"You don't even say hello to me when I come to the Factory," Page said, as if that were an answer.

"Free me from more of your crap," Brigid said.

Brigid decided something had to be done to this hapless wannabe. She went over to Viva and said, "We gotta beat the shit out of Page." Viva was game. Then Brigid returned to talk to Page.

"I'm going to treat you so well from now on," Brigid said. "First, I'd like you to come with Viva to her apartment. We'll have some fun. We'll whip you."

That was not an invitation everyone would have accepted. But to Page, what was a little whipping if Warhol's two Superstars accepted her, and the threesome headed off together.

Once in the apartment, Brigid went into the back room to get what she called her lollipops, a collection of dildos that she laid out like surgical instruments. Picking one of them up, she turned it on so it buzzed like a leaf blower and told Page she would love it. "But first, my dear, you've got to take off your clothes," Brigid said. "Just take them off. Then we'll start whipping you. You're going to be a sacrifice to Andy."

The nuns of the Sacred Heart had educated Brigid and Viva. As much as the two women had distanced themselves from the Church, its rituals were embedded within them. No image stayed as alive as the crucifixion, and they set Page on a cross. They had no nails, but they had rope, and they tied her up on their makeshift crucifix.

Then Viva got her whip and lashed Page on her back with such force that it streamed with blood. As their supposed victim yelled

out louder and louder, Brigid and Viva had the melancholy realization that Page was shouting not in pain but in orgiastic screams of pleasure. As far as Warhol's two Superstars were concerned, the evening had been for naught.

When Brigid and Viva told Warhol about the evening, it was as if he had been there gauging the whipping. He loved such stories. Warhol did not admonish the two women, saying they might have killed Page, grievously injured her, or made her so angry that she would go to the police. As they told him this tale several times, he listened as if hearing it anew and recorded their every word.

Warhol would not have liked to be whipped on a cross, but he could turn from sadism to masochism in a twist of the wrist. He took on as his plaything Rod La Rod, a hulkingly tall Alabama teenager who roughed Warhol up in public. If La Rod could abuse Warhol to such an extent when others were watching, what did he do to him in the privacy of their bedroom?

Writing about it later, Warhol treated the whole business as an amusing game. La Rod would "grab me, and rough me up—and it was so outrageous that I loved it." Sadomasochism had become the vice of choice at the Factory.

<div style="text-align:center">||||||||||||||||||||</div>

*T*he *Chelsea Girls* had made Brigid Berlin famous in the limited environs of Lower Manhattan. As she pedaled down the streets on her bicycle, people waved to her. They had no idea that Rotten Rita had given Brigid the bicycle so she could be his drug delivery person and that she kept her stash of drugs under the seat. She found it terribly exciting, but one day she got busted, and while thanks to family connections she pled it down to a misdemeanor, that was the end of Brigid Berlin, drug dealer.

Her use continued, though. Brigid shot up herself and others

with pleasure and urgency, and without great concern for the cleanliness of the needles. That was how she ended up in a hospital during the summer of 1967 with hepatitis. This was no fancy room with catered meals this time, but a bed in a two-patient room in a ward full of heroin addicts.

On the morning the hospital discharged Brigid, a doctor followed by an entourage of interns evaluated her for the last time. The interns were handsome, and Brigid made up her face carefully for them. The lead doctor said this was the thirteenth time she had been admitted for drug-related reasons, and he could see that she had what could be the beginnings of liver cirrhosis. Brigid was unconcerned—this was but another amusing misadventure to recount to Warhol when she talked to him next. She received her hospital discharge papers and left.

Due to her hospitalization, Brigid had taken no drugs in a month, and when she got home, she was on an incredible natural high. She felt so good she could hardly believe it. And then she thought, *If I feel this way without amphetamine, imagine how I'll feel with it.* So she mixed amphetamine in a glass of water and, after drinking it, experienced the most fantastic jolt of her life. Speed was her drug, and there was no way she would walk away from it.

14.

Up Your Ass and Other Niceties

Anyone who spent much time walking around Greenwich Village was bound to be accosted by Valerie Solanas. She would thrust a mimeographed copy of *SCUM*, her feminist manifesto, into the passerby's face, asking for money in exchange for her pamphlet.

The initials SCUM stood for the Society for Cutting Up Men. Those who gave Solanas a dollar or two and started reading were confronted by a daringly provocative first sentence: "Life in this society being, at best, an utter bore and no aspect of society being at all relevant to women, there remains to civic-minded, responsible, thrill-seeking females only to overthrow the government, eliminate the money system, institute complete automation and destroy the male sex."

Those who read on often wondered—was this little woman bundled up in black clothes with a cap pulled down over her eyes a

revolutionary? Or was she a satirist mocking the world in which she lived?

When Solanas wrote, "Every man, deep down, knows he's a worthless piece of shit," some women might nod their heads in silent assent, but they would hardly go along with her solution. She believed men were colonizing women's minds, making them abject and subservient. To gain their freedom, women would have to eliminate the other half of the human race.

Solanas was not for killing *all* men. Those who admitted their worthlessness could become members of SCUM's male auxiliary, where they would be properly instructed. "SCUM will conduct Turd Sessions, at which every male present will give a speech beginning with the sentence: 'I am a turd, a lowly abject turd,'" Solanas wrote. Afterward, they had the option of going "off to the nearest friendly suicide center where they will be quietly, quickly, and painlessly gassed to death."

Mary Harron, who directed a film about Solanas, compares SCUM with the manifesto later written by Ted Kaczynski, the notorious Unabomber. For almost two decades, from 1978 to 1995, the Unabomber killed and maimed by mailing bombs to unsuspecting victims. Kaczynski believed modern society was so corrupt that his actions were right and good. Like Kaczynski, Solanas lived in a shadowy place where genius and madness reside in a doomed partnership. And like Kaczynski, her idealism would take a dark turn.

Solanas rarely talked about her upbringing. Her bartender father, Louis, was an alcoholic and an avid devotee of pornography. Full of ingratiating charm behind the bar, he appeared devoted to Solanas and her younger sister, Judith. When Solanas was four, her father and his dental hygienist wife, Dorothy, divorced. The two sisters went to live with their grandmother in Atlantic City. During the week, they played on the expansive boardwalk along the ocean

beach. On Sundays, they visited with their father, where he molested and abused his older daughter.

Solanas's father was the most important man in her life. How could she conflate this loving man with these acts she did not understand? In this working-class Catholic world, such despicable conduct was both unthinkable and unspeakable. To the nuns at the Holy Cross Academy, where Solanas studied until she punched out one of the sisters, such acts did not exist because, in God's world, they *could* not exist.

Solanas was fiercely intelligent, with a spirit and mind that far transcended the narrow world in which she lived. As she reached her teenage years, her behavior grew out of control as she sought to flee her inner demons. She shoplifted and did other little crimes. When Solanas became pregnant at fourteen, her mother brought up her daughter's newborn daughter as her own. That added another moral and emotional complexity to Solanas's life. She knew this little girl was not her sister but her child. But it was never spoken of, not even in the privacy of their home. The following year, Solanas became pregnant again. This time, the newborn was given away.

Few working-class girls of Solanas's generation went to college, but she was a nearly straight-A high school student and, in 1954, headed off to the University of Maryland, her way paid by her child's adoptive parents as a quid pro quo. There were not many openly queer students in College Park, and none like Solanas, a lesbian who occasionally slept with a man or two, and someone who, when offended, might strike out physically.

For Solanas, sex was devoid of morality. She made extra money as a prostitute as well as a cocktail waitress. A psychology major, she slowly developed the themes that became SCUM. A decade before Betty Friedan's groundbreaking *The Feminine Mystique*, Solanas was already speaking out about how a patriarchal society abused women.

Solanas went to graduate school, but it wasn't for her, and she ended up in Lower Manhattan. She sought to live around what she considered her own kind, but she soon discovered even in the bohemian Greenwich Village there was no one quite like her, and she was often alone. When she was not writing, she was often peddling mimeographed copies of *SCUM* on the street.

Whatever one thought of Solanas's audacious treatise, there was something courageous about an unpublished author caring so much about her work that, day after day, she suffered the humiliation of serial rejection by a public that hurried by, immune to her pleas. Having no money, she turned tricks, begged, or hit up her few friends to survive. Sometimes she slept in hotels, or sometimes on the street.

Solanas wrote a play, *Up Your Ass*, dramatizing the ideas she espoused in *SCUM*. The heroine and Solanas's alter ego, Bongi Perez, makes her journey through a world of largely dispirited characters. "Very fucky world we live in," Bongi philosophizes. "My only consolation's that I'm me—vivacious, dynamic, single, and queer."

Solanas wanted to get *Up Your Ass* to Warhol. To her, the underground filmmaker was the natural one to produce her play. Despite her studious aggressiveness on the streets of Greenwich Village, Solanas was a shy, withdrawn person who had to pull herself out of the shadows. Instead of thrusting her play in Warhol's hands at Max's or the Factory, she mailed it to him.

When Warhol scanned *Up Your Ass*, he worried the cops were setting him up for a bust. The play was no obscener than parts of a Warhol film. But he played around, provoking his audiences for both their and his amusement. Solanas was serious. She may have been a one-note Lenin, but she was a social threat the way Warhol was not.

Warhol chose not to respond. In February 1966, Solanas wrote him a polite letter asking him "to please return my script." Warhol

was constantly being hit up by people wanting all kinds of things from him, and he either lost Solanas's play or purposefully threw *Up Your Ass* away. It was not a grand crisis. Solanas had scores of copies, but he was her last, best chance at getting it produced. Conventional producers had dismissed her work as a disgusting aberration, and the play lay dormant.

Warhol ignored her, but the New York television host Alan Burke did far worse. Burke was a precursor to Jerry Springer, who made his considerable living mocking people and showing them at their absolute worst. Solanas went on the show to discuss lesbianism. She realized she had been set up as soon as she entered the set. The audience was full of people who thought lesbianism was a disease that must be stomped out, and Burke did much of the stomping.

The show's producer told Solanas she could use any language; if necessary, her offending words would be bleeped out. But when she said, "Men have fucked up the world," the audience gasped in disbelief, and the host acted as if he had been slapped in the face. When Solanas talked about her lesbianism, Burke chortled incredulously. "What's the matter, Solanas, can't get one?" he sneered. "Didn't anyone ever take you to the prom?" Solanas chased Burke off the set, throwing a chair at the host.

In August 1967, Solanas mailed another package to the Factory, including a letter-sized SCUM recruiting poster, with its picture of a presumably female hand giving the finger, the perfect symbol of Solanas's attitude toward the all-encroaching world. Solanas wrote Warhol, "Maybe you know some girls who'd like to join. Maybe you'd like to join the Men's auxiliary." That SCUM had no actual members was a subtlety unworthy of discussion.

A month and a half later, Solanas wrote Warhol again, including posters she asked him to put up in the Factory bathroom "and another for you to put under your pillow at night." She was gentle and

almost obsequious in her requests; that was yet another side of So-
lanas and a measure of what she would do to advance SCUM.

Solanas had an ingratiating manner, pushing herself forward
until she sat plopped in the middle of one's life. There was no secu-
rity or barriers to entry at Warhol's office, and Solanas progressed
from mailing items to Warhol at the Factory to spending time there
herself. That summer, she hung out at the Factory multiple times,
among the Superstars but not one of them. She could often be found
standing on the side of things, observing the goings-on. She and
Warhol interacted occasionally. She tried to engage him in her cru-
sade. As always, he was remote.

Despite his growing celebrity, Warhol did not try to isolate him-
self. He surrounded himself with an ever-changing entourage,
including so-called freaks and losers from all walks of life. He used
them to populate his movies, but they were also his extended family.
Many of them would have been lost without Warhol, and he might
have been lost without them and their interest and adulation, too.

Solanas was inching nearer and nearer to Warhol, but in the
swirl of people in his orbit, this small, dark person barely registered.
Yet she was watching and learning.

That summer of 1967, Warhol cut a deal with the Hudson The-
ater to show an erotic film in the Times Square venue. While he was
shooting the film, Solanas kept hitting him up for money. Warhol
told Solanas he would pay her $25 if she played a role.

I, a Man is a self-conscious rip-off of *I, a Woman*, a 1965 erotic
Danish-Swedish film that did lots of business, and not just in the
marginal theaters that typically showed such fare. The original film
told the story of Siv, a nurse who seeks to break through the conser-
vative constraints imposed on her by her parents and the conserva-
tive climate. She does this by running through a series of lovers,
deciding in the end that no one man can satisfy her. In Warhol's riff,

the handsome protagonist, Tom (Tom Baker), attempts to sleep with one woman after another, looking for the one who will truly satisfy him. There was plenty of room for cameos from Warhol's Superstars in *I, a Man.*

Nico had her star turn speaking to her would-be seducer in a tender, intimate voice, telling him, "I'd rather stand up." Ultra Violet steals her scene, or rather, her tongue does. For two and a half minutes, her obscenely long tongue flashes in and out of her mouth in a kissing scene Hitchcockian in length.

Solanas is the only one of the eight actresses whose scene is not in an apartment with Tom, the kind of man she believed populated the earth, a repulsive character devoid of human feelings except when he projected them to get what he wanted. And he wanted only one thing.

Solanas meets Tom on the staircase leading to her supposed apartment. She's dressed all in black and wearing no makeup; her face and clothing telegraph her ambiguous sexuality to the viewer. Unlike other women who are desperate to be wanted, she boldly confronts Tom without artifice or guile.

"Your instincts tell you to chase chicks, right?" Solanas says.

"Right!" Tom says enthusiastically.

"My instincts tell me to do the same thing," Solanas says.

When Solanas finished playing the role, she accused Warhol of not paying her.

||||||||||||||||||||

When Solanas made one of her periodic stays in a tiny room at the Chelsea Hotel, she had no idea that one of the other tenants was Maurice Girodias, the French publisher of the English-language Olympia Press. One day, she happened to read a "Notice to Unknown Writers" in the back of an Olympia book soliciting

manuscripts. The notice listed books by the publisher, including *Lolita*, *The Ginger Man*, and *Naked Lunch*. While Girodias published literary masterpieces that the bourgeois moralists considered obscene, among his other books was *Story of O*, a classic of twentieth-century pornography.

Girodias was sincere in seeking out unpublished writers. A lousy businessman who jumped in and out of bankruptcy and a man of volatile ups and downs, he understood the literary avant-garde. A self-conscious champion of women's rights, he grasped immediately that Solanas had unique talents. Although she had no examples of her fiction to show him, he offered her a $500 advance to write what would likely be an autobiographical novel. The book could have been as wildly provocative as William S. Burroughs's *Naked Lunch*. Girodias wrote a few sentences on a piece of paper codifying their verbal agreement. It was a daring act on Girodias's part and immensely exciting to Solanas.

That August of 1967, Solanas proudly took Girodias to the Factory to watch a screening of *I, a Man*. She had none of the hypocrisy that is a natural accompaniment to the drive for success. Solanas did not like the way Warhol treated his Superstars at the Factory, and she said so to his face. He was exploiting them, she argued—using them to enhance his own celebrity and paying them peanuts (if anything) for the privilege.

Solanas was also quickly losing confidence in her publisher, Girodias. She kept reading the supposed contract with him. The more times she read it, the more upset she became. No man could be trusted, and by her foolishly signing that paper, she believed, the Frenchman owned her. He owned her next novel. He owned *SCUM*. He owned *Up Your Ass*. Instead of going to Girodias to discuss if this was true, she filled with inner rage at his betrayal.

Although Solanas had ambivalent attitudes toward Warhol, she

did not hesitate to request a favor of him. She asked the artist to show the contract to his lawyer, Ed Katz. Warhol did not have to help her, but he did. Katz's assessment was clear: he said a few sentences on a sheet of paper was not a contract. It would not hold up in court for a minute.

That should have reassured Solanas, but her troubled mind was starting to play tricks on her. The way Solanas perceived reality, it was fine for the lawyer to *say* the contract was bogus . . . but he was a man, after all. Why should she trust him? And anyway, Girodias had probably paid him off.

It obviously wasn't going to work out with Girodias, so Solanas segued back to Warhol to get *him* to make a movie out of the *SCUM Manifesto*, starring none other than Solanas herself. Warhol had no interest in her polemic and was not about to join her revolution. But his message to her was anything but clear. His way of saying no was often to say yes and move on. He gave Solanas some encouragement, but in the end, nothing happened.

Solanas had come close to the opportunity to write a book she so profoundly desired, but her suspicions overwhelmed her. The acid of paranoia landed drip by drip in her psyche, slowly eating her sanity away.

15.

Lonesome Cowboys Riding High

At the end of January 1968, Warhol and his entourage flew to Arizona to shoot his version of a Western in Old Tucson, a set used in many Hollywood productions. The film is a custard pie in the face of the macho image of the cowboy, the last preserve of the traditional American man. In Warhol's homoerotic fantasy, tight jeans, high-heeled boots, and leather vests have a different meaning than in a John Ford film. There likely had been a script in New York, but all they had on the set were three pages of vague ideas.

Unlike Alfred Hitchcock, Warhol did not play cameo roles in his movies, but he was properly outfitted to walk before the camera in *Lonesome Cowboys*. He wore a jacket of intricately woven snakeskin and leather. A simple leather belt would not do. His was bejeweled. He topped everything off with an enormous twenty-gallon hat that overwhelmed his small head.

As excited as some Arizonans were about Warhol's visit, others were appalled. The sheriff was worried enough that he flew above

the set in a helicopter. The officer was too high in the sky to see that the sheriff in *Lonesome Cowboys*, Francis Francine, was a transvestite. The aircraft made so much noise that it risked drowning out the shooting. Viva convinced the sheriff to ground the copter. He settled for standing atop a water tower, spying on the proceedings with a telescope.

Viva is the only woman in the nine-person cast. She plays Ramona, a prostitute from the East who enjoys her work. As the film begins, Ramona makes love to Julian, a young stud played by Tom Hompertz. At this time a Warhol film was nothing without mammary glands. Time and again Viva's breasts appear like a Warholian signature as the couple fondles, although, as the *New York Times* critic wrote, Hompertz "acts as if he would prefer making love to himself." The scene ends as listless copulation appears about to begin.

After eight minutes, the film segues to Ramona on a dusty Western street, wearing a dark suit and standing next to her nurse, played by Taylor Mead. Five wranglers ride into town. It's not John Wayne and his ranch mates approaching Ramona but ersatz cowboys whose Western garb is more costume than outfit. "Should I get an eastern perm?" one cowboy asks. "You shouldn't use such greasy kids' stuff," another cowboy says.

In one scene, the cowboys topple Ramona off her horse, rip off her shirt so her breasts are visible, pull down her pants, and start to have sex. It appears nothing less than rape. "You're all fags anyway," Ramona says, an accusation that does nothing to deter them. It was a scene that if shot these days would be righteously condemned, not treated as an amusing digression.

Scores of locals watched the scene in appalled silence, including art students and children who wanted to see a movie being made. The onlookers realized immediately this was not *High Noon*.

"Disgusting pigs," says the naked Ramona/Viva. "Look at all these children shocked out of their minds."

When Ramona asks the transvestite sheriff to protect her, he says he has other, more important things to do.

"Like what?" Ramona asks.

"Well, there's cattle rustling," the sheriff says. "There's, uh, stagecoach robbing."

"What's more important," a philosophical Ramona asks, "my hymen or your money?"

Viva was a natural comedienne. *Vogue* called Viva the "Lucille Ball of the Underground," not a bad comparison. When the group flew back to New York after the weeklong shoot, Viva showed up at the Tucson airport without identification. She was not allowed to drink at the bar, hardly a significant intrusion on her liberty. But she was outraged. Instead of making nice with the authorities, she made a scene, saying she was among "famous people."

When *Lonesome Cowboys* played in Atlanta, it was reviled. Looking to have a handy list of degenerates and perverts, the police photographed the audience. There is no evidence whether they captured a few church deacons and school principals in their net.

|||||||||||||||||||||

The Factory had long been located at East 47th Street, but in late 1967, Warhol's landlord told him the building was being demolished and he would have to leave. That was not necessarily bad news. Warhol would never say it, but as far as he was concerned, he had reached such an elevated level of fame that he needed a more conventional studio, without crazies and half-crazies running in and out, providing constant distraction.

The new quarters at Union Square West that Warhol moved

into in early February 1968 were physically far closer to the hip world of Greenwich Village than the previous Factory had been. Still, the new Factory was light-years away from the bohemian world. When one exited the sixth-floor elevator, the tall windows, wood floors, white walls, and glass-topped desks gave no hint that this was the studio of one of America's leading artists. The back part of the space was painted black and housed the darkroom. There was no grubby pay phone on the wall, but a stylish white phone for Warhol's use.

Warhol rarely fired people or dismissed them from his sight. They just seemed to know it was time to go. Most of his cohorts from the old days had left. La Rod never made it down to Union Square, pushed out by Paul Morrissey, who was intent on cleaning house. Ondine, too, picked up on the cues that Morrissey and Warhol were giving, and he left for good around that time as well, mumbling curses. Billy Name tried to restart work at the new studio, but soon realized it was time to go. And Malanga was no longer a central presence. They had been wild, intemperate, and irrational, but they also had been passionate, inspired, and daring, and all of it was gone, the good and the bad.

|||||||||||||||||||||||

Solanas had almost no friends and nowhere to live, and as the winter winds blew, she flew to San Mateo to stay with her sister. That did not work out well, and she left to wander the streets of San Francisco and Berkeley peddling SCUM. Solanas believed the two most important men in her adult life—Warhol and Girodias—had betrayed her. She carried her obsessions with her to the West Coast. While in California, she wrote letters to both men, addressing them as "Toad." Despite being a writer, Solanas did not seem to understand that words had consequences. If you said or wrote certain things, they forever changed what the person thought about you.

On February 1, 1968, Solanas wrote Warhol: "I really do believe that if you didn't have your lies + deception + notarized affidavits, you'd shrivel up + die." A week later, she wrote him again: "Toad—If I had a million dollars, I'd have total control of the world within 2 wks; you + your fellow toad, Girodias, (2 multi-millionaires) working together control only bums in the gutter, + then only with relentless, desperate, compulsive effort." Three days later she penned yet another message: "You can shove your planefare up your ass; I now have a little sum saved—enough for, not only planefare, but a few other things as well." Solanas's biographer, Breanne Fahs, believes "a few other things" is likely an ominous reference to buying a gun.

After several months, Solanas returned to New York. Terrified of getting on a plane, she traveled across the country on a Greyhound bus. Back in Lower Manhattan, she tinkered with her play, but was so distressed that she could not truly focus on her creative efforts. Warhol and Girodias were evil men who conspired to destroy her. She could not get them out of her head.

||||||||||||||||||||

Viva had moved up to an apartment on East 83rd Street, but she was still part of the Warhol scene. On a Sunday evening in February 1968, she went down to Greenwich Village to attend a dinner party for Warhol that the St. Johns were giving. Everyone was there, including Marco and Barbara St. John; their son, Marco Jr.; Andy; Brigid; Warhol's business manager, Fred Hughes; and the *Merv Griffin Show* booker Paul Solomon, who had become part of the entourage. Brigid arrived late because she had to wait for her amphetamine dealer to show up.

St. John had reason to think he was as much the star as anyone in the room. A versatile actor who could play almost any role, he went on to costar alongside Julie Harris on Broadway in the romantic

comedy *Forty Carats.* At the same time, he had a recurring role in the daily soap opera *As the World Turns.*

Barbara cooked curry and meringues and did whatever she could to make this a festive occasion. Viva arrived with marijuana that she said was so strong a single toke was enough to keep one high for the entire evening. Viva did not need grass to loosen her tongue, but she set off on a restless tirade, mocking the woman upstairs, who was so terrified of Viva that she would not exit her apartment when Viva was around.

Warhol could not stand the back-and-forth of social patter. During the evening, he mumbled a few remarks and had one monologue. He told how, that afternoon, he had been watching a live television program featuring stars from the forties, and he went on in extensive detail about what he had heard as if it were some revelation.

Brigid was worried that there would be no more meringues and she would be left out. Barbara promised to bake a second batch.

Little Marco scurried around the living room. Many bohemians raised their offspring as little adults, the way children were brought up in the Middle Ages. Marco Jr. was privy to everything and was not shuttled off to bed. He took umbrage against Viva. "Pig!" he kept shouting at her. "Pig!"

At one point in the evening, Viva talked about living with Marco and Barbara and considering herself his second wife. "Yeah, Jesus, real cute woman," St. John recalled. "And crazy as a loon, but I mean, in a good way. We had a great time together. But I wasn't going to leave Barbara for Viva. The whole group of us was kind of wacko. We all loved each other. So, it was interesting for everyone."

St. John was a player. He had several girlfriends, but he loved Viva. There was excitement and energy about her like no one else, but by her admission, she was disturbed. She told the others she had

suffered two nervous breakdowns and was worried she was going insane.

At eight o'clock one morning late that winter, Barbara Goldsmith rang Viva's doorbell at her Upper East Side apartment. The thirty-six-year-old journalist was writing a profile of Viva for *New York*, a new magazine. Goldsmith believed the truth lay in the details. She noted down—and probably recorded—everything that morning, including the fact that Viva answered on the third ring. A talented and ambitious journalist, Goldsmith would go on to write several bestsellers, including *Little Gloria . . . Happy at Last*, about the custody battle over Gloria Vanderbilt. At this point, Goldsmith was trying to make her name as prominent as some of her subjects.

Viva had been getting all kinds of attention lately, and she was a perfect subject for Goldsmith. Viva was rising out of the underground into media consciousness, just as Superstars Baby Jane and Edie had done before her. The *Village Voice* named her the new Garbo or Dietrich. The *Times* settled for a comparison with Lynn Redgrave. Viva was hoping to parlay this into a big-time career. A major profile in this fledgling magazine was another step in the process.

As Viva journeyed from Greenwich Village to the Upper East Side, she brought with her the studious sloppiness that was often one of the marks of the bohemian soul. "Oh, God, don't look at this place," Viva exclaimed. "I haven't cleaned up or picked up a thing in months." Viva walked across the living room with ballet-like moves, never touching the rumpled dresses, underwear, magazines, newspapers, laundry bags, and an iron spread across the floor. In the bedroom, it was a mystery how Viva slept on a sheetless double mattress covered with the remains of pancakes, a carton of orange juice, makeup, a makeup mirror, clothes, books, and photographs. The answer: she did not sleep on the bed, but on the living room sofa.

Viva told Goldsmith that Warhol wasn't treating her right, comparing him at times to Satan and even using that name for him when she was riled up. And she was, more and more often, riled up. One morning the journalist went down to the Factory with Viva. They found the downstairs door locked and Satan nowhere to be seen. That infuriated Viva, and she went looking for a pay phone to call someone upstairs.

The neighborhood was such that the first five pay phones Viva found were disabled, but finally, she found one that worked.

"Listen, you bastard, this is Viva," she screamed into the phone, as if there could be any doubt. "Get down here fast and open that goddamned door."

When the person who answered hung up, she called Warhol's home phone, and when he did not pick up, she gave the answering service a considerable piece of her muddled mind.

"I'll show them," Viva raged. "They kicked me out, and I'm going to lock them in." With the limited tools of a bobby pin and a dime, she tried to take off the doorknob. As she worked at a fevered pace, Warhol showed up.

"Why don't I have a key to this place?" she screamed in Warhol's face. "I'm not treated with any respect around here."

Warhol replied in his standard way to threats, a nonplussed non-reaction. That only revved up Viva's anger further. She flung her handbag at him, striking him in the face.

"You're crazy," Warhol said. "What do you think you're doing?"

Goldsmith spent hours with Viva and had a treasure of material to show for it. In her piece, Goldsmith quotes Viva saying on the set of *Lonesome Cowboys* that she slept with a different man every night, one night bedding two of her fellow actors. She said she had many partners because "I hate to sleep alone. I have nightmares, and I like to have someone in bed to cuddle up." Viva opined on drugs, saying,

"I prefer mescaline and peyote to synthetic drugs. I can't see anything wrong with taking something that actually grows out of the ground." Viva later said none of this was true.

Janet Malcolm famously wrote: "Every journalist who is not too stupid or full of himself to notice what is going on knows that what he does is morally indefensible. He is a kind of confidence man, preying on people's vanity, ignorance, or loneliness, gaining their trust and betraying them without remorse." Viva had a full share of mental health problems and did not know how to control what she said. She spewed an endless stream of consciousness, uninterested in limiting her words.

Viva was a quirky individualist seeking out new patterns in her life, and she probably could have gotten away with her wildly intemperate comments. The images did her in.

Viva was having breakfast when the doorbell rang. She had forgotten she had an appointment with the photographer Diane Arbus, so she answered the door wrapped in a white sheet.

Arbus did not do glamour shots. She had a long career as a commercial photographer but, like Warhol, she used that as a springboard for more complex and ambitious artistic work. She was already becoming known for her stark, unflinching style of documentary photography that leaned into the darker and more macabre elements of mid-century life. That *New York* editor Clay Felker assigned Arbus to take the photographs suggested he planned to portray Viva as a strange creature that should be pushed back underground.

Viva said she would dress and put on her makeup before Arbus shot her. "No, no, don't get dressed," Arbus said. "I'm just shooting your head."

Viva lay back on the sofa, her nude body stretched from one end to the other. Arbus had Viva roll her eyes so they showed little but

white emptiness. Despite her promise, Arbus photographed Viva's entire body.

Goldsmith also writes the photographer took pictures of Viva having sex with Marco St. John and his wife, Barbara. St. John has no recollection of this. But Arbus's lying about not photographing Viva naked was so deceitful that Janet Malcolm might have added photography to her list of morally reprehensible professions.

On the day that Viva was scheduled to go on *The Merv Griffin Show*, she saw a copy of the April 29, 1968, issue of *New York* for the first time. Her quotes in "La Dolce Viva" were bad enough, but that was nothing compared to the pictures.

A nude Viva lay on the couch, her body scrawny, her breasts nearly nonexistent, her eyes nothing but whiteness. The image was profoundly disturbing and exploitative. Hordes of *New York*'s advertisers fled, and years afterward, editor Felker said publishing Arbus's photo had been a "terrible mistake."

On such a day, Viva could not bring herself to go on *Merv Griffin*. But the booker convinced her, saying she would have the opportunity to tell the viewers what a terrible thing had been done to her and how much was false. On the show, she said she was going to sue Arbus for libel, but she did not do so and tried to flee the damage. But it was no good. She was supposed to be a model for *Vogue*, but when editor Diana Vreeland saw the *New York* nude photo, she rescinded the invitation. Other opportunities disappeared, and in some ways, Viva retreated into the underground world.

16.

The Doors Are Locked

JUNE 1968

By mid-1968, the carefully curated world that Warhol had created was starting to come apart. For close to a decade, Warhol and his entourage had been downing amphetamine. It was not a drug that left one ranting in the gutter, but it wore down the human spirit. There had been suicides and still almost no one backed off from the drug. In the early years the original Factory had been a place of glorious freedom, where all kinds of wondrously strange, unique people congregated. In the new Factory the doors were shut to any but those who contributed to Warhol's enterprises.

Warhol had the fame he always wanted, and with it had come money beyond his imagination, and with that money came people who worked for him because they wanted a slice of the fortune. With the fame came overwhelming jealousy, artistic colleagues who instead of celebrating his achievements looked at him asking, why not me? He had always been a loner, but never had he been so alone. He had no idea the number of people who did not wish him well.

One of those was Valerie Solanas. He had done nothing wrong to her, and she had no reason to want to wish him harm. But he was famous and that was reason enough. When he met her on Union Square West outside the Factory on June 3, 1968, he had no reason to fear her. She was just another of these wannabes and hangers-on who plagued his life. It was no big deal that she came up the elevator with him. He wasn't going to squander his late afternoon talking to her. Instead, he started to talk to Viva on the phone.

Solanas pulled out her Beretta and pointed it at Warhol, and at first no one paid any attention. But as the first shot rang out, Warhol understood immediately what was happening.

"Oh, Valerie!" Warhol shouted. "No! No!"

The bullet went wide of its intended mark, but Solanas responded by shooting at him again, and once again missing. Warhol tried to crawl under a desk, but as he did so, Solanas moved nearer. She was so close that her third shot hit his abdomen. The projectile struck his lung, then ricocheted through his esophagus, gallbladder, liver, spleen, and intestines before exiting on his left side. Warhol said he felt "a horrible, horrible pain like a cherry bomb exploding inside me." He later told friends, "It hurt so much, I wished I was dead."

Warhol screamed, writhing in agony as Solanas retreated. Believing Warhol was as good as dead, Solanas moved on to other targets. As far as she was concerned, any man in the room deserved to die. The art critic Mario Amaya was cringing on the floor and was the next logical target. Unlike Warhol's bullet, the shot that hit the critic whizzed through his body, doing hardly any damage. Even after being hit, he was in good enough shape to jump up and try to flee.

Solanas saw Fred Hughes wincing in abject fear. Warhol's business manager was symbolic of the noncreative, bureaucratic figures

who had started hovering around Warhol, partly driven toward him by the scent of money. Shooting him would not do that much good, for others would be ready to take his place.

Solanas had neither time nor interest in considering that. She stood before Hughes with her pistol pointed at him and said, "I have to shoot you." This task had been set before her, and she had to follow through. At this, Hughes dropped to his knees. "Please don't shoot me, Valerie, you can't," he pleaded. "I'm innocent. I didn't do anything to you. Please, just leave."

Hughes had reason to think his plea worked, for Solanas walked over to the elevator and pressed the button. But then she returned. Solanas stood so close to Hughes that aiming at his forehead was no problem, but when she pulled the trigger, the gun jammed. Solanas had come prepared. She pulled her backup revolver out of a paper bag and prepared to send Hughes off to the great beyond. Just then, the elevator door opened. "There's the elevator, Valerie. Just take it!" Hughes said.

Solanas entered the elevator. The door closed behind her.

When Viva, who had been on the phone with Warhol, heard a loud noise in the background, she thought it was a whip snapping. Gerard Malanga loved to crack his whip; everyone knew that. Was it him? When the phone went dead, Viva called back. That was when Hughes told her Warhol had been shot and the floor was covered with blood.

The Factory was a surreal place where truth and fantasy melded seamlessly. Viva did not believe anybody had been shot. It was just another of the games people played there constantly—tricks and in-jokes that fooled the yahoos. Viva was not going to fall for that. She went back to having her hair done.

When the elevator door opened at the Factory, the terrified inhabitants feared it was Valerie returning to create more mayhem.

Instead, it was a familiar figure, Malanga, and two of his friends, picking up a check for $50 to pay for a flyer to promote Malanga's program at the Cinematheque. Warhol lay bathed in blood.

Nobody had been closer to Warhol than Malanga. He knew the one thing he must do for his longtime colleague was to reach his mother to tell her before reporters began to call. Figuring a subway was faster than a taxi, he rushed to Warhol's townhouse. Within minutes, the news of the shooting was on the radio. As Malanga arrived at the residence, the phone rang.

Not believing anything untoward had happened, Viva nonetheless decided to go to Warhol's studio. By the time she arrived, an ambulance had taken Warhol to Columbia Hospital. As the elevator opened, she saw blood on the telephone cord. That brought it home to her, and she passed out.

As soon as she woke up, Viva called Ultra Violet, who felt her fellow Superstar was on LSD and this was some sick drug vision.

When Nico heard on television that Warhol had been shot, she lit fourteen candles. That was the number hotels used to avoid thirteen, and she prayed for some good luck.

No one knew the dire seriousness of Warhol's condition. He had been pronounced dead, and only a desperate, daring operation saved him.

<p style="text-align:center">||||||||||||||||||||</p>

That evening, Solanas went up to a police officer in Times Square and turned herself in, handing the cop her two pistols. "The police are looking for me," she said. "They want me. He had too much control over my life."

As Solanas was shuttled in and out of mental institutions, she called Warhol's office asking for $20,000 for her defense fund and wrote him letters: "You can ride along only so far with Viva, Bridgit

[*sic*] Polk and the rest of your trained dogs. Having worked and associated with me, you've had a taste of honey."

It was not until June 1969 that the state declared Solanas sane enough to stand trial. Although Solanas was an attempted murderer, she pled guilty to "reckless assault with intent to harm" and was sentenced to three years in prison, minus the one year of time served.

||||||||||||||||||||||

S olanas faced a measure of justice, but Warhol's sentence never ended. He was doubly wounded. Every moment, he felt some measure of physical pain. The psychological pain never left him, either. He feared the cruel acts of strangers. He did not like to be touched or for people to get too close to him. He worried any package was a bomb. "He always thought he was going to get poisoned or shot or blown up," said Brigid. He played the same Andy Warhol he had always played in public, but it was ever more of an act.

In 1970, Warhol sat for a portrait by seventy-year-old Alice Neel, one of his favorite artists. Neel was a realist who painted her subjects with searing truthfulness that never lost its underlying humanity.

Afraid to go alone to Neel's studio in Harlem, Warhol asked Brigid to accompany him. To pose for Neel, Warhol took off his shirt. That was just the beginning of his exposure. This man, who believed profoundly in truth but often fled from it, lay his entire being before Neel.

As Warhol sat there, Brigid took several Polaroid snapshots. In them, Warhol looks like St. Sebastian in El Greco's painting in the Prado Museum. Warhol does not have arrows in his naked chest but has the same look of resignation as the third-century martyr.

Brigid's photos are memorable, but Neel's *Andy Warhol* is a

masterpiece that captures Warhol's emotional essence. His legs are so thin they seem unlikely to hold up the rest of his body. The lower part of his stomach is held in by the corset he wore the rest of his life. His sagging breasts could have been those of an elderly woman. His face is red, his eyebrows gray, and his eyes closed. He is diminished and vulnerable.

One might think that Warhol, so aware of his mortality, would only attempt great things for the rest of his life, but not so. For the last few years, he had worked primarily as an underground film-maker. He had made scores of films that charitably would be called semipornographic. Now he set out to fulfill his longtime dream of doing "a movie that was pure fucking, nothing else." He initially was going to call the film *Fuck*. It was the first commercial movie featur-ing full sexual penetration.

Having had enough physical exposure in Warhol's films, Viva was ready to say no, but then she looked at him. "Andy came out of the hospital a different person," she said. "The doctor who operated on him said his insides were all falling apart. He was in horrible pain and never complained. Hardly ever. And I felt sorry for him. And I said, 'Okay, let's do it.'"

Viva and Louis Waldon were the two actors in what was little more than a hundred-minute stag film. Bohemian living had taken its toll on thirty-year-old Viva. Her mildly disheveled hair was gray in places. She still had that unique profile and, at times, still had the charisma of a star. She was willing to make the sleazy film, doing something no actress had done before, but Andy paid her almost nothing. At one point, she contemplated selling Warhol's ad-dress book with its bullet hole and his bloody clothing to get some money.

Warhol's people had purchased the wrong film stock. That gave the color a blue-green tint. In the classic Warholian manner, Andy

took what in any other production would have been considered a disaster and turned it into an artistic plus, renaming the film *Blue Movie*. But to Warhol, it would always be "the fucking one." To argue the film had socially redeeming value, he exploited a bit of political dialogue in the film and said *Blue Movie* was "about the Vietnam War and what we can do about it."

Viva and Waldon do not squander their time in foreplay, kissing, cuddling, and exchanging words of affection. In the first part of the film amid a desultory conversation, they get on with the job at hand, Waldon not even bothering to take off his black socks. The sex is about as erotic as amoebas mating, but it delivered on the promise—real, unsimulated sex.

The film opened in Greenwich Village at the Garrick Theatre in July 1969. That's where George Abagnalo, Warhol's newest and youngest employee, moonlit as an assistant to the manager. Morrissey had hired the then-sixteen-year-old high school student in July 1968 to run errands, maintain scrapbooks of film reviews and ads, and design the handmade posters used outside theaters showing Warhol's films. He did so in part because of Abagnalo's knowledge of cinema.

After his stint at the Factory, the teenager hurried down to his second job at the Garrick. On July 31, 1969, he stopped short just before walking into the theater. "The manager stood looking through the glass doors and motioned me not to enter," Abagnalo said. "He was afraid if I walked in the door and said I worked there, the police would have arrested me."

Abagnalo had arrived amid a bust by the vice squad, who had received word of *Blue Movie*'s content and had arrived to shut it down. Standing in the street, he watched the manager and the other staff members get taken away.

Though *Blue Movie* is the first film depicting full-fledged sexual

intercourse to be shown in a theater, Warhol thought it "ridiculous" that authorities shut it down.

||||||||||||||||||||||

The park at Union Square had once been an inviting place where parents brought their children for romps, lovers walked arm in arm, and seniors sat on the benches contemplating life. By the time Warhol moved his studio to Union Square, the park was a spot to be avoided by respectable people. Many of the benches were broken. That hardly mattered, for nobody would sit there unless they were looking to buy heroin, cocaine, or marijuana from one of the ever-present dealers who roamed the park—or were willing to risk getting mugged by one of the many junkies who made it their home. Warhol was not responsible for the scene at Union Square, but he had helped create an atmosphere in which drugs were one of the accoutrements of a hip life.

Warhol's new offices were a world away from his life at the original Factory. His corporate side had taken over. Everything was controlled. Whatever he had once been, Warhol no longer had a sense of the artist as an exalted being living above the mundane struggles of commerce. "The new art is really a business," Warhol said.

And for Warhol—whose fame and infamy had skyrocketed in the wake of the assassination attempt—business was good. Although he continued to produce some original art, such as his celebrated portrait of Mao, and he spent time reworking some of his earlier art, from this point forward Warhol became primarily a commissioned portrait painter. His staff would start with a photo taken by Warhol of a CEO, a rich royal, or an heiress. They had the silk-screening process down to a science. Sometimes, with nary a touch from Warhol, they produced a flattering portrait—for which the subject would happily pay the famous artist up to $50,000.

Some looked at this commercial spectacle with dismay. Critic Barbara Rose thought future generations might see Warhol as "the holy whore of art history who sold himself, passively accepting the attention of an exploitative public which buys the artist rather than his art, which it is perfectly willing to admit is trash."

"Andy doesn't believe in art," reflected Brigid. "He's the first one that will say to you, 'Can't you find someone to get me a $40,000 portrait commission? I will give you a good chunk, dear, a good chunk.'" Warhol's new employees benefited profoundly from his new direction. Several of them became wealthy. They weren't about to criticize the money machine Warhol had created.

Brigid was uncomfortable with much of what she saw happening. "I think Andy is a business genius," she said. "I don't think he's an artist. He's in another field all of its own." The Factory was never where one talked about art, but now it was all about the art of the deal. "He gets me really upset when the only thing he can talk about is money," Brigid said.

17.

The Last Superstar

In June 1969, a year after Solanas shot Warhol and Amaya, the curator returned to the Factory to interview the artist for a magazine story. Warhol was late, and Amaya spent a good hour observing the scene. This post-Solanas Factory was a controlled setting for a man full of endless anxieties and apprehension—almost completely unrecognizable from what it had been just a few years before.

The elevator opened into a vestibule and Dutch doors that unlocked with the touch of a buzzer. The large main room was mostly empty except for two desks. A typist sat in an enclave transcribing tapes, the only obvious work going on in the Factory. The office was as neat and clean as an operating room.

While Amaya was musing about all the changes and his dreadful memories of the shooting, Warhol finally arrived. The two men shared a terrible bond, and Amaya wanted to discuss it. "I still can't believe it happened, Andy," Amaya said. "It was like a Magritte

painting for me, with everything being so real and yet so totally un-real at the same time."

"I can't remember much about it," Warhol said. "Only the noise, the noise was so terrible, with those loud shots and then everyone screaming and shouting at once."

That day changed his life forever, and Warhol did not like reliving the pain. Amaya had come to interview him, but Warhol was in control, and he quickly segued into talk of more amusing matters.

"I don't know why we can't get Candy Darling in on this piece," Warhol said. "In fact, the whole piece could be all about her. She's terrific."

Darling had an exquisite sense of timing and came through the door precisely at that moment. She wore a black dress and had stun-ning blond hair and looked like a forties film star. Darling was her own creation. When she got herself together, she was a triumph of femininity. She wore heavy makeup, but no heavier than Joan Craw-ford or Bette Davis, and her skin was alabaster perfect. Her eye makeup was inspired, and her legs, well, they were sublime, but it was the whole presentation that was so stunning. She was a pres-ence, and the room changed when she entered it. That's largely why Warhol liked to go out with her in the evening.

Darling was the last of Warhol's Superstars. The others liked some measure of celebrity, but all Darling cared about was stardom. She knew she belonged in a pantheon alongside Kim, Liz, Lana, and the other immortals. Although she had never met them, they were her family, whose loves, scandals, and tragedies were hers.

Forty-seven-year-old Judy Garland had just died, and Darling wore mourning black. Judy had tried to kill herself before, but this time, her handlers said she died of an accidental overdose of barbi-

turates. Whatever the truth, no one would ever forget Judy singing "Somewhere Over the Rainbow" in *The Wizard of Oz*, and on this gray day, the melody hung over the city.

"I thought we were going to Judy Garland's wake," Darling said. "It's at Campbell's Funeral Home, across the road from the Metropolitan Museum on 81st Street. There's a big thing in the paper about it."

"Liza Minnelli has insisted that no one will be allowed to wear black," Amaya said. White was the color of choice. It was as if, by fiat, Garland's daughter could transform the funeral into a First Communion.

"We can go around the corner and get me a white dress," Darling said. "I look just swell in white. Veronica Lake wore white in *Bring on the Girls*."

Not about to splurge on a dress for his new Superstar, Warhol grabbed a taxi with the others to take them to the street outside the Frank E. Campbell Funeral Chapel. Thousands stood eight abreast, waiting patiently for their moment with Judy. A *New York Times* reporter who walked the long line described the crowd as "thousands of elderly women, weeping young men, teenaged girls, housewives, nuns, priests, beggars, cripples and hippies." In other words, everyone except heterosexual adult men.

Warhol did not like being alone, but he also did not like being lost in the anonymity of a large crowd. As he shuffled slowly forward, Amaya continued to ask him questions. "You know, some people might get the idea that you're obsessed with death," the curator said. "The Marilyn pictures, the Disaster series, the Kennedy pictures, your own near-murder, and now Garland's funeral."

"Oh, no. Really?" said Warhol. "Oh, I don't want to give that impression at all."

Since the shooting, Warhol fled from death as if it were a contagious disease. As he stood amid the massive crowd, he became increasingly anxious.

After an hour and a half, they were about to enter the funeral home when Warhol said, "Oh, let's leave. This is boring." It wasn't boring at all, but that was his code word for anything he did not like.

And so they left, and Darling did not have a chance to see Garland lying with peonies shaped in a rainbow above her white-and-gold coffin. She could not see silver slippers on Judy's tiny feet or her hands resting on a prayer book. And she could not stand there for a moment communing with a grand star to whom she felt such kinship.

||||||||||||||||||||||

Darling was born James Slattery on November 24, 1944, and lived in Forest Hills, Queens, for her first years. Her father, John F. Slattery, was a compulsive gambler. He worked as a cashier at New York racing tracks. That was like an alcoholic tending bar. He lost so much money gambling that he rarely brought home a whole paycheck. To provide for Darling and her older half brother, Warren, Candy's mother, Theresa (Terry), had no choice but to work. She headed into Manhattan each morning to the Empire State Building for her job at the Jockey Club.

John and Terry liked to drink, and so did their friends, so they often went out to bars. At the beginning of the evening, John was a gregarious being. But once he got enough whiskey in him, he became surly and mean. Sometimes, he turned violent, beating up his wife and abusing Warren, Terry's son from her first marriage. Darling dealt with this the only way she could, by becoming a psychic recluse.

The first film Darling saw was the 1955 biblical epic *The Prodigal*,

starring Lana Turner as the heathen seductress Samarra. Producer Dore Schary said *The Prodigal* was the worst movie he made at MGM, a considerable statement given the competition. All ten-year-old Darling saw was the exquisite Lana, and tried to replicate her.

Darling dumped enough blue food coloring into the bathwater to turn it Technicolor blue. Then she got her mother's plants from the living room and set them on the bathtub's side, creating her version of the Middle East. After placing her mother's expensive ocelot coat on the floor next to the tub, she put on eye shadow, covered her head with a yellow towel to look like Lana's blond hair, and stepped demurely into the water. When she got out, she stood on the coat as she put on her mother's high heels.

In 1957, the Slatterys divorced, and the diminished family moved to Massapequa Park, Long Island. That Candy's mother could not understand what was happening to her child did not diminish her love for her.

In high school, Darling did anything to stay home and avoid the amused disdain from so many of her classmates. The young men shunned her, and the young women treated her as an unwanted outlier. "I have lived most of my life starving for affection. Spiritual and emotional hunger," Darling wrote in her journal. "I have lived my life through movie stars."

Better than going to school was pretending she was sick and spending the day before the television. She loved the *Million Dollar Movie* series on Channel 9 in the evening. After watching Kim Novak in *Picnic*, she became obsessed with the young actress, one of the first divas she adored. Who in the world would want to go to school when you could disappear in a movie?

"Someday, I'll be a movie star," she scribbled in her diary. "That's it. And I'll be rich and famous and have all the friends I want."

Darling dropped out of Massapequa High School at age sixteen

and entered the DeVern School of Cosmetology in Baldwin. Even before graduating, she worked part-time in her friend Lorraine Newman's beauty parlor. Darling entertained customers with her imitations of Marilyn Monroe. She had the actress down perfectly, assuming her identity, speaking in Marilyn's sultry, wispy voice.

Darling created dramatic hairdos that sent her customers out into the humdrum world of Long Island newly reborn. Some women were ecstatic, while others were outraged at Darling for trying to transform them and their lives. While she worked for a year as a hairstylist, she renamed herself Candy Darling, a movie star's moniker.

In the sixties, there was no social media Darling could use to help her understand what she was feeling and no organizations to help her on whatever course she chose. She was alone with profound feelings of womanhood. But she figured it out—slowly, haltingly, authentically.

A secret life is a hidden life, and it is unclear when Darling started taking the train into the city, changing her clothes in the bathroom, applying makeup, and emerging as a young woman. To her, Manhattan was Valhalla, a mystical city where everything was ventured and nothing was denied. In the urban streets, she sought out her kind.

Darling learned that for her, the safe space was Greenwich Village, where for the first time she found other people like her. The heart of the scene was Christopher Street, where the queens sashayed along like they were marching in the Easter parade. Among them, almost no one replicated a woman as well as Darling.

Darling studied womanhood for years, working through movie and fashion magazines. There was no female gesture, no nuance, that she had not appropriated. It wasn't perfect. If her stubble showed through her thick makeup, that was a problem. And so were

her teeth. About half of them were gone. To promenade as a star, she had to keep her mouth shut. Then there was that outgrowth between her legs that she called her "flaw." That was the biggest problem of all.

In all her years in the city, Darling never had her own place. Dependent on the casual largesse of friends and acquaintances, she traveled from one apartment to another, sleeping on cots, mattresses, whatever, sometimes in places beyond squalid. However she lived, and no matter how much she contributed to the mess around her, she always managed to go on the street the next day looking as if she had awakened in a suite at the Plaza. It was hard to find high heels for her large feet, and sometimes her shoes were run-down, but the eyes quickly moved up to the rest of her.

Darling was not about to follow in her mother's footsteps and take some miserable nine-to-five job. She took a position as a file clerk for a couple of months before she quit. The teenager preferred making money turning tricks. But no way would Darling be anything like a streetwalker. She had others arrange her "dates." Approaching it like a business, she gave her customers what they wanted as best she could. And she was so good at adopting femininity that the illusion for her customers—that she was a young woman—was completely convincing.

The johns loved it when Darling dressed like a Catholic schoolgirl in a pristine white blouse, a little tie, and a short skirt. That was exciting enough, but when she told them she was fourteen, they were beside themselves with anticipation. Then she told them the bad news. She was having her period and would have to limit their pleasure to oral sex.

These were often disturbed, dangerous men. If they thought Darling was a woman and discovered otherwise, there was no telling their response. But Darling lived by that illusion, whatever the cost.

The danger was not just in engaging in prostitution. In those years, it was illegal for a man to dress as a woman. Darling had less to worry about than other members of the trans community. "When people talk about how courageous Candy was, I always insist she really wasn't," said her friend Abagnalo. "Other transsexuals could never pass. They would walk down the street wearing a dress and be subject to tremendous hostility. But because Candy almost always passed, how much courage did she need?"

That did not mean she was accepted. Even in the bohemian world of Greenwich Village, people like Darling were mocked and derided, sometimes banned from gay bars that wanted nothing of their kind. That was Darling's life wherever she went. As she saw it, "I've been treated with incredible cruelty since the day I was born, and I have always remained nice," always the lady.

In the endless street life of the Village, sooner or later, everyone met everyone else. That's how Darling met her trans friend Holly Woodlawn. Darling also linked up with Jackie Curtis. Big, bold, and brash, Jackie straddled the sexes. She/he was a playwright who churned out one sensationalist, overwrought off-off-Broadway play after another. The three were soon linked in an unshakable bond.

18.

The Dying Swan

Warhol had an astute awareness of dress: not just designer names and styles percolating up from the street in the sixties, but how dress was a key to character. He was walking in Greenwich Village one August day in 1967 with his new business manager, Fred Hughes, at the height of the Summer of Love. Hippies were almost as ubiquitous in the Village as in San Francisco's Haight-Ashbury. They made bold statements about life in their tie-dyed shirts, painted faces, and rummaged clothes. Warhol fancied that art could be almost anything, and these hippies were their own artwork.

Walking ahead of him was a very different kind of couple. It was uncanny the way Warhol could decipher sexual identity hidden from almost anyone else. The person with the long brown hair was a man, yes. But his gorgeous blond partner, although brilliantly portraying a woman, was also a man. Hers was a stunning presentation,

high heels like stilts and a sundress with one strap fallen around her arm, an invitation to the dance.

Warhol began talking to the intriguing couple. It turned out the dark-haired man was Curtis, an off-off-Broadway playwright. But it was Candy Darling who intrigued Warhol. "I could see she had real problems with her teeth," Warhol said, "but she was still the most striking queen around."

In his world, Warhol was as understanding of what his audience would accept as Walt Disney and Johnny Carson in their worlds. In his early years of underground filmmaking, he would not have walked into the glittering parties on Park Avenue with Darling on his arm. But all that was changing. As Warhol said, "People began identifying a little more with drag queens, seeing them more as 'sexual radicals' than as depressing losers." He was quick to understand that Darling could be a glorious addition to his growing entourage of beautiful, intriguing people.

The following month, Warhol saw Darling make her theatrical debut in twenty-year-old Jackie's Hollywood burlesque *Glamour, Glory, and Gold* in Bastiano's Cellar Studio. Darling wanted to be a movie star, not a mere actress, but she was willing to act onstage if the road to stardom led across the off-off-Broadway theater boards. The *New York Times* reviewer appreciated her performance: "A skinny actress billed as Candy Darling also makes an impression. Hers was the first female impersonation of a female impersonator I have ever seen."

Darling knew she was a star and deserved appropriate treatment. The indignities she sometimes suffered appalled her. One evening she headed into the Stonewall Inn with her friend Jeremiah Newton. The grubby, Mafia-controlled bar was the kind of place gays were relegated to if they wanted to spend an evening with their own kind. It was not even safe there. One evening in June 1969, cops

busted the tavern, taking patrons away in cuffs. The customers rioted in an outburst that became a crucial watershed in the movement for gay liberation.

All Darling wanted to do was get into the bar, but the doorman would not let her enter the establishment. "If I let you in," the doorman said, "pretty soon I'll have to let you all in, and what d'ya think will happen?"

"What do you mean by 'you all'?"

"I mean all you drag queens."

"How dare you!" Candy exclaimed. "What do you think this dump is anyway? The Côte Basque?"

Darling struggled to figure out her identity. "I am not a genuine woman," she wrote in her diary. And for all that she had done to transform herself, it took considerable courage to admit as much. "But I am not interested in genuineness." Of course Darling was interested in genuineness, but where did it lie, and how could she reach it? "What can I do to help me live in this life?" she asked herself. Beyond stardom, she sought love and genuineness, but in what secret enclave was it hidden?

No matter who dismissed her or what sordid mattress she had to sleep on to have a place to rest her head, Darling had the confidence of a grand diva. She acted the star long before she was one, and when she finally achieved some measure of stardom, she acted far beyond her legitimate stature. Darling was her own obsession and could be singularly dismissive of lesser beings. Nothing fascinated Candy more than Candy.

|||||||||||||||||||||||

Darling got her lifelong dream of being in a film in *Flesh*, directed by Paul Morrissey and produced by Warhol in 1968. After being shot by Solanas, Warhol largely gave up filmmaking and

turned almost everything over to Morrissey. *Flesh* was disjointed and sexually exploitative enough to be a Warhol film. Made to satisfy the needs of an audience that enjoyed watching movies full of nudity, *Flesh* had a coherent plot, until then a no-no in a Warhol film.

For that reason alone, Morrissey considered himself a far better director than Warhol. "Andy not only did not try to put direction in, he was incapable of it," Morrissey sneered. "He didn't even think in sentences, only disconnected nouns and fragments."

In *Flesh*, Darling pops into one scene featuring her dear friend Jackie Curtis and Geri Miller, a topless dancer. The three appear to be prostitutes in a brothel, but they aren't telling. In her striped dress and scarlet lipstick, Darling watches as Miller performs oral sex on Joe Dallesandro, the star of the film. Morrissey had an elevated commercial sensibility, and *Flesh* earned far more money than *The Chelsea Girls*.

Along with her cohorts Curtis and Woodlawn, Darling starred next in the most intellectually daring Warhol film. It was originally called *PIGS (Politically Involved Girls)*, mocking Solanas's SCUM (Society for Cutting Up Men), but Warhol decided on a less provocative title, *Women in Revolt*. The premise was a savage satire of women's liberation extremists.

Darling plays a socialite with the intriguing name Candy Darling, who has a rare problem among Park Avenue's residents. She is having an affair with her brother. "You've made me old before my time!" Candy yells at him. Incest will do that to you.

Darling decides to dump her sibling and become a movie star. Her father is not happy. "I'm Candy Darling, and I can do it on my own," she tells Mr. Darling, shaking her blond hair and speaking with the I-don't-give-a-damn élan of Joan Crawford in *The Women*.

"Why should I be second best to any man. I want to be first best. I want to be a star. The women's liberation movement showed me."

At the film's end, a journalist interviews Darling about how she became a big star. She gives Curtis a great deal of credit, calling her "the biggest PIG of them all." The reporter asks a profound philosophical question: "You made these great epics with no words, no dialogue, no speaking parts, always fucking the directors. If you're supposed to be a liberated woman, why can't you make a movie unless you fuck around?"

The reporter, played by Jonathan Kramer, accuses Darling of being a miserable, unhappy woman, a lesbian who slept with her brother. She did not even attend her parents' funeral after they committed suicide because it conflicted with her shooting schedule. These accusations set Darling off. She tells the reporter to get out and starts hitting him. He attacks her back. More powerful than Darling, he beats her to the ground.

As poor Darling lies writhing in agony, the reporter stands looking down on her. "I got the story I came for," he says. "Goodbye, Candy." Candy calls out for help. The photographer, played by George Abagnalo, steps forward. In a scene worthy of the Marx Brothers, he tries to lift her, but she is too heavy, and they fall. He gets up and drags her off camera by her legs.

Women in Revolt might have found some measure of commercial success, but the distribution was poor, so the film did not do well.

Warhol also had to contend with the stars of the film wanting more money. His new nickname was Granny, and Granny did not like paying people. When they came beseeching him, he wrote small checks, and when they returned asking for more money, he often made himself scarce.

Warhol liked being called Granny. Abagnalo got him a senior

citizen's discount card in the name of "Granny Warhol" for Walter Reade Theaters, though he was not nearly old enough. Warhol was delighted and at least once presented his card at the box office to see a film.

Julia Warhola had lived with her son for almost two decades, but in the months after the shooting she began a steady decline. Sometimes she wandered aimlessly in the streets, having no idea where she was. It was clear Julia was suffering from some measure of dementia, and Warhol felt he could no longer take care of her. He arranged for his mother to go back to Pittsburgh to live with his older brother Paul and his wife. It became too much for Paul, too, and Julia spent the last fifteen months of her life in a nursing home, hoping that Andy would visit. He called almost daily, but never returned to the city of his birth. When Julia died in 1972, Warhol appeared curiously unmoved, his primary concern that the funeral be as cheap as possible. He did not attend the services.

<div align="center">||||||||||||||||||||||</div>

Darling appeared as the blond siren in *Women in Revolt*, exuding the on-screen charisma of a star, but she felt her presentation of herself as a woman was incomplete. She was not about to have gender-affirmation surgery, but short of that, she was willing to do almost anything to complete her transition.

In March 1970, Darling had a hormone shot and began twice a day taking Premarin tablets, which are themselves estrogen hormones. She quickly moved on from Premarin to twice-a-month shots of the powerful female hormones Delestrogen and Delalutin. She did not have the money to buy the hormones all the time. Although it was not good to start and stop such serious treatment, she had no choice. She understood that there could be severe side effects

to all this, but she was in a battle to enhance her feminine being and was willing to use almost any weapon available.

That spring, Darling also planned to have a procedure to end the mustache that appeared sometimes on her upper lip. "God is guiding me into this," Darling wrote in her diary. "I think after my beard is removed, I will have an operation on the Adam's apple, then a skin peeling."

Although Darling never made another film with Warhol after *Women in Revolt*, she often went out on his arm. When Darling entered a scene, all eyes turned toward her, like a hundred flashbulbs going off. She was finally, slowly, becoming a celebrity in her own right.

In October 1971, Warhol and Darling arrived at the premiere of the film *Some of My Best Friends Are . . .* in a white limousine. Darling had a starring role in the movie about a group of self-pitying queers bemoaning their fate on Christmas Eve in a gay bar. The film may have been abysmal, but no one played the cinema queen better than Darling. When she walked into the theater in her stunning white gown and fur, it was as if a golden goddess had descended into mundane Midtown Manhattan.

Early the following month Darling flew out to the Hollywood of her dreams with Warhol and Morrissey for a showing of *Women in Revolt*. "Andy and I mobbed at Gauman's [*sic*] Chinese last night," she wrote friends back east. "Signing loads of autographs."

As much as Darling adored being around this world of stars, there was an underlying melancholy. *Myra Breckinridge* was the role of a lifetime for a transsexual woman. Based on a scandalous novel by Gore Vidal, the film chronicles the adventures of a gorgeous transsexual who has had gender-affirming surgery. Raquel Welch made a disaster of the title role in one of the worst films of the decade.

If only Hollywood had let a trans woman play a trans woman, Darling would have had a breakthrough role in the history of filmmaking and a triumph for the queer community.

Despite Warhol's reputation for stinginess, he could be generous if the recipient did not aggressively beseech him for money, and he could bestow it on them as unexpected largesse. Warhol gave Darling the $150 an appointment she needed to get a new regimen of more potent hormones and pills. They did their job, shrinking her penis into a nub, raising her voice even further, and diminishing her facial hair.

Warhol was not done with his munificence. Knowing that Darling's teeth cursed her life, he paid for a series of caps. It was a kind gesture, but Darling still had about ten missing teeth. That meant she always had to open her mouth in a manner that did not expose that embarrassment.

Meanwhile, Darling's star continued to rise. She flew to Germany to star in *The Death of Maria Malibran*, a film about the short life of the legendary Spanish opera singer. Avant-garde director Werner Schroeter turned the movie into a series of delirious tableaux. Darling was a diva in her own right, and she walked through the film like a 1940s movie star who had mysteriously descended into nineteenth-century Europe.

Although Darling had roles in any number of obscure films and off-off-Broadway plays, her most impressive part was as the bewitching, slutty Violet in the 1972 off-Broadway production of Tennessee Williams's *Small Craft Warnings*. This play was not Williams at his greatest. Darling's role as Violet, a forlorn prostitute, did not have the unforgettable resonance of Blanche DuBois in *A Streetcar Named Desire*. Darling was nonetheless superb in the role, holding her own with professional actors, performing a significant role in a play by America's leading dramatist.

Darling was a woman of emotional extremes, moving from giddy heights to startling lows. "I do not know happiness," she told her friend Newton. "I know only despair." But another day, another movie prospect, another lover, another party, and all was right with the world. Through it all, she believed she was destined for greatness, telling a friend to hold on to her letters because "someday they are sure to be worth money."

<hr>

Several times a month, Darling took the train back to Massapequa Park and a cab to the modest house where she had grown up. She brought almost none of her friends back with her. Darling's mother still lived there. The place was messy, and there was little food in the refrigerator. Darling's pink bedroom was just as it always had been, with movie magazines stacked everywhere. The room was like a museum; Darling slept in another bedroom rather than disturb anything.

In the spring of 1973, Darling's new agent got her an opportunity to be the opening act at Le Jardin, a hot new nightclub at the Diplomat Hotel on West 43rd Street. She had never thought of herself as a nightclub singer, but she fancied herself a star who could do anything, and this was a new direction with few limits. The pay was incredible, more than $1,500 a week.

To be near the club, Candy stayed in a room at the Diplomat. Within a few days, the cluttered disarray was so bad the maid would not enter. But Darling walked out of her room as the glamorous Candy Darling, queen of all arts, imperious to all, including, on occasion, her closest friends.

Stars are always late. On opening night, Darling walked out on the stage at least two hours after the scheduled time. She sang ballads movie stars sang. She didn't have much of a voice. She was a

personality. That's why the crowds came to see Darling for her weeklong gig.

Darling's stomach was so swollen that she had to wear loose-fitting clothes. She was convinced that it was just an ugly attack of gas. Nothing to worry about. Darling was so used to ignoring the minor indignities she suffered on her journey to full womanhood that it was not clear when she asked her doctor about the bulge in her stomach, and when she learned it was cancer.

<div align="center">||||||||||||||||||||</div>

Darling lived ferociously for a while, running from the dark specter that haunted her. One evening, a few months later, she went to Le Jardin, which was no longer a nightclub but a wild disco, the precursor to Studio 54. Although she was suffering the debilitating consequences of chemotherapy, Darling danced with abandon. One hardly noticed the two men holding her up.

When Darling was in Manhattan's Cabrini Medical Center, she asked her friend Newton to find a photographer to capture an image of how she wanted to be remembered. He brought back Peter Hujar. The photographer was no Avedon or Arbus, but Hujar had the sensibility, the sensitivity, and the awareness to capture an immortal photo. Darling and Hujar were partners in this venture. Darling lay on her side, framed by white flowers, playing the dying swan. Next to her was a dark rose.

Darling wrote a "To whom it may concern" letter to be read after her death. She said she was ready to die. "I am just so bored by everything," she wrote. "You might say bored to death." The disease was stripping her of her very being, and life was no good any longer. "I will never forget you, Andy," she wrote. She concluded: "I wish I could meet you all again."

The off-off-Broadway playwright Robert Heide came to visit.

The garlands of white flowers so surrounded Darling's bed that she felt it was already like a funeral. "Bob," she asked, "do you think I will leave some kind of minor following or legend behind me?"

As the end neared, Darling called Campbell's to see if they would allow her to have her funeral there. The funeral home was the place for stars like Valentino and Judy Garland, where she felt she belonged. She had no money, and as so often in her life, for her final act, she depended on the kindness and generosity of friends.

When twenty-nine-year-old Darling died on March 21, 1974, there were not the lines in the street outside Campbell's there had been for Garland, but any number of people came to pay their respects. The funeral services in the same room where Garland's body had lain were filled to overflowing. Warhol was not there.

Out in the street stood an array of drag queens. On this of all days, they probably could have talked their way into Campbell's, but preferred to stand outside, where they usually stood, and mourned Darling as profoundly as anyone inside. As Darling's casket was carried out and placed in the hearse on Madison Avenue, a Rolls-Royce limousine carrying the aged Gloria Swanson passed regally by. Did Swanson even know who Darling was? Or had she come this day to pay respects, one star to another?

19.

The Eternal Mystery

Since the shooting, it had become a rite of passage for newspaper feature writers to come to the Factory to profile Warhol. One day in June of 1969, it was Joseph Gelmis's turn. The *Newsday* movie critic generally did not do profiles, but Warhol was irresistible copy. The story was a big enough deal that Gelmis brought a *Newsday* photographer with him.

It took Gelmis no time to measure Warhol's physical condition. He first noticed Warhol's sad, lusterless eyes; listless, distracted manner; and "anemic pallor." Although Warhol was only forty, it was apparent the shooting had drained much of his life.

Gelmis had just turned his recorder on and started interviewing Warhol when Brigid showed up. None of Warhol's Superstars spent more time around him than Brigid did. She pulled out her recorder and began taping the reporter who was taping Warhol. Then, when the photographer took out his camera, Brigid pulled out hers and shot the photographer shooting Warhol.

Warhol ignored Brigid and continued talking to the journalist. Then he saw a scene he had observed many times. "Look at Brigid," Warhol said. "What are you doing, Brigid? You're taking off your clothes."

Having squandered enough film on Warhol and the reporter, Brigid turned to a far more interesting subject. Standing in front of the floor-length mirror, she shot Polaroid color photos of herself in her considerable half-naked glory.

Attention was Brigid's favorite food. In January 1968, she took over the Bouwerie Lane Theatre in the Village for her one-person show: *Brigid Polk Strikes! Her Satanic Majesty in Person.* The performance consisted of her lying on a couch on the stage, calling various people, including her parents, and broadcasting the conversations to the audience.

Brigid's parents had no idea what their daughter had done. That was not enough revenge. She sold tapes of her talking to her parents for $25 a piece to Warhol, who used the dialogue in his play, *Andy Warhol's Pork.*

The play is a satire of life in the original Factory, with characters based on Warhol, Viva, and Brigid. After a short run in New York, *Pork* moved to London in August 1971. On the second evening, as droves of customers walked out, one theater lover sat in a back row with an enormous pair of binoculars, watching the scenes of group sex, masturbation, lesbianism, and sexual assault with evident pleasure.

Before the critics drove *Pork* out of the West End, calling it among other bouquets "the nearest thing to a theatrical emetic we are ever likely to see," a couple from New York, who had evidently not read the reviews, chanced into one of the last performances. As they tried to make sense of it all, they had the disturbing realization

that the obnoxious lesbian character was excoriating parents who sounded distressingly like their good friends the Berlins. The Berlins may have been the self-involved, shameless, selfish snobs their daughter said they were, but Brigid's assault on them turned her parents into sympathetic figures who deserved better.

Brigid's temper was like a tsunami rising from a still sea, striking the innocent and guilty alike. One afternoon, she came into the Factory, marching forward with amphetamine-fueled energy. Abagnalo was sitting at a table where Brigid joined him.

Warhol entered the room and asked Brigid to elaborate on gossip he had heard.

"I'm in a very bad mood now, Andy," she said. "I'm having my period. Leave me alone."

"But I want to know if . . ."

"I told you I'm in a very bad mood!" Brigid yelled. "Just get the fuck out of here! Leave me alone!!!"

"But . . . but . . . but . . ."

"I mean it, Andy, get the fuck out of here!"

Warhol stood there, a withered, exhausted look on his face beyond exasperation.

Then he turned and left.

Abagnalo was stunned. "You can't speak to Andy that way," he said. "He's one of the most famous artists in America. This is *his* Factory. This is *his* space. You shouldn't talk to him like that."

"I don't give a shit."

Brigid was always on edge. Shooting up amphetamine made her focus on life within life, making trivial details fascinating. Toys, how she had come to love them. She would go to the five-and-dime store and stand over the various items, focusing on G.I. Joes, Barbies, and jack-in-the-boxes for hours. No matter how often she poked

herself, she was never high enough, never the way she wanted to be, and that was an irritant. But amphetamine was glorious stuff, glorious.

Brigid had always been neat. Now she was compulsively tidy, spending hours cleaning her room at the George Washington Hotel. It did not do simply to vacuum the rug with her Singer vacuum cleaner. First, she had to cleanse it with Old Glory Extra-Professional-Strength shampoo, scrubbing the carpet in tiny sections. Then she began vacuuming, starting at the end of her bed and moving on to the rug. When she finished that job, she looked for another. The closet. The drawers. It was endless.

Brigid's years of amphetamine addiction had taken their toll. Her feet hurt, probably because she suffered from chronic venous insufficiency, a disease common among long-term heavy drug users. In one conversation, Brigid told Viva she had become mad, full of crazed suspicions. The only solution was to go into rehab, but she was not about to do that and prove her parents' caustic evaluation of her correct. Brigid's situation got so bad that, at one point, she contemplated suicide, but still, she sought no help.

The first ritual of Brigid's day was calling Warhol. None of his other friends dared to do that. It was not so much a conversation as an endless monologue. Brigid's soliloquies often went on for an hour or more. Warhol zoned in and out.

Brigid provided Warhol with mild diversions, but she was profoundly troubled. She needed help, but neither Warhol nor anyone else was there for her. If she was to get out of her dark world, she would have to do it herself.

||||||||||||||||||||

Nico was in a bad place. She had named her first solo album, 1967's *Chelsea Girl*, to play off her part in Warhol's popular

movie. The title song, written by Lou Reed and Sterling Morrison of the Velvet Underground, journeyed through many of the scenes in *The Chelsea Girls*. The film is a voyeuristic exploration of people Warhol considered to be degenerates, but Nico's rich rendering of Reed's and Morrison's songs can be read as a lament for lost lives.

Nico wrote none of the songs, but they are all hers. She turned each one into a poignant essay in sadness. But it was an odd album— not rock and roll, not a collection of romantic ballads or operatic rifts, but something so different that it could not be easily understood by mainstream music audiences. And Nico did not want to go out on a tour to promote the album. The audience, she feared, would look at her beauty but would not hear her songs. She was an impossible promotional partner, showing up late to events and media, or often not at all.

Her record label, Verve, was no longer interested in the singer, and Nico went to Elektra for her next album, of her own songs produced by John Cale. *The Marble Index* is a daring album released in November 1968. The former Velvet Underground violist did a remarkable job of creating a new, innovative sound that combined his grounding in modern European music with flashes of Tibetan chants and even Russian folk. But as for Nico's surrealistic lyrics— as artistically ambitious as they were, they were often incomprehensible.

The Marble Index hardly found an audience. It did not help that the cover image was not the exquisite blond beauty the world knew, but the darkest of brunettes, with thick black makeup around her eyes and sunken cheeks that made her look haunted.

At thirty, Nico was forging a new image for herself, starting with thick-soled, handmade Russian boots. She always wore pants and now, over them, swirling capes. Her clothes were often a mishmash of black and brown that seemed not discordant but a mark of nature.

As she walked on the streets of New York, the tall woman looked like a creature of the nineteenth century who had just arrived across the steppes of Russia.

Realizing that her career as a recording artist was likely ending, Nico decided to return to film to make her personal artistic statement. Her first opportunity was not playing a role but writing the music for a French quasi-underground film, *Le lit de la vierge* (*The Virgin's Bed*), directed by the provocative artist Philippe Garrel. Nine years younger than Nico and the son of a famous French actor, Garrel bonded with Nico immediately, and they were soon lovers. In Garrel, Nico found a serious artistic visionary—someone with whom she could confront the emptiness of the universe with immortal art. Garrel was no Jim Morrison; Morrissey described the director as looking like "Laurence Olivier doing Richard the Third. He was all hair with a pointed nose sticking through."

As Nico embraced Garrel, she had terrible news to face. The drugged-out Brian Jones was discovered at the bottom of his swimming pool in July 1969. Then, the following February, her decimated mother died in a Berlin clinic. Nico had done almost nothing for Grete in her last declining years and did not attend the funeral. She had thought she was alone before, but without a mother, she was alone in a new way.

Nico and Garrel stayed for a while at the Chelsea. An artist in all things, he made Nico's clothes from scratch and further transformed her image. Her hair was now orange-red and cut mannishly, and her dark clothes hung balefully on her tall, stately body. Nothing remained of the Nico known primarily for her beauty.

It is unclear which of them started shooting heroin first, but they were partners in this, as in everything. "I have found the way to turn my shame about my mother into feelings of pleasure that I can

dream I am in paradise with her," Nico wrote a friend. "I have found a way to turn day into night."

When heroin enters your house, she rarely leaves, and when she does, she leaves her residue over everything. The couple continued making films, but their primary creative activity was getting and shooting heroin, getting and shooting heroin, getting and shooting heroin.

Nico still sang sometimes. When she did, it was in a voice of overwhelming melancholy.

20.

Just Another Party

Warhol had lost contact with Edie. Then, one day in 1970, she called the Factory, and they started talking just like old times. Warhol seemed delighted to reconnect and spoke with a level of warmth and intimacy that was rare with him.

"Can you believe it, Edie?" Warhol said. "When I was shot, we were in the hospital at the same time, and you wrote me that beautiful letter."

"I prayed for you, too, Andy."

Edie had been in hospitals for months. She had gone to see a fancy gynecologist in New York one afternoon, who asked her if she would like to take acid. It was no longer her drug, but she was game for anything. They drove up the Hudson in his Aston Martin and stopped in a motel. The married doctor and father shot her up with three ampoules of acid and did the same to himself. Then they made love all night long, one staggering orgasm after another, ecstasy and death riding in tandem.

The doctor had morning office hours, and as they drove back into the city, Edie said, "I wish I was dead." Before he dropped her off, the doctor gave her a shot to bring her down. That did not work, and she took a handful of Placidyl sleeping pills.

Edie ended up in a coma, and the police arrived. Saying she had attempted suicide, the authorities committed her to the New York State Psychiatric Institute at Columbia Presbyterian Hospital. The doctors put her on such a strong dose of Thorazine that it set off tremors. When she finally exited the psychiatric institute, she thought she would be transferred to a private hospital. Instead, she was shipped to Manhattan State on Wards Island, where she stayed for three months. As soon as she got out, Edie flew to California. She could hardly walk and talk.

Edie told Warhol she had been living at home on the ranch in California, but it had been a disaster. Warhol surmised that her mother was the problem, and Edie said she was.

Mrs. Sedgwick looked at her daughter with a narrow, judgmental gaze. Edie could not take it for more than a couple of months. She moved out and rented a place in Isla Vista near the beach and the University of California, Santa Barbara. Her doctor said Edie was not up to living alone, and an amiable young woman moved in with her. Edie figured it would take about a year before she could return east and resume her life.

After talking to Warhol, Edie asked that he pass the phone to Malanga. That may have been the primary reason for the call.

"Hey, Gerard, I have to ask you for something," Edie said.

"Ask away," Malanga said. "Anything for you, Edie."

"I need some amphetamine pills."

"Wow, I mean, I don't . . . you know I don't have any of that."

"But can't you get some?"

"No, Edie, I don't know anybody."

"How about Billy? He's got to have a dealer."

"Edie, Billy is into health foods these days. Look, I'm so sorry I can't help you."

"That's okay, Gerard, I guess I can get some out here."

It was strange, Edie hitting Malanga up for drugs. She was living in a college town full of dealers and she soon found her supply. One day, the cops busted her, and she ended up in Cottage Hospital, where she was born and where her father died in 1967.

There were almost as many drugs inside the hospital as outside, and Edie was on uppers and downers much of the time. When she could not get anything else, she scored heroin. She had plenty of time to think about life at the Factory. To her, Warhol was an evil Svengali who took the innocent, turned them into servile robots, and when he no longer needed them, tossed them out into the cruel streets. "I hate them. I hate them," she said. "The *way* those sons-of-bitches took advantage of me. Warhol is a sadistic faggot."

In the summer of 1970, Edie returned to Cottage Hospital. Every time she entered an institution, she swore she had learned what she had to learn and would never return. During her treatment, one of the *Ciao! Manhattan* producers, David Weisman, came to her seeking to complete the project in Southern California. Since the film was based on Edie's life, there was no film without her.

For Edie, it may have seemed a wonderous proposal to get her back on a firm path the way no therapy could. But the film was precisely what many of Warhol's had been: a cruel exploitation of her life. The story was set out in the opening title cards:

In 1970 a young west-coast heiress returned home.
After two years as the superstar of New York's underground.
After three years of hospitalization.

Her character's name in *Ciao! Manhattan* is Susan, but it is Edie, pure and not so simple. She loved having the klieg lights following her, and the camera focused on her intimate behavior. But it was bewildering that she did not understand how she was being used, or perhaps she was so far gone she did not care.

The producers got Edie an apartment a block from her doctor and the hospital. Edie's mother hired two nurses, who had the hopeless task of watching over a patient who did not want to be watched over. The director shot Edie nude or partially nude as often as possible—not that there was anything erotic about the footage. She was so thin that her new breast implants looked like mountain peaks growing on a desert plain.

Edie was a wonderful dancer but was so high that her moves were painfully disjointed. In some scenes, she can hardly stand up. It might have made sense to stop filming until she sobered up, but the film was about a profoundly troubled drug addict. For the filmmakers, this was great stuff, and the shooting continued.

While the filming was going on, Edie was in real life having shock treatments as a way of purging her mind of suicidal thoughts. The producers loved this detail, and they wanted to shoot their version of shock therapy for *Ciao! Manhattan*. Edie's doctor thought it a bad idea, but Edie insisted. The film company went to the small mental hospital Edie knew intimately. They brought the cameras and lights into the hospital, past the muttering patients wandering the corridors. And they set up in the room with the Reiter Electro-stimulator, where Edie had her actual treatments.

Edie showed them how the rubber device went into the patient's mouth once they were put out with Pentothal and strapped down. She was game for taking the Pentothal and playing this out for real. But this was a line that Edie's doctors, and the film crew, would not

cross. When the actor playing the doctor pretended to zap Edie with an electric shock, she made her body jump up off the table. It didn't happen like that in real life, but it made for dramatic film.

The footage of Edie having the shock therapy segued to her last scene in the movie, in which she looked exuberant, young, and innocent in a white satin dress. The scene was shot on her wedding day in July 1971 at the Sedgwick ranch. The groom, twenty-year-old Michael Post, stood next to her in a formal cutaway. Tall and lean with hair down to his shoulders, he looked a perfect child of the sixties, duded up for this special day.

Michael had his own drug problems. He had met Edie in rehab at the Cottage Hospital. In a manic quest for fulfillment, Edie was sleeping with an array of patients, and Michael stayed away from her. He had this very un-sixties idea of staying a virgin until his twenty-first birthday, when he would make love with his chosen one alone on a mountain. Getting close to Edie ended that idea.

Edie's new husband was eight years her junior. He wanted to do nothing more than take care of his sick, vulnerable bride, managing her life as best he could. Yet he believed the marriage would not last. He knew nothing of the people she spoke about and the places she had gone. She was the vibrant center wherever they went. He stood next to her, saying nothing. She still loved to dance, and when she was too drunk or stoned to stand alone, he held her up so she could dance and dance and dance.

On the evening of November 15, 1971, Edie and Michael went to just another party. Too much to drink, just too much of everything, staying until the dregs of the evening, arriving back in their apartment in the early morning hours. Edie fell asleep immediately. She was a heavy smoker and had a loud, raspy breath that made it difficult for Michael to fall asleep. When he woke up at 7:30, he turned

and saw Edie's body in the same position as when she fell asleep. He reached over and touched her. Twenty-eight-year-old Edie was dead.

|||||||||||||||||||||

Michael called to tell Brigid. Edie was so young. It made no sense. Brigid knew she must tell Warhol. After turning on her tape recorder, she called him.

"She suffocated," Brigid said.

When Warhol heard, he had no shock of recognition, no devastated response. He felt toward Edie what he called "probably very close to a certain kind of love," but there was nothing, nothing. He featured her in eight of his films, bringing him the attention he so desired, but there was nothing, nothing. He traveled with her to the haunts of the rich and privileged, homes he could not have gone to on his own, but there was nothing, nothing.

"Oh, how could she do that?" Warhol asked, as if she had done this to ruin his day.

"I don't know," Brigid said.

"Does he inherit all the money?" Warhol asked, referring to Edie's husband. Mourning often turns to money, but not this soon.

"She didn't have any money," Brigid said.

That was quite enough of the subject for Warhol.

Abagnalo was at the Factory later that afternoon. Although he had never met Edie, the young man was stunned at Warhol's lack of concern. He had gotten his true education working at the Factory. As much as he admired many aspects of Warhol, he could not understand his human disregard. Was there some secret trove of feelings no one saw?

"Warhol is in a lot of ways inscrutable," said Abagnalo. "And sometimes you have to tell yourself, well, maybe we won't be able to uncover all the mystery. Maybe the mystery will go on forever."

|||||||||||||||||||||||

Warhol's Superstars played crucial roles in turning him into the most famous contemporary artist in the world. They elevated him until he stood far above them, and many of them paid terrible prices. By 1974 two of the muses had died, three were addicts, and a fourth fought for mental equilibrium. Warhol had not poked needles into their arms or driven them crazy with his entreaties, but the climate around him was full of madness and danger and he reveled in that, standing back watching. He used these women, and for the most part discarded them.

Only Jane Holzer had the money to pay Warhol for her portrait, though he made a photo booth strip shot of Edie. He didn't paint the others. What a unique series it would have been. An unguarded image of Baby Jane, sticking her tongue out with an insouciant stare. And Edie, so many choices to make her come alive in a shimmering pose. Ingrid Superstar would do her best to look like Edie. Viva would dress as a bewitching star with a touch of Garbo. As for Nico, it had to be an image from her early twenties, this woman of transcendent beauty. Woronov would strike a bold, manly pose. International Velvet would play the ingenue, her heavily made-up features framed by the darkest of hair. Ultra Violet's whole life was posing; she would be a natural. Of course, Brigid would insist on disrobing, making her breasts part of her portrait. As for Candy Darling, as theatrical as ever, she would want a deathbed scene.

These portraits of Warhol's Superstars exist only in a virtual gallery. They deserve to be remembered for the women they were, fascinating figures in a daring age.

AFTERWORD

Lives

BRIGID BERLIN

The woman whose nickname was "the Duchess" came to live like one. Brigid kicked her addiction to amphetamine, and with her inheritance from her parents lived an upscale lifestyle. She had despised her mother, but she came to replicate her life, assuming the same ultraconservative attitudes as Honey. Brigid liked to lie in bed watching Fox News, her source for all that was right and truthful. Eighty-year-old Brigid died in 2020.

BABY JANE HOLZER

Jane Holzer lives in Palm Beach, where she was brought up, overseeing real estate investments on Worth Avenue and elsewhere. Holzer has a reputation as a fierce, unyielding landlord. Unlike in her childhood, these days she is accepted in Palm Beach society.

NICO

The heroin-addicted singer continued making films with her lover Garrel and recording albums. Nico toured widely in Europe, the

United States, Australia, and Japan, where her unique artistry had admiring audiences. After over a decade and a half of addiction, she kicked her heroin habit. In July of 1988, forty-nine-year-old Nico was on the Spanish island of Ibiza with her son, Ari. At around noon on the hottest day of the year, she went out on her bicycle to buy marijuana. She fell, hitting her head, and died soon afterward.

VALERIE SOLANAS

When Solanas was released from prison in 1971, she wandered from place to place, ending up in San Francisco. It was there in 1988 that fifty-two-year-old Solanas died of pneumonia at the Bristol, a single-occupancy welfare hotel. There were apparently typewritten pages in her room. What they contained will never be known because her mother destroyed every memory of her daughter.

INGRID SUPERSTAR

Ingrid Superstar left the Factory with a drug problem and a profoundly damaged psyche. She ended up living with her mother in Kingston, New York, working in a sweater factory. One day in 1986, the former Warhol Superstar went out to buy cigarettes and never returned. The police found no trace of her.

INTERNATIONAL VELVET

After leaving the Factory, Susan Bottomly continued her career as a model for about a decade. She has since disappeared from public view.

ULTRA VIOLET

In 1988, Ultra Violet published her memoir of the factory years, *Famous for 15 Minutes: My Years with Andy Warhol.* She had learned a great deal from her time with Dalí and Warhol and became a successful artist with studios in New York City and Nice. Seventy-eight-year-old Ultra Violet's last Manhattan show closed three weeks before her death in 2014.

VIVA

After leaving Warhol's entourage, Viva had roles in several films, most notably *Play It Again, Sam* and *Cisco Pike.* In 1970 she published a fictionalized autobiography, *Superstar: A Novel.* She had a short-lived marriage to the French underground filmmaker Michel Auder, and has two daughters, the actress Gaby Hoffmann, and the author Alexandra Auder, who in 2023 wrote *Don't Call Me Home*, a memoir about her crazed bohemian upbringing. Eighty-six-year-old Viva lives alone in Palm Springs, California, and paints in the desert sun.

MARY WORONOV

After her short-lived career as a Warhol Superstar, by the mid-seventies Woronov became a B-movie diva. She married and divorced twice in quick succession. In 1995 she published *Swimming Underground: My Years in the Warhol Factory.* These days eighty-one-year-old Woronov lives alone in an apartment in Los Angeles, where she is known primarily as a painter.

ANDY WARHOL

In the seventies, Warhol churned out portraits of the rich and powerful including the Shah of Iran and those around him. Warhol also enjoyed photographing street hustlers and observing the scene at Studio 54, the hip Manhattan disco. To remain relevant, in the eighties he collaborated with the young artist Jean-Michel Basquiat. On February 22, 1987, fifty-eight-year-old Warhol died while recovering from gallbladder surgery. Warhol is buried in Pittsburgh, the city from which he fled.

ACKNOWLEDGMENTS

To write *Warhol's Muses*, I was blessed with a treasure of intimate, detailed research.

Andy Warhol recorded his entire life beginning in 1965. These 3,400 tapes are a biographical resource of a richness unlike anything in history, memorializing Warhol's life from the moment he got up to his last conversation at night.

Warhol willed the tapes to the Andy Warhol Foundation for the Visual Arts in New York City. Nearly forty years since Warhol's death, the tapes sit at The Andy Warhol Museum in Pittsburgh almost entirely unutilized.

Hoping to have the first-time use of the tapes from 1965 to 1971, the crucial years for *Warhol's Muses*, I approached Michael Dayton Hermann, director of licensing, marketing, and sales at the Warhol Foundation. Hermann was cordial, but said I could not hear the tapes for fear of libel. I said that did not make sense since almost everyone on the tapes is deceased. He went on to say the recordings are full of talk of "sex, drugs, and illegal activities." That also did not seem a credible reason to hide the tapes from researchers.

Hermann agreed to let me listen to several of the tapes at The Andy Warhol Museum Archives, where they are stored. I would have to pay to have the material digitized ($990) and sign an agreement

that "all note-taking, transcribing, and quoting are prohibited under the terms of the license owner." I could leave the archives to take notes, but at the end of my stay, I would have to give the foundation a copy of the document.

I arranged for a weeklong visit to The Andy Warhol Museum in Pittsburgh primarily to hear the tapes. The tapes proved largely uninteresting, and it was a pain to leave the archives to take notes. By midweek, I was feeling sorry for myself and the waste of time and resources. That's when Matt Gray, the director of archives, approached me with boxes containing transcripts of the tapes from the period of my book.

I had signed no agreement concerning transcripts. I was so nervous that Gray might change his mind that I stood up and began photographing the pages. I did this for nearly three days and left Pittsburgh that weekend with an iPhone full of almost 1,500 pages of documents. I am so thankful that Gray takes his commitment to a truthful portrait of Warhol and his world so seriously that he gave me the transcripts.

Before I left, Gray told me the Warhol Foundation believes it owns the copyright to the tapes and I would have to be careful using them. Warhol sought no releases, rarely spoke more than a few words, and often taped people without their knowledge. The two surviving individuals on the transcripts in my possession, Viva and Marco St. John, both say they had no idea Warhol was recording them. It seems to me if anyone owns these rights, it is the people whose voices are the ones largely heard on these tapes, likely recorded without their permission.

I proceeded as if the tapes were copyrighted, but by whom I was not sure. In these lengthy transcripts, I have utilized the facts in certain sections but have rewritten the material so that there is not even a sniff of the original language.

I would only implore the nonprofit Warhol Foundation to help fulfill its mandate of "encouraging new Warhol scholarship" by opening up the tapes to researchers before February 2037, the fiftieth anniversary of Warhol's death. Until that is done, the definitive biography of Andy Warhol cannot be written.

I had another source of research of enormous value. For about five years in the seventies, Jean Stein recorded hundreds of interviews for a biography of Edie Sedgwick, not just about the main subject but the whole cultural ambiance. When she could not write the book, George Plimpton forged the material into an oral history, *Edie: American Girl*, one of the classic books about the sixties.

For the most part, *Edie* quoted snippets of long interviews and had no room for many of Stein's interviews. All this material sits at the New York Public Library on Fifth Avenue, an inestimable trove of research and a contribution to history almost as large as *Edie: American Girl*.

When I was completing my research, author Cynthia Carr graciously sent me the galleys for her then-forthcoming biography, *Candy Darling: Dreamer, Icon, Superstar*, so I could fully utilize her work. If readers are intrigued by Darling, I suggest they read Carr's wonderful book.

I did my own interviews as well. I spent two days with Warhol's first assistant, Gerard Malanga, in Hudson, New York. His grand spirit matches his great memory. Malanga read the manuscript and had important comments. I became close to another former Warhol employee, George Abagnalo, who read various versions of the manuscript with an incredible sense of detail and spent hours reviewing it with me. He assisted from beginning to end. He also found the cover photo.

I was in a spirited dialogue with Viva when her daughter published a memoir so upsetting to her mother that Viva stopped taking

my calls. Among my other interviews, I also fondly recall talking to the late Richard Ekstract.

The term "mensch" was invented to describe Marty Bell. The author and Broadway producer read the manuscript twice, giving invaluable help. I can't find a superlative strong enough to describe my wife, Vesna Leamer. She read *Warhol's Muses* several times, but that was just the beginning of all she does.

My career headed back upward when I became David Halpern's client. The first thing my new agent did was take me to Michelle Howry, Putnam's executive editor. A brilliant move. From then on, it's been a steady climb. Ashley Di Dio is Howry's able assistant, and Putnam publicist Katie Grinch is a miracle worker.

Among the many other people I must thank is Gregory Pierce, director of film and video development at The Andy Warhol Museum. He was always helpful when I wanted to watch Warhol's films. As he has so astutely done for several of my books, William Coates helped research the project. Kersten Deck did a superb job fact-checking the manuscript. I highly recommend her to my fellow authors. I also had good fortune in having the estimable Rob Sternitzky copyedit the manuscript. I must also thank the author Scott Eyman, who gave me the idea for *Warhol's Muses*. As always, Don Spencer transcribed my interviews.

Others who were helpful in so many ways include Robert Heide, Daniel Bellizio, Elizabeth Murray Finkelstein, Eric Shiner, Stephen Shore, Jim and Irene Karp, Dick and Susan Nernberg, Alex Speyer, Dr. Heath King, Robert and Mary Francis Leamer, Jean Wainwright, Andrew Holter, Nigel Hamilton, Pat Hackett, Esther Robinson, Ellen F. Brown, Breanne Fahs, Steven Ekstract, John and Melissa Ceriale, April Flynn, Mike Pomerantz, Don and Nancy Herzog, Marco St. John, Dan Moldea, Gus Russo, Dr. Derek Barton, Mark Olshaker,

Nancy Lubin, Sally Rosenthal, Bob Bates, Joel Swerdlow, Edward Leamer, Ama Neel, Eric Dezenhall, Julie Newmar, Bennett Tramer, Biba St. Croix, Dale Coudert, Craig Highberger, Wilma Siegel, Erik Brown, Ellen Stern, Bob Slater, Susan Cipolla, Sophie Jones, Chris Rawson, Rebecca Holmberg, and Steve Kasher.

NOTES

ABBREVIATIONS

JSP: Jean Stein papers, Manuscripts and Archives Division, New York Public Library

AWT: Transcripts of Andy Warhol's taping of his life from around 1965 to 1971, including phone calls, other conversations, meetings, and events, The Andy Warhol Museum

NOTE: Unless otherwise mentioned, interviews were conducted by the author. For his research he often used the Kindle edition along with the original book.

PROLOGUE: JUNE 1968

xiii **Feiden was a "woman producer":** Glenn O'Brien, "History Rewrite," *Interview*, March 7, 2009.

xiii **"I'm a playwright," Solanas said:** O'Brien, "History Rewrite."

xiii **actors from the High School of Performing Arts:** Robin Finn, "Public Lives; She's Happy. Hirschfeld's Happy. The Secret?," *New York Times*, October 24, 2000.

xiv **"We'll keep men in bullpens, and women":** Breanne Fahs, *Valerie Solanas: The Defiant Life of the Woman Who Wrote* SCUM *(and Shot Andy Warhol)* (New York: Feminist Press at CUNY, 2014), 131, Kindle.

xv **"tragically damaged person":** Fahs, *Valerie Solanas*, 132.

xv **"Do you know what this is?":** Fahs, *Valerie Solanas*, 132.

xv **"If you don't agree that you will produce my play":** Michael Kaplan, "I Could Have Saved Andy Warhol from Being Shot," *New York Post*, June 2, 2018.

xvi **"You don't want to do that":** Fahs, *Valerie Solanas*, 132.

xvi **Andy Warhol Films was in the phone book:** George Abagnalo interview.

xix **"surround himself with dreary, creepy people":** John Wilcock, *The Autobiography and Sex Life of Andy Warhol* (New York: Trela Media, 2010), 24.

xix **"Valerie!" Warhol shouted. "No! No!":** Victor Bockris, *Warhol: The Biography* (London: Penguin, 1990), 298.

CHAPTER 1: RIDING THE WHIRLWIND

1 **silk-screen portrait of Marilyn Monroe sold for $195 million:** Robin Pogerin, "Warhol's 'Marilyn' at $195 Million Shatters Auction Record," *New York Times*, May 9, 2022.

2 **"I really look awful":** Andy Warhol, *The Philosophy of Andy Warhol: From A to B and Back Again* (Boston: Mariner Books, 1977), 113.

5 **"The superstar was a kind of early form":** Jean Stein, *Edie: American Girl*, ed. George Plimpton (New York: Grove Press, 1982), 225, Kindle.

5 **Warhol's most memorable portraits:** Corice Arman et al., *Warhol Women* (New York: Lévy Gorvy, 2017), 33.

CHAPTER 2: PARTY OF THE DECADE

7 **Brillo pads, Heinz ketchup, Kellogg's Corn Flakes:** Steven Watson, *Factory Made: Warhol and the Sixties* (New York: Pantheon Books, 2003), 149.

8 **cohost a party for Warhol:** Bockris, *Warhol*, 199.

9 **two filthy bathroom stalls:** Blake Gopnik, *Warhol* (New York: Ecco, 2020), 353.

9 **sat a red sofa that had been picked up off the street:** Gopnik, *Warhol*, 381.

10 **Warhol decided in June:** Gopnik, *Warhol*, 115.

10 **procedure that regrew the skin:** Cristina Rouvalis, "My Perfect, Imperfect Body," *Carnegie*, Fall 2016.

10 **silver color that would:** Gopnik, *Warhol*, 375.

11 **tam-o'-shanter:** Gopnik, *Warhol*, 371.

12 **"Ohh, I'm doing work just like that myself":** David Bourdon, *Warhol* (New York: Abrams, 1989), 80.

12 **cartoon images of Dick Tracy and Superman:** Donna De Salvo et al., *Andy Warhol: From A to B and Back Again* (New York: Whitney Museum of American Art, 2018), 176–77.

12 **"Well, you seem to be too similar":** *Andy Warhol: Transcript of David Bailey's ATV Documentary* (London: Bailey Lichtfield, 1972).

12 **for prices as high as $1,200:** De Salvo et al., *Andy Warhol*, 102.

13 **"I think the art was":** Roy Lichtenstein interview, JSP.

13 **"I think everybody should be a machine":** Gene Swenson, "What Is Pop Art," *Art News*, November 1963.

14 **The process took no more:** I thank Gerard Malanga for his detailed description of the silk-screening process.

14 **five men gathered:** Kathleen White, "7 Things You Need to Know: Pop Art," Sotheby's, April 12, 2018, https://www.sothebys.com/en/articles/7-things -you-need-to-know-pop-art.

14 **He never again would let himself:** Bockris, *Warhol*, 199.

14 **But the photographers, especially the one:** Bockris, *Warhol*, 199.

15 **if he should blame:** Gopnik, *Warhol*, 359.

15 **"ragged edge of bourgeois capitalism":** Elizabeth Murray Finkelstein interview.

16 **Sculls had unceremoniously canceled their order:** Bockris, *Warhol*, 199.

17 **including Philadelphia and Newport:** Gopnik, *Warhol*, 7.

17 **Andrej returned from a year in the United States:** Bernard Weinraub, "Mothers," *Esquire*, November 1966.

19 **"nervous condition" would worsen:** Gopnik, *Warhol*, 928.

19 **Lexington Avenue and 89th Street in 1959:** Gopnik, *Warhol*, 928.

20 **watercolor portrait of cosmetics:** De Salvo et al., *Andy Warhol*, 160.

20 **"such gilderies as a still life with coke bottle":** *New York Herald Tribune*, December 4, 1957. Note: *Coke* is lowercased in the *Herald Tribune* story.

20 **helped "little baby Andy" by doing the lettering:** Arman et al., *Warhol Women*, 171.

20 **Five or ten minutes was enough:** Gerard Malanga interview, JSP.

CHAPTER 3: STRUTTING HER STUFF

23 **Warhol's friend the British-born photographer:** Bob Colacello, Andy Warhol, and Jane Holzer, "Beyond Baby Jane," *Interview*, June 1978.

25 **Mick made himself:** Dylan Jones, *Loaded: The Life (and Afterlife) of the Velvet Underground* (New York: Grand Central, 2023), 37, Kindle.

25 **guests included the British photographer:** Andy Warhol and Pat Hackett, *Popism: The Warhol Sixties* (London: Penguin, 2007), 75.

25 **"It was the way he put things together":** Warhol and Hackett, *Popism*, 75.

26 **He also tried on:** *Pensacola News Journal*, November 29, 1967; *Philadelphia Inquirer*, April 10, 1966.

26 **"switched on . . . feeling and living every minute":** *Sydney Morning Herald*, August 23, 1964.

27 **after purchasing lots:** *Palm Beach Post*, May 7, 1936.

27 **exclusionary policies banning Jews:** Laurence Leamer, *Madness Under the Royal Palms: Love and Death Behind the Gates of Palm Beach* (New York: Hachette, 2009), 85.

27 **"hurt terribly":** Scott Eyman, "Jane Holzer: Palm Beach's Glamorous 'Superstar,'" *Palm Beach Post*, January 16, 2011.

28 **sneaked out to dance at Manhattan hot spot El Morocco:** David Marcus, "The 'Sweet' in Sweet Baby Jane Holzer," *Miami Herald*, December 12, 1984.

28 **Holzer was walking along Madison Avenue:** Jones, *Loaded*, 33.

28 **"I can't see how I was ever 'underground'":** Bourdon, *Warhol*, 164.

29 **wanted to be a star:** Barbara Marshall, "You Made Me, Andy," *Palm Beach Post*, February 16, 2014.

29 **"My chin goes up":** *Life*, March 19, 1965.

29 **"I think he saw somebody":** Isabel Eberstadt interview, JSP.

29 **"Some of the people around Warhol":** Eyman, "Jane Holzer."

29 **Formerly an off-Broadway lighting designer:** Billy Name interview, JSP.

30 **"If you put your hand":** Gopnik, *Warhol*, 350.

30 **did not speak for days:** Isabel Eberstadt interview, JSP.

31 **The self-styled pope of Greenwich Village:** Gopnik, *Warhol*, 408.

31 **said he slept only two or three hours a night:** Bourdon, *Warhol*, 66.

31 **"give you that wired, happy":** Watson, *Factory Made*, 166.

31 **between 8 and 10 billion pills:** Will Hermes, *Lou Reed: The King of New York* (New York: Farrar, Straus and Giroux, 2023), 148, Kindle.

32 **no one even monitoring:** Gerard Malanga interview.

32 **She is asked to kiss:** John G. Hanhardt, ed., *The Films of Andy Warhol Catalogue Raisonné: 1963–1965* (New York: Whitney Museum of American Art, 2021), 66–68.

33 "You know, I'm really in love with TV commercials": Gopnik, *Warhol*, 399.

34 The story such as it is: Hanhardt, ed., *The Films of Andy Warhol*, 161.

34 "Andy, Jane, and I used the movie as a way to social climb": Sam Green interview, JSP.

36 "It was just like eating": Gopnik, *Warhol*, 396.

36 With his legs crossed: Patrick S. Smith, *Andy Warhol's Art and Films* (New York: Umi Research, 1986), 489.

36 One day early that summer of 1964: Hanhardt, ed., *The Films of Andy Warhol*, 185.

37 "They sort of stripped": Jane Holzer interview in *Andy Warhol: Transcript of David Bailey's ATV Documentary*.

37 named Holzer "Baby Jane": Baby Jane Holzer, interview by Anita Pallenberg, *Cheap Date*, no. 5, Fall 2002.

38 arrived in a limousine: Gerard Malanga interview.

39 Warhol was not rubber-stamping them: Gerard Malanga, "A Conversation with Andy Warhol," *The Print Collector's Newsletter*, January–February 1971.

39 the reams of teenage girls: Gerard Malanga interview.

39 "Oh, God, Andy, aren't they di*vine*!": Tom Wolfe, *The Kandy-Kolored Tangerine-Flake Streamline Baby* (New York: Farrar, Straus and Giroux, 1987), 202.

39 "There is no *class* anymore. Everyone is equal": Marilyn Bender, "The New Society, Young and Daring," *New York Times*, December 14, 1964.

40 a brigade of leather-garbed motorcyclists dismounted: Jones, *Loaded*, 34.

41 "the most contemporary girl I know": Tom Austin, "Still the It Girl of the Arts," *Miami Herald*, September, 19, 2010.

41 "Is it all right if I bring": Douglas Watt, "Small World," *New York Daily News*, August 1, 1965.

42 "Why Baby Jane Holzer Is More Important than Viet Nam": Derro Evans, "'New Wave' Author Rolls Ashore Here," *Austin-American*, November 19, 1965.

43 "With me, fame happened": Truman Capote interview, JSP.

CHAPTER 4: THERE IS ALWAYS A PRICE

46 "He's a voyeur-sadist, and he needs": Henry Geldzahler interview, JSP.

47 **He wished he had been there:** Bourdon, *Warhol*, 191.

47 **"a super-intelligent white rabbit, a voyeuristic one":** Emile de Antonio, "Marx and Warhol," JSP.

47 **a wooden carousel horse:** Henry Geldzahler interview in *Andy Warhol: Transcript of David Bailey's ATV Documentary*.

47 **advancing the careers of artists he admired:** Robert Rauschenberg interview, JSP.

48 **"Andy set himself up as a sort of scorpion":** Emile de Antonio interview, JSP.

48 **in November 1964:** *Andy Warhol: Flower Paintings*, November 21–December 17, 1964, Castelli Gallery, https://www.castelligallery.com/exhibitions/andy-warhol7.

48 **"He literally was mass-producing them":** Emile de Antonio interview, JSP.

49 **painting around 250 waterscapes of lilies:** Anna Claire Mauney, "Monet's Water Lilies: Their History and Evolution," *Art & Object*, April 11, 2022, https://www.artandobject.com/news/monets-water-lilies-their-history-and-evolution.

49 **The Castelli show almost sold out:** Gopnik, *Warhol*, 395.

49 **"What is incredible about":** Bockris, *Warhol*, 210.

50 **Podber entered the Factory dressed in a black leather:** Bourdon, *Warhol*, 190.

50 **"like a pimple":** Gopnik, *Warhol*, 419.

50 **"Oh, no, don't get upset":** Marco St. John interview.

50 **"What is brilliant about Andy is not related to art":** Robert Hughes interview, JSP.

51 **"Andy didn't invent an aesthetic":** "Gerard Malanga: An Interview," *Gay Sunshine: A Journal of Gay Liberation*, January–February 1974.

51 **"He knew an original idea when he saw one":** Barbara Rose interview, JSP.

51 **"The Campbell Soup cans, the beer cans":** Barbara Rose interview, JSP.

51 **from his fellow pop artist Robert Rauschenberg:** Dinner party scene in *Andy Warhol: Transcript of David Bailey's ATV Documentary*.

51 **"Andy's greatness is in recognizing":** Henry Geldzahler interview, JSP.

52 **pantheon beside Picasso, Michelangelo, and Rembrandt:** Gopnik, *Warhol*, 912.

52 **"the defining figure for several generations that conceive":** Jed Perl, "Picasso's Transformation," *New York Review of Books*, November 2, 2023.

52 **"Suppose a woman painted Campbell"**: Gloria Steinem interview, JSP.

53 **"before drink time, when the bar looks"**: Hanhardt, ed., *The Films of Andy Warhol*, 286.

53 **he could barely button his wrinkled pants**: Catherine O'Sullivan Shorr, *Andy Warhol's Factory People* (New York: CreateSpace, 2014), 105.

53 **"I'll drink an entire quart"**: Warhol and Hackett, *Popism*, 113.

53 **"If I drink this other bottle"**: Hanhardt, ed., *The Films of Andy Warhol*, 286.

54 **"humiliation and degradation"**: Isabel Eberstadt interview, JSP.

54 **"an enormous amount of bitchery and malice"**: Isabel Eberstadt interview, JSP.

54 **she never became the journalist**: Stephanie LaCava, "Writer Fernanda Eberstadt on Growing Up at Warhol's Factory," *Interview*, April 1, 2024.

54 **"really one of the most"**: Hanhardt, ed., *The Films of Andy Warhol*, 286.

55 **"Andy Warhol's cinema is a meditation"**: Gopnik, *Warhol*, 406.

55 **"This guy comes along who does"**: Bockris, *Warhol*, 211.

56 **"I want to enjoy what I wear"**: *Life*, March 19, 1965.

56 **The other guests were individuals**: Television listing, *Binghamton Press*, September 19, 1967.

56 **"We want to do a story about you"**: Wolfe, *The Kandy-Colored Tangerine-Flake Streamline Baby*, 203.

57 **"I only eat candy"**: Tom Wolfe, *The Painted Word* (New York: Farrar, Straus and Giroux, 1975), 76.

57 **"Let me tell you about the very rich"**: F. Scott Fitzgerald, "The Rich Boy," in *The Short Stories of F. Scott Fitzgerald* (New York: Scribner, 1995).

58 **"For Andy, in the beginning, I brought glamour"**: Barbara Marshall, "You Made Me, Andy," *Palm Beach Post*, February 16, 2014.

58 **"so faggy and so sick and so druggy"**: Jane Holzer interview, JSP.

59 **playing a "Baby Jane type"**: Ward Cannel, "Beyond Understanding," *Victoria Advocate,* September 21, 1965.

59 **"But really, we would prefer not to know"**: Cannel, "Beyond Understanding."

59 **"Holzer had that made her so contemporary"**: Ward Cannel, "Cannel at Bay," *News-Virginian*, September 20, 1965.

59 **"with an easy charm has been highly":** Eugenia Sheppard, "Publicity's Glare Is Hard to Take," *Journal Herald*, July 2, 1965.

59 **"Mrs. Holzer is a particular instance":** Sherman L. Morrow, "The In Crowd and the Out Crowd," *New York Times Magazine*, July 18, 1965.

60 **"They built us up, then tried":** Charles Champlin, "Baby Jane Just Old-fashioned Girl," *Los Angeles Times*, March 16, 1966.

60 **"one of her maids":** Leonard Lyons, "The Lyons Den," *Buffalo Evening News*, November 17, 1967.

60 **wear a see-through plastic:** Earl Wilson, "It Happened One Night," *Tyler Morning Telegraph*, March 24, 1966.

60 **wore a transparent vinyl miniskirt:** Jack O'Brian, "The Voice of Broadway," *Fort Worth Star-Telegram*, May 5, 1966.

60 **in a backless gown:** "Back Interest," *Leaf Chronicle*, July 3, 1966.

61 **pajama bottoms and a spangled bra:** Jack O'Brian, "The Voice of Broadway," *Evening Herald*, February 23, 1967.

61 **author Jan Cremer:** Earl Wilson, "Show Time," *Richmond Times-Dispatch*, January 27, 1966.

61 **actor Timmy Everett:** Dorothy Ridings, "Young Broadway Director Has Tar Heel Roots," *Charlotte Observer*, January 16, 1966.

61 **"Contrary to what she believes":** Alex Freeman, "TV Close-Up," *Hartford Courant*, January 26, 1966.

61 **Jane took acting lessons:** Arlene Dahl, "Baby Jane Puts Stamps on 'Way Out' Fashions," *Chicago Tribune*, August 8, 1966.

61 **Jane cut a single:** Jennifer Jarratt, "Whatever Happened to Baby Jane," *Detroit Free Press*, June 1, 1967.

61 *The Berlin Wall Teenager*: Jack O'Brian, "Voice of Broadway," *Asbury Park Press*, October 13, 1966.

61 *Nothing but the Blues*: Charles McHarry, "On the Town," *New York Daily News*, May 10, 1966.

62 **"I was a famous model of the '60s":** Marian Christy, "Old Baby Jane Now Walks Tall," *Palm Beach Post*, April 5, 1971.

62 **confiscated the estate, and auctioned:** Miriam Hall, "Wealth Makes Waves at N.Y. Beach Resort," *Philadelphia Inquirer*, July 19, 2004; *Newsday*, February 16, 2009.

62 **the precious stained glass windows and antique cupboards:** Suzy Knick-

erbocker, "If You're Losing Your Roof Make Off with the Door Knobs," *Buffalo Evening News*, June 23, 1975.

CHAPTER 5: TRUTH, NAKED AND OTHERWISE

65 **that had opened in December 1965:** "Max's Kansas City," Wikipedia, https://en.wikipedia.org/wiki/Max%27s_Kansas_City.

65 **The room glowed with a strange red:** Steve Kasher, "John Chamberlain and Max's," unpublished essay.

66 **The movie star was told to return to his hotel:** Watson, *Factory Made*, 317.

66 **"Oh, Gore, we have a beautiful boy for you":** Gore Vidal interview, JSP.

67 **"Persky would inveigh famous writers into coming there for an evening":** Gore Vidal interview, JSP

67 **He lived for a few months with Philip Norman Fagan:** Gopnik, *Warhol*, 412.

67 **he killed himself:** Gopnik, *Warhol*, 415.

67 **she no longer created the excitement:** Lester Persky interview, JSP.

67 **"You've got to have a new Superstar":** Stein, *Edie*, 180.

68 **Williams looked up at him:** Ronald Tavel interview, JSP.

70 **"the perfection of high breeding":** Richard P. Birdsall, "William Cullen Bryant and Catherine Sedgwick—Their Debt to Berkshire," *New England Quarterly*, September 1955.

71 **"out of the top drawer":** Stein, *Edie*, 56.

71 **He spent three months in the Austen Riggs Center:** Stein, *Edie*, 48.

72 **"Came pretty close to it":** Edie Sedgwick interview for *Ciao! Manhattan*, JSP.

73 **He openly despised Black people:** Stein, *Edie*, 97.

73 **wire helmet to flatten his ears:** Stein, *Edie*, 54.

74 **mock him for what he considered his pathetic concave chest:** Diana Davis interview, JSP.

74 **Minty was an alcoholic:** Stein, *Edie*, 83.

74 **he criticized those with bad legs:** Stein, *Edie*, 88.

74 **"Oh, for God's sake, Fuzzy":** Stein, *Edie*, 89.

75 **"Here was this great stallion":** Muffie Brandon interview, JSP.

75 **father having sex with a visiting lady:** Jonathan Sedgwick interview, JSP.

75 **she was bulimic, eating enormous:** Saucie Sedgwick interview, JSP.

76 **Suky was terrified and rode back:** Suky Sedgwick interview, JSP.

76 **"Do not send her to a hospital":** Suky Sedgwick interview, JSP.

77 **he would leave his wife:** Stein, *Edie*, 111.

77 **the Sedgwicks moved Edie to the Westchester psychiatric branch:** Stein, *Edie*, 115.

79 **"Stop being depressed":** Stein, *Edie*, 139.

79 **"Edie, you're the only member of the family":** John Anthony Walker interview, JSP.

80 **received an $80,000 inheritance:** Thomas C. Goodwin interview, JSP.

81 **she kept in vials:** Danny Fields interview, JSP.

81 **Goodwin totaled the Mercedes:** Thomas C. Goodwin interview, JSP.

82 **"who had seen the big sadness":** Thomas C. Goodwin interview, JSP.

83 **few props included weights, a leather mask, straps:** Ronald Tavel screenplay for *Vinyl*, https://www.ronaldtavel.com/wp-content/uploads/2020/10/vinyl_screen.pdf.

83 **The stoned cast and crew paired off:** Ondine interview, JSP.

84 **"Like binary stars, they revolved":** Bourdon, *Warhol*, 205.

84 **"One person fascinated me more":** Bockris, *Warhol*, 245.

85 **Warhol breezily dismissed:** *New York Times*, April 9, 1965.

86 **"a vision in a lilac jersey jumpsuit":** *New York Times*, April 8, 1965.

86 **Edie had six fur coats:** *New York Times*, April 8, 1965.

86 **"the best-looking dancing legs since Betty Grable":** Marilyn Bender, "Edie Pops Up as Newest Superstar," *New York Times*, July 26, 1965.

CHAPTER 6: "THE TIMES THEY ARE A-CHANGIN'"

88 **"I'd like to present":** Ultra Violet, *Famous for 15 Minutes: My Years with Andy Warhol* (New York: Harcourt, 1988), 97, Kindle.

88 **Starting in 1965:** Stanley Meisler, "The Surreal World of Salvador Dalí," *Smithsonian*, April 2005.

89 **"a pink Chanel suit and bought a big":** Warhol and Hackett, *Popism*, 264.

89 **an apartment on East 80th Street:** Gerard Malanga interview.

89 **filmed in March 1965:** "*The Life of Juanita Castro*," Wikipedia, https://en.wikipedia.org/wiki/The_Life_of_Juanita_Castro.

90 **she pulled out the beet:** Ultra Violet, *Famous for 15 Minutes*, 100.

91 **The waiter dropped his tray:** Ultra Violet, *Famous for 15 Minutes*, 150.

91 **"Fuck you, Tennessee, how dare you say":** Gopnik, *Warhol*, 431.

92 **"Andy Warhol Causes Fuss in Paris":** Gopnik, *Warhol*, 432.

92 **they shot Edie for their magazines:** Chuck Wein interview, JSP.

93 **"a retired artist":** Jean Pierre Lenoir, "Paris Impressed by Warhol Show," *New York Times*, May 13, 1965.

93 **"I've had an offer from Hollywood":** Lenoir, "Paris Impressed by Warhol Show."

93 **"Everything is beautiful":** Gopnik, *Warhol*, 432.

94 **a white mink coat over black tights:** Marylin Bender, "Edie Pops Up as Newest Super Star," *New York Times*, July 26, 1965.

94 **five feet eleven inches tall:** Richard Witts, *Nico: The Life and Lies of an Icon* (New York: Virgin, 1993), Kindle.

94 **sent her firstborn to the Kinderheim Sülz orphanage:** Jennifer Otter Bickerdike, *You Are Beautiful and You Are Alone: The Biography of Nico* (New York: Hachette, 2021), 14, Kindle.

95 **"My mother came to see me":** Bickerdike, *You Are Beautiful*, 15.

95 **Her grandfather was a railroad switchman:** Bickerdike, *You Are Beautiful*, 19.

95 **an American GI raped her:** Bickerdike, *You Are Beautiful*, 23.

96 **Tobias had been in love with the Greek director Nico Papatakis:** George Abagnalo informed the author of the friendship between Herbert Tobias and Nico Papatakis.

96 **"Nobody knew who she really was":** Bickerdike, *You Are Beautiful*, 236.

96 **a copy of Nietzsche's *Beyond Good and Evil*:** Bickerdike, *You Are Beautiful*, 34.

97 **also with the French actress Jeanne Moreau?:** Bickerdike, *You Are Beautiful*, 38.

97 **"I have dreamt of you":** Witts, *Nico*.

98 **"I've just slept with Alain Delon!":** Bickerdike, *You Are Beautiful*, 48.

99 **appeared on the New Year's 1963 cover:** Hermes, *Lou Reed*, 143.

99 **That left Ari stateless:** Bickerdike, *You Are Beautiful*, 51.

100 **"He did not treat me very seriously":** Witts, *Nico*, loc. 1815.

100 **Dylan wrote a song for her:** Witts, *Nico*, loc. 1824.

100 **"They would offer me drinks":** Witts, *Nico*, loc. 1846.

101 **shoving a loaded pistol into Nico's vagina as a dildo:** Witts, *Nico*, loc. 2117.

101 **Edie sat playing with her lipstick:** Witts, *Nico*, loc. 2172.

101 **she thought looked like a lean Elvis:** Witts, *Nico*, loc. 2168.

101 **Malanga brandished a long whip:** Nico interview, JSP.

101 **"smelled all over of piss and shit":** Gopnik, *Warhol*, 434.

102 **"The face that grows out from the magazine":** Gerard Malanga, "Coming Up for Air," *Poetry Magazine*, February 1967.

CHAPTER 7: THE YOUTHQUAKER LOSES HER WAY

103 **The cast rehearsed for a week:** Hanhardt, ed., *The Films of Andy Warhol*, 355.

104 **Edie sneezes for the forty-fourth time:** Hanhardt, ed., *The Films of Andy Warhol*, 361.

104 **"It looks like a Hollywood movie":** Ronald Tavel interview, JSP.

105 **"when in the future they want to know about the riots in the cities":** Vincent Canby, "When Irish Eyes Are Smiling," *New York Times*, October 27, 1968.

105 **Warhol contacted Richard Ekstract:** Richard Ekstract interview.

105 **publisher would give the once-recorded tapes:** Steven Ekstract interview.

106 **"doesn't have to participate in life":** Watson, *Factory Made*, 229.

106 **calling the tape recorder "my wife, Sony":** Gopnik, *Warhol*, 674.

106 **"The acquisition of my tape recorder":** Warhol, *The Philosophy*, 26.

106 **"I've never had as good a conversation with Andy":** Interview with Henry Geldzahler in *Andy Warhol: Transcript of David Bailey's ATV Documentary.*

107 **She asked one of the other Superstars:** Mary Woronov, *Swimming Underground: My Years in the Warhol Factory* (London: Serpent's Tail, 2000), 117.

107 **For him it was unnerving:** AWT.

107 **"Everyone, absolutely everyone, was tape-recording":** Warhol and Hackett, *Popism*, 291.

107 **There were over 3,400 tapes:** Matt Gray, The Andy Warhol Museum, to Laurence Leamer, email, December 18, 2023.

108 **scurrying to one party:** Bourdon, *Warhol*, 211.

108 **"more parties than a caterer":** *Time*, August 27, 1965.

108 ***Vogue* called her a "youthquaker":** *Vogue*, August 1965.

109 **"Edie Pops Up as Newest Super Star":** Marilyn Bender, "Edie Pops Up as Newest Super Star," *New York Times,* July 26, 1965.

109 **He had been married twice:** Mitchell Freedman, "Dr. John Bishop, 77, Practiced in Sag Harbor," *Newsday*, October 3, 2002.

109 **all about the vitamin shots laced with amphetamine:** Boyce Rensberger, "Two Doctors Here Known to Users as Sources of Amphetamines," *New York Times*, March 25, 1973.

109 **"All of a sudden, I went blind":** Edie Sedgwick interview, *Ciao! Manhattan* tapes, JSP.

109 **"Everyone was trying to get":** Rene Ricard interview, JSP.

110 **"Because you're so young":** Andy Warhol, *a: A Novel* (New York: Grove, 1998), loc. 4168, Kindle. (Warhol was always taping people, but in the summer of 1965, he outdid himself. He set out to produce a nonfiction novel by taping Ondine for an entire day. It took him several days to complete the project. The material quoted here probably was recorded on August 13, 1965.)

110 **"He wasn't going to pay for it because he was so cheap":** Richard Ekstract interview.

110 **Warhol was supposed to show it off:** Richard Ekstract interview.

111 **"attempting to shatter Sedgwick's fragile psyche":** Hanhardt, ed., *The Films of Andy Warhol*, 390.

112 **Edie and Warhol showed up unfashionably late:** Lynn Sands, "High Times," *Newsday*, September 30, 1965.

112 **"I lived a very isolated life":** *New York Post*, September 5, 1965.

112 **"Everybody in New York is laughing at me":** Bourdon, *Warhol*, 213.

113 **the mobile disco playing the latest rock and roll:** Watson, *Factory Made*, 246.

114 **"Edie and Andy! Edie and Andy!":** Stein, *Edie*, 254.

114 **"We *were* the art exhibit, we were the art incarnate":** Warhol and Hackett, *Popism*, 168.

115 **Merv Griffin had Edie and Warhol on his popular talk show:** *Boston Globe*, October 6, 1965.

115 **next to Gloria Steinem to discuss:** *Morning News*, October 15, 1965.

116 **"Her style may not be for everybody":** *Life*, November 25, 1965.

116 **He asked the playwright:** Robert Heide interview.

117 **At the end of the shooting of *Lupe*:** Bourdon, *Warhol*, 216.

118 **"I wonder when Edie will kill herself":** Robert Heide, "All About Andy," *WestView News*, July 4, 2000; Bourdon, *Warhol*, 216.

CHAPTER 8: NIGHTS OF AMPHETAMINE DREAMS

119 **Brigid hated music:** AWT.

120 **the mogul's bedside when he died:** UP, "Fabulous Career Ends for Hearst," *Press Democrat*, August 15, 1951.

120 **"Dick, I never thought I'd live to see you in a Roosevelt bed":** Leonard Lyons, "The Lyons Den," *St. Louis Globe-Democrat*, December 26, 1947.

120 **a Westchester estate:** *Reporter*, October 1, 1979.

120 **tied her hands:** AWT.

121 **If she lost a pound, she received five dollars:** Esther B. Robinson, dir., *A Walk into the Sea: Danny Williams and the Warhol Factory*, documentary, DVD, 2007.

121 **parents told her she had diabetes:** AWT.

122 **The girls got on their roller skates:** AWT.

122 **she told the priest that she and her sister had gone roller-skating:** AWT.

122 **Honey shoved the sandwich in Brigid's:** AWT.

123 **parents took the thirteen-year old to a physician, who prescribed Dexedrine:** Robinson, dir., *A Walk into the Sea*.

123 **they tasted just as delicious as before:** Vincent Fremont and Shelly Dunn Fremont, *Pie in the Sky: The Brigid Berlin Story*, documentary, Vincent Fremont Enterprises, 2000.

123 **As soon as the Berlins went out the door:** AWT.

124 **The Catholic institution was primarily for orphans:** *Indianapolis Star*, March 20, 1949.

124 **She placed a framed picture:** Fremont and Fremont, *Pie in the Sky*; AWT, 52B.

125 **shuttled her off to a physician:** AWT.

125 **window dresser at the Tailored Woman:** Fremont and Fremont, *Pie in the Sky*.

125 **"Good luck with that fairy":** *Boston Globe*, July 21, 2020.

126 **John ripped off her pearl necklace:** AWT.

126 **Ruth came back on other occasions:** AWT.

126 **standing naked in the living room:** AWT.

126 **loved herself from her neck up:** AWT.

127 **She liked to wear a Battaglia blazer:** Watson, *Factory Made*, 230.

127 Rotten worked in a fabric showroom: Gopnik, *Warhol*, 408.

128 "bruised and demented": Warhol, *a: A Novel*, loc. 1040.

128 "I was just in the bathroom": Warhol, *a: A Novel*, loc. 7413.

129 "Not the poke, but the pokee": Warhol, *a: A Novel*, loc. 7415.

129 took almost all her mother's rubies: AWT.

129 call her parents, not to wish them Merry Christmas: AWT.

129 Nothing less than $50,000 would do: AWT.

CHAPTER 9: THE LONG GOODBYE

132 Malanga danced by himself before the tiny stage: Hermes, *Lou Reed*, 136.

133 He had a way of leaning forward: Bourdon, *Warhol*, 208.

134 "I only like the foooood that floooats in the wine": Warhol and Hackett, *Popism*, 182.

135 "She was mysterious and European": Warhol and Hackett, *Popism*, 183.

135 promoting her as the "1966 Girl of the Year": Bourdon, *Warhol*, 221.

137 screens showed Warhol's underground movies: Grace Glueck, "Syndromes Pop at Delmonico's," *New York Times*, January 14, 1966.

137 "Do you eat her out?": Warhol and Hackett, *Popism*, 184.

138 "Why are they exposing us to these nuts?": Glueck, "Syndromes Pop at Delmonico's."

138 Not wanting to be left out: Warhol and Hackett, *Popism*, 184.

139 "Oh, I'm not making any money on the movies": Gerard Malanga interview.

139 "I can't be patient. I just have nothing to live on": Victor Bockris and Gerard Malanga, *Up-Tight: The Velvet Underground Story* (New York: Cooper Square Press, 2003), 28.

139 "They're going to make a film, and I'm supposed": Bockris and Malanga, *Up-Tight*, 28.

139 "I don't believe it. What?": Stein, *Edie*, 284.

140 "I'm leaving. Goodbye": Stein, *Edie*, 284.

140 they took to be a prostitute, who looked like: Rene Ricard interview, JSP.

140 "looked like a piece of trash": Kenneth Goldsmith, ed., *I'll Be Your Mirror: The Selected Andy Warhol Interviews, 1962–1987* (New York: Da Capo Press, 2009), 129.

141 Ingrid was earning extra money: Watson, *Factory Made*, 218.

141 "We treat her like dirt, and that's the way she likes to be treated": Gopnik, *Warhol*, 480.

142 "Is it true you're slightly retarded, Ingrid?": Gopnik, *Warhol*, 480.

142 Eleven people piled into the rented: Bockris, *Warhol*, 29.

142 the toilet often did not work: Bockris and Malanga, *Up-Tight*, 29.

143 Nico got $100: Gopnik, *Warhol*, 500.

143 begging for gas money: Gopnik, *Warhol*, 555.

143 "Both of the films were about as interesting": Ellen Goodman, "Festival and Films by Andy Warhol," *Detroit Free Press*, March 15, 1966.

144 "Everybody was trying to be the first person": Gerard Malanga interview, JSP.

145 "He'd just disappear right in front of you": Jones, *Loaded*, 38.

146 "I prefer to remain a mystery": Goldsmith, ed., *I'll Be Your Mirror*, 87.

CHAPTER 10: THE BONE CRUSHER

148 "I thought it was hot, and you know I got even": Mary Woronov interview in *Andy Warhol's Factory People*, dir. Catherine O'Sullivan Schorr, Planet-GroupEntertainment, 2008.

148 She was born prematurely, with a cyst resembling a tail: *Bizarre*, April 2004.

148 grandmother suggested she be returned: *Bizarre*, August 2004.

148 At the all-girls Packer Collegiate Institute: "Boro Girls Among Packer Grads," *Brooklyn Eagle*, June 14, 1963.

148 did not have to worry about boys pushing to the front: *Purple*, no. 26, Fall/Winter 2016.

148 the sound of the teenager's "bones cracking": Woronov, *Swimming Underground*, 53.

148 leaving her with cracked ribs and a broken finger: Woronov, *Swimming Underground*, 56.

149 who also acted in college theater: "Dramatic Club Slates Prize-Winning Play," *Ithaca Journal*, April 9, 1966.

149 "the mark that said I was a woman": Woronov, *Swimming Underground*, 14.

150 "In my experience, people seldom discussed": John Richardson, "Rauschenberg's Epic Vision," *Vanity Fair*, April 30, 2008.

150 **Woronov did not know if the camera:** Mary Woronov interview in *Andy Warhol's Factory People.*

151 **Warhol rechristened Woronov:** *Purple,* no. 26, Fall/Winter 2016.

152 **"I acted like a guy":** Mary Woronov interview in *Andy Warhol's Factory People.*

152 **"by far the most successful and most ambitious":** "The Dom," Downtown Pop Underground, https://dsps.lib.uiowa.edu/downtownpopunderground /place/the-dom/.

153 **"He took a passive role and gave me":** Watson, *Factory Made,* 274.

153 **took out a large fake syringe and pretended:** *Purple,* no. 26, Fall/Winter 2016.

154 **"$10 for H, for John's toothache":** Stephen Shore and Lynne Tillman, *Factory: Andy Warhol* (New York: Phaidon, 2016), 97.

154 **a room in the back of the dance hall set up with mattresses:** Gopnik, *Warhol,* 494.

154 **"I composed my first rigid speed concerto in":** Watson, *Factory Made,* 294.

155 **"the unbearable emptiness that the outside held for us":** Woronov, *Swimming Underground,* 161.

155 **his body was carried down:** Woronov, *Swimming Underground,* 162.

155 **"We should send her down the mail chute":** Guy Trebay and Ruth La Feria, "Tales from the Warhol Factory," *New York Times,* November 12, 2018.

156 **The Velvet Underground's lead singer was in the hospital:** Hermes, *Lou Reed,* 176.

156 **loquacious Brigid handled the interviews:** Bockris and Malanga, *Up-Tight,* 49.

156 **"Paul's relationship with Danny Williams was really sadistic":** Gopnik, *Warhol,* 460.

156 **including one night in a motel:** Goldsmith, ed., *I'll Be Your Mirror,* 117.

156 **One day, he fell asleep:** Goldsmith, ed., *I'll Be Your Mirror,* 86.

157 **"Oh, what a pain":** Gopnik, *Warhol,* 460.

157 **Eleven months after his son's disappearance:** Tony Scherman and David Dalton, *Pop: The Genius of Andy Warhol* (New York: Harper, 2009), 349.

157 **"a Harvard kid named Danny Williams":** Warhol and Hackett, *Popism*, 204.

158 **That she was deaf in one ear might have:** Witts, *Nico*.

CHAPTER 11: A FALLEN DEBUTANTE

161 **Gerard Malanga took the train:** Gerald Malanga interview.

161 **thick wreath of white coq feathers:** "Susan Bottomly," Wikipedia, https://en.wikipedia.org/wiki/Susan_Bottomly.

162 **Bottomly was just seventeen years old:** Susan Bottomly interview, JSP.

163 **found time to take his lover's letters to the post office:** Warhol and Hackett, *Popism*, 221.

163 **"She always throws her garments on the floor":** Gerard Malanga, diary entry, August 4, 1966, JSP.

164 **having dinner at El Quijote, a restaurant at the Chelsea Hotel:** Watson, *Factory Made*, 290.

165 **"a divine accident":** Gerard Malanga, "A Conversation with Andy Warhol," *The Print Collector's Newsletter*, January–February 1971.

165 **"99.9% of them" degenerates:** Goldsmith, ed., *I'll Be Your Mirror*, 129.

165 **fortified herself with vodka:** Woronov, *Swimming Upward*, 61.

166 **"a stupid cunt":** Woronov, *Swimming Upward*, 58.

166 **"You shut up, or I'll pull out your nails":** Geralyn Huxley and Greg Pierce, ed., *Andy Warhol's* The Chelsea Girls (New York: Distributed Art Publishers, 2018), 87.

167 **"gonna be up for a week":** Huxley and Pierce, ed., *Andy Warhol's* The Chelsea Girls, 69.

167 **Nowhere in the films:** The author writes about this with a measure of knowledge he wishes he didn't have. His two closest friends became amphetamine addicts. One died of an overdose in 1967 during San Francisco's Summer of Love. The other withdrew from his habit, but was a broken man who limped through the rest of his short life.

168 **Warhol later said he was so upset:** Warhol and Hackett, *Popism*, 227.

168 **followed the action around the set:** George Abagnalo pointed this out to the author.

168 **did not pay the actors:** Bockris, *Warhol*, 259.

169 **Then he walked back across the park:** Stein, *Edie*, 269.

169 **One evening in October, the drapes:** Gerard Malanga's diary in Stein, *Edie*, 304.

169 **to get a room at the Chelsea:** Bob Neuwirth interview, JSP.

170 **"I think you have to love yourself":** Bob Neuwirth interview, JSP.

171 **The younger woman was in awe of Edie:** Susan Bottomly interview, JSP.

171 **"who had such perfect, full, fine features":** Warhol and Hackett, *Popism*, 221.

171 **"There was a tall, ominous, conical girl":** Kevin Kelly, "Wild, Wild Warhol," *Boston Globe*, October 4, 1966.

171 **how Edie could do such a thing when:** Susan Bottomly interview, JSP.

172 **that Senator Edward Kennedy kept hitting on her:** Edie Sedgwick interview, *Ciao! Manhattan* tapes, JSP.

172 **she pressed her cigarette out on:** Bob Neuwirth interview, JSP.

CHAPTER 12: BAND-AIDS ARE NOT JUST FOR WOUNDS

175 **Chelly Wilson, the queen of the 42nd Street–area porn theaters:** Heidi Julavits, "Not All Disaster Movies Contain Explosives," *Vulture*, December 8, 2021.

175 **a "skin flick":** Stein, *Edie*, 318.

176 **the filmmakers employed a professional 35mm camera:** Stein, *Edie*, 320.

176 **chanted, "Love, love, love":** *Newsday*, March 27, 1967.

176 **Kites danced in the air:** *Village Voice*, March 30, 1967.

177 **been a doctor at the US embassy in Paris:** Mitchell Freedman, "Dr. John Bishop, 77, Practiced in Sag Harbor," *Newsday*, October 3, 2002.

178 **"What do we do in this scene?":** Richie Berlin interview, JSP.

178 **"an Irish Catholic nun in her lips":** *Village Voice*, February 22, 1968.

179 **Brigid had no such reticence:** Mary Beth Hoffmann interview, JSP.

179 **"I was already so bombed":** Edie Sedgwick interview, *Ciao! Manhattan*, JSP.

180 **"Uh, you have to take your blouse off":** Watson, *Factory Made*, 344.

181 **it would cost $97.82:** Watson, *Factory Made*, 344.

181 **"performing genius on the order of Mick Jagger, a comic Greta Garbo":** Watson, *Factory Made*, 345.

181 **"pathetic . . . creatures that need help":** Barbara Goldsmith, "La Dolce Viva," *New York*, April 29, 1968.

181 **"Oh, we have to go to this party":** Trebay and La Feria, "Tales from the Warhol Factory."

182 **he chased his daughter in another boat:** AWT.

182 **To escape, she jumped out of the boat:** *Village Voice*, February 22, 1968.

182 **"the behavior completely contradicted the spoken word":** Scherman and Dalton, *Pop*, 389.

182 **"brilliant woman who was always pregnant":** Viva Facebook post, undated.

182 **the dining room committee of the Rosary Society:** *Syracuse Post-Standard*, November 18, 1963.

182 **a five-foot statue of the Virgin Mary:** Goldsmith, "La Dolce Viva."

182 **the Church sent the worst of the priests to upstate:** *Nude Restaurant*, AWT.

182 **to go for a walk in the woods:** *Nude Restaurant*, AWT.

182 **She slept with a cross over her bed:** Goldsmith, "La Dolce Viva."

183 **forced to sit and watch:** *Village Voice*, February 22, 1968.

183 **she told her daughter to be quiet or cross her legs:** *Village Voice*, February 22, 1968.

183 **Viva said one of her brothers tried:** AWT.

183 **What should a virgin do if a man tries to rape her?:** AWT.

184 **Viva would play the Reverend Mother:** AWT.

185 **Warhol's films usually opened:** George Abagnalo informed the author of the changes in exhibition of Warhol films.

185 **shot in one day in October 1967:** "*The Nude Restaurant*," Wikipedia, https://en.wikipedia.org/wiki/The_Nude_Restaurant.

186 **"A bare denizen of the 'Restaurant' observes":** Bosley Crowther, "Dress Is Decidedly Optional in Andy Warhol's 'Restaurant,'" *New York Times*, November 14, 1967.

CHAPTER 13: COME ON LIGHT MY FIRE

187 **"These candles are arranged in such a way":** Stein, *Edie*, 326.

187 **she grabbed on to the red-hot doorknob:** Bobby Anderson interview, JSP.

188 **sleeping on a mattress on the floor:** Stein, *Edie*, 337.

188 **After insisting on doing her exercises:** Bobby Anderson interview, JSP.

188 **driven by the rock promoter Sepp Donahower:** Paul Morrissey interview, JSP.

189 **Danny Fields introduced Nico to Jim Morrison:** Witts writes that the couple met first in March. Witts, *Nico*, loc. 3422.

189 **"We hit each other because we were drunk":** Witts, *Nico*, loc. 3562.

189 **"The light of the dawn was a very deep green":** Witts, *Nico*, loc. 3582.

190 **Nico dyed her hair red to please Morrison:** Witts, *Nico*, loc. 3642.

191 **a stamp pad to Max's to collect:** Bourdon, *Warhol*, 250.

191 **One evening, Ultra Violet took off:** Gopnik, *Warhol*, 540.

191 **"Andy Warhol is my husband!":** George Abagnalo interview.

192 **to get what she called her lollipops:** AWT.

192 **Viva got her whip and lashed Page on her back:** AWT.

193 **"grab me, and rough me up":** Warhol and Hackett, *Popism*, 264.

193 **pedaled down the streets:** Warhol and Hackett, *Popism*, 264.

194 **bed in a two-patient room in a ward full of heroin addicts:** AWT.

CHAPTER 14: UP YOUR ASS AND OTHER NICETIES

195 **"Life in this society being, at best":** Valerie Solanas, *SCUM Manifesto* (New York: VandA, 2013), 5, Kindle.

196 **"Every man, deep down, knows he's a worthless piece of shit":** Solanas, *SCUM Manifesto*, 7.

196 **"off to the nearest friendly suicide center":** Fahs, *Valerie Solanas*, 33.

196 **Mary Harron, who directed a film:** Fahs, *Valerie Solanas*, 64.

197 **she punched out one of the sisters:** Fahs, *Valerie Solanas*, 28.

197 **When Solanas became pregnant:** Fahs, *Valerie Solanas*, 28.

198 **he worried the cops were setting:** Gopnik, *Warhol*, 611.

198 **In February 1966, Solanas wrote him a polite letter:** Gopnik, *Warhol*, 56.

198 **"to please return my script":** Valerie Solanas to Andy Warhol, letter, February 9, 1966, The Andy Warhol Museum.

199 **"What's the matter, Solanas, can't get one?":** Fahs, *Valerie Solanas*, 81.

199 **"Maybe you know some girls who'd":** Valerie Solanas to Andy Warhol, letter, August 1, 1967, The Andy Warhol Museum.

199 **"and another for you to put under your pillow at night":** Valerie Solanas to Andy Warhol, letter, August 16, 1967, The Andy Warhol Museum. (Warhol lost Solanas's play, but saved her letters.)

201 **"Your instincts tell you to chase chicks, right?":** Fahs, *Valerie Solanas*, 105.

203 **It would not hold up in court:** Fahs, *Valerie Solanas*, 113.

CHAPTER 15: LONESOME COWBOYS RIDING HIGH

205 **There likely had been a script in New York:** Dan Pavillard, "Wherefore Art Thou, Script," *Tucson Daily Citizen*, January 27, 1968.

205 **A simple leather belt would not do:** Gopnik, *Warhol*, 590.

207 **"Lucille Ball of the Underground":** "Long Live Viva, Warhol's Juliet," *Arizona Daily Star*, February 2, 1968.

207 **she was among "famous people":** Gopnik, *Warhol*, 593.

207 **the police photographed the audience:** Gopnik, *Warhol*, 593.

209 **"Toad—If I had a million dollars":** Valerie Solanas to Andy Warhol, letter, February 7, 1968, The Andy Warhol Museum.

209 **"You can shove your planefare up your ass":** Valerie Solanas to Andy Warhol, letter, February 10, 1968, The Andy Warhol Museum.

209 **"a few other things":** Fahs, *Valerie Solanas*, 119.

209 **costar alongside Julie Harris on Broadway:** Joan Walker, "Meanwhile, Folks, Back in Soap City," *New York Times*, April 5, 1970.

210 **Viva arrived with marijuana that she said:** AWT.

210 **"Pig!" he kept shouting at her. "Pig!":** AWT.

210 **"Yeah, Jesus, real cute woman":** Marco St. John interview.

210 **She told the others she had suffered two nervous:** AWT.

211 **Goldsmith was trying to make:** "Barbara Goldsmith," Wikipedia, https://en.wikipedia.org/wiki/Barbara_Goldsmith.

212 **"What do you think you're doing?":** Barbara Goldsmith, "La Dolce Viva," *New York*, April 29, 1968.

213 **"Every journalist who is not too stupid":** Janet Malcolm, "The Journalist and the Murderer," *New Yorker*, March 5, 1989.

213 **"No, no, don't get dressed":** *New York*, April 21, 2016.

214 **St. John has no recollection:** Marco St. John interview.

214 **"terrible mistake":** *"La Dolce Viva,"* Wikipedia, https://en.wikipedia.org/wiki/La_Dolce_Viva.

CHAPTER 16: THE DOORS ARE LOCKED

216 **"Oh, Valerie!" Warhol shouted. "No! No!":** Bockris, *Warhol*, 298.

216 **ricocheted through his esophagus, gallbladder, liver, spleen, and intes-
tines:** Bockris, *Warhol*, 303.

216 **"It hurt so much, I wished I was dead":** Fahs, *Valerie Solanas*, 137.

218 **picking up a check for $50 to pay:** Gerard Malanga interview.

218 **she lit fourteen candles:** Witts, *Nico*.

218 **"The police are looking for me":** Fahs, *Valerie Solanas*, 141.

218 **"You can ride along only so far with Viva":** Valerie Solanas to Andy Warhol,
letter, October 4, 1968, The Andy Warhol Museum.

219 **"reckless assault with intent to harm":** "Valerie Solanas," Wikipedia,
https://en.wikipedia.org/wiki/Valerie_Solanas.

219 **"He always thought he was going":** "Factory Workers Warholites Remem-
ber: Brigid Berlin," *Interview*, November 30, 2008.

219 **a portrait by seventy-year-old Alice Neel:** The artist Wilma Siegel pointed
out the importance of the Neel portrait.

219 **Brigid took several Polaroid snapshots:** Brigid Berlin, *Polaroids*, ed. Dagon
James, Vincent Fremont, and Anastasia Rygle (New York: Reel Art, 2015),
144–48.

220 **"a movie that was pure fucking, nothing else":** Warhol and Hackett, *Pop-
ism*, 371.

220 **"Andy came out of the hospital a different person":** Viva interview.

220 **contemplated selling Warhol's address book:** AWT.

221 **"the fucking one":** AWT.

221 **"about the Vietnam War and what we can do about it":** *"Blue Movie,"* Wiki-
pedia, https://en.wikipedia.org/wiki/Blue_Movie.

221 **moonlit as an assistant to the manager:** George Abagnalo interview.

221 **"The manager stood looking through the glass doors":** George Abagnalo
interview.

222 **Warhol thought it "ridiculous":** Warhol and Hackett, *Popism*, 371.

222 **the park was a spot to be avoided:** Gopnik, *Warhol*, 688.

222 **"The new art is really a business":** Gopnik, *Warhol*, 700.

223 **"the holy whore of art history":** Barbara Rose, "In Andy Warhol's
Aluminum Foil, We All Have Been Reflected," *New York*, May 31,
1971, 56.

223 **"Andy doesn't believe in art":** Brigid Berlin interview in *Andy Warhol: Tran-
script of David Bailey's ATV Documentary*.

223 **"I think Andy is a business genius"**: Brigid Berlin interview in Bailey, *Andy Warhol: Transcript of David Bailey's ATV Documentary*, 706.

CHAPTER 17: THE LAST SUPERSTAR

225 **"I still can't believe it happened, Andy"**: Mario Amaya, "Reflections on the Day a Girl Shot Andy Warhol and Mario Amaya," *Nova*, December 1969.

227 **"thousands of elderly women, weeping young men"**: *New York Times*, June 27, 1969.

229 **Producer Dore Schary said *The Prodigal***: "The Prodigal," Wikipedia, https://en.wikipedia.org/wiki/The_Prodigal.

229 **a yellow towel to look like Lana's blond hair**: Paul Morrissey and Candy Darling interview in *Andy Warhol: Transcript of David Bailey's ATV Documentary*.

229 **"I have lived most of my life"**: Cynthia Carr, *Candy Darling: Dreamer, Icon, Superstar* (New York: Farrar, Straus and Giroux, 2024), 591.

229 **"Someday, I'll be a movie star"**: Susan's Place: Transgender Resources.

231 **outgrowth between her legs that she called her "flaw"**: Warhol and Hackett, *Popism*, 282.

231 **preferred making money turning tricks**: Carr, *Candy Darling*, 48.

231 **dressed like a Catholic schoolgirl in a pristine white**: Carr, *Candy Darling*, 55.

232 **"When people talk about how courageous Candy"**: George Abagnalo interview.

232 **"I've been treated with incredible cruelty"**: Candy Darling, interview with Aaron Bates, no date, The Andy Warhol Museum.

CHAPTER 18: THE DYING SWAN

234 **"I could see she had real problems with her teeth"**: Warhol and Hackett, *Popism*, 283.

234 **"People began identifying a little more"**: Warhol and Hackett, *Popism*, 281.

234 **"A skinny actress billed as Candy Darling"**: Dan Sullivan, "Cloudland Revisited in Off Off Broadway Play," *New York Times*, October 4, 1967.

235 **"pretty soon I'll have to let you all in, and what d'ya"**: Carr, *Candy Darling*, 150.

236 **"Andy not only did not try":** William Grimes, "A Warhol Director on What Is Sordid, Then and on MTV," *New York Times*, December 26, 1995.

236 **"You've made me old before my time!":** Vincent Canby, "Warhol's 'Women in Revolt,' Madcap Soap Opera," *New York Times*, February 27, 1972.

237 **Abagnalo got him a senior:** George Abagnalo interview.

238 **funeral be as cheap as possible:** Gopnik, *Warhol*, 742.

239 **"God is guiding me into this":** Carr, *Candy Darling*, 181.

239 **"Andy and I mobbed at Gauman's":** Candy Darling to Hi Kids, undated letter, The Andy Warhol Museum.

240 **gave Darling the $150 an appointment:** Carr, *Candy Darling*, 245.

241 **"I do not know happiness":** Bill Brownstein, "Mystery of Candy Darling Revealed in Documentary," *Gazette* (Montreal), May 27, 2011.

241 **"someday they are sure to be worth money":** Candy Darling, undated letter to friend, The Andy Warhol Museum.

242 **"I am just so bored by everything":** Candy Darling to To Whom it may concern, undated note, The Andy Warhol Museum.

243 **"do you think I will leave some kind of":** Robert Heide, "Candy Darling," The Andy Warhol Museum.

243 **Darling called Campbell's:** Carr, *Candy Darling*, 424.

CHAPTER 19: THE ETERNAL MYSTERY

246 **"Look at Brigid":** Joseph Gelmis, "Above Ground," *Newsday*, June 14, 1969.

246 **enormous pair of binoculars, watching the scenes:** Raymond R. Coffey, "London Critics Murder Andy Warhol's 'Pork,'" *Detroit Free Press*, August 6, 1971.

247 **excoriating parents who sounded distressingly:** Fremont and Fremont, *Pie in the Sky*.

247 **"I'm having my period":** George Abagnalo interview.

248 **she was never high enough:** AWT.

248 **cleanse it with Old Glory Extra-Professional-Strength shampoo:** Warhol, *The Philosophy*, 201.

248 **Her feet hurt, probably:** AWT.

248 **Brigid told Viva she had become mad:** AWT.

248 **at one point, she contemplated suicide:** Brigid Berlin interview in *Andy Warhol: Transcript of David Bailey's ATV Documentary.*

250 **"Laurence Olivier doing Richard the Third":** Bickerdike, *You Are Beautiful,* 203.

250 **"I have found the way to turn my shame":** Witts, *Nico,* loc. 4670.

CHAPTER 20: JUST ANOTHER PARTY

253 **they started talking just like old times:** AWT.

253 **They drove up the Hudson:** Edie Sedgwick, tape of conversation; *Ciao! Manhattan,* JSP; Stein, *Edie,* 366.

254 **She could hardly walk and talk:** Stein, *Edie,* 370.

254 **"Hey, Gerard, I have to ask you for something":** AWT.

255 **"The *way* those sons-of-bitches took advantage of me":** Stein, *Edie,* 376.

255 **David Weisman, came to her seeking:** Stein, *Edie,* 388.

256 **purging her mind of suicidal thoughts:** Stein, *Edie,* 399.

258 **"She suffocated":** Brigid Berlin transcript at The Andy Warhol Museum.

258 **"Warhol is in a lot of ways inscrutable":** George Abagnalo interview.

259 **photo booth strip shot of Edie:** De Salvo et al., *Andy Warhol,* 230.

BIBLIOGRAPHY

Alexander, Paul. *Death and Disaster: The Rise of the Warhol Empire and the Race for Andy's Millions.* London: Warner Books, 1998.

Arman, Corice, et al., *Warhol Women.* New York: Lévy Gorvy, 2019.

Auder, Alexandra. *Don't Call Me Home.* New York: Viking, 2023.

Berlin, Brigid. *Brigid Berlin: Polaroids.* Edited by Dagon James, Vincent Fremont, and Anastasia Rygle. New York: Reel Art, 2015.

Bickerdike, Jennifer Otter. *You Are Beautiful and You Are Alone: The Biography of Nico.* New York: Hachette, 2021.

Bockris, Victor. *Warhol: The Biography.* London: Penguin, 1990.

Bockris, Victor, and Gerard Malanga. *Up-Tight: The Velvet Underground Story.* New York: Cooper Square Press, 2003.

Bourdon, David. *Warhol.* New York: Abrams, 1989.

Brutvan, Cheryl. *To Jane, Love Andy: Warhol's First Superstar.* West Palm Beach, FL: Norton Museum of Art, 2014.

Carr, Cynthia. *Candy Darling: Dreamer, Icon, Superstar.* New York: Farrar, Straus and Giroux, 2024.

Dalton, David. *A Year in the Life of Andy Warhol.* New York: Phaidon, 2003.

Darling, Candy. *Candy Darling: Memoirs of an Andy Warhol Superstar.* New York: Open Road Integrated Media, 2015.

Dederer, Claire. *Monsters: A Fan's Dilemma.* New York: Knopf, 2023.

Degen, Natasha. *Merchants of Style: Art and Fashion After Warhol.* London: Reaktion Books, 2023.

De Salvo, Donna, et al. *Andy Warhol: From A to B and Back Again.* New York: Whitney Museum of American Art, 2018.

Fahs, Breanne. *Valerie Solanas: The Defiant Life of the Woman Who Wrote SCUM (and Shot Andy Warhol).* New York: Feminist Press at CUNY, 2014.

Finkelstein, Nat. *Andy Warhol: The Factory Years, 1964–1967*. New York: power-House, 1989.

Finkelstein, Nat, and David Dalton. *Edie, Factory Girl*. New York: powerHouse, 2007.

Fitzgerald, F. Scott. "The Rich Boy." In *The Short Stories of F. Scott Fitzgerald*. New York: Scribner, 1995.

Gilot, Françoise, and Carlton Lake. *Life with Picasso*. Harmondsworth, UK: Penguin, 1966.

Goldsmith, Kenneth, ed. *I'll Be Your Mirror: The Selected Andy Warhol Interviews: 1962–1987*. New York: Da Capo Press, 2009.

Gopnik, Blake. *Warhol*. New York: Ecco, 2020.

Guiles, Fred Lawrence. *Loner at the Ball: The Life of Andy Warhol*. New York: Bantam Press, 1989.

Hanhardt, John G., ed. *The Films of Andy Warhol Catalogue Raisonné: 1963–1965*. New York: Whitney Museum of American Art, 2021.

Hermes, Will. *Lou Reed: The King of New York*. New York: Farrar, Straus and Giroux, 2023.

Hughes, Robert. *The Shock of the New*. New York: Knopf, 1991.

Huxley, Geralyn, and Greg Pierce, ed. *Andy Warhol's "The Chelsea Girls."* New York: Distributed Art Publishers, 2018.

Jones, Dylan. *Loaded: The Life (and Afterlife) of the Velvet Underground*. New York: Grand Central, 2023.

Leamer, Laurence. *Madness Under the Royal Palms: Love and Death Behind the Gates of Palm Beach*. New York: Hachette, 2009.

Scherman, Tony, and David Dalton. *Pop: The Genius of Andy Warhol*. New York: Harper, 2009.

Shore, Stephen, and Lynne Tillman. *Factory: Andy Warhol*. London: Phaidon, 2016.

———. *The Velvet Years: Warhol's Factory, 1965–67*. New York: Thunder's Mouth Press, 1995.

Shorr, Catherine O'Sullivan. *Andy Warhol's Factory People*. New York: CreateSpace, 2014.

Smith, Patrick S. *Andy Warhol's Art and Films*. New York: Umi Research, 1986.

Solanas, Valerie. *SCUM Manifesto*. New York: VandA, 2016.

Stein, Jean. *Edie: American Girl*. Edited by George Plimpton. New York: Grove Press, 1982.

Ultra Violet. *Famous for 15 Minutes: My Years with Andy Warhol*. New York: Harcourt, 1988.

Viva. *Superstar*. New York: Open Road Integrated Media, 2015.

Warhol, Andy. *a: A Novel*. New York: Grove, 1998.

———. *The Philosophy of Andy Warhol: From A to B and Back Again*. Boston: Mariner Books, 1977.

Warhol, Andy, and Pat Hackett. *The Andy Warhol Diaries*. New York: Twelve, 2014.

———. *Popism: The Warhol Sixties*. London: Penguin, 2007.

Watson, Steven. *Factory Made: Warhol and the Sixties*. New York: Pantheon Books, 2003.

Wilcock, John. *The Autobiography and Sex Life of Andy Warhol*. New York: Trela Media, 2010.

Wilson, Colin. *The Outsider*. New York: Penguin Books, 2016.

Witts, Richard. *Nico: The Life and Lies of an Icon*. New York: Virgin, 1993.

Wohl, Alice Sedgwick. *As It Turns Out: Thinking about Edie and Andy*. New York: Farrar, Straus and Giroux, 2022.

Wolfe, Tom. *The Kandy-Kolored Tangerine-Flake Streamline Baby*. New York: Farrar, Straus and Giroux, 1987.

———. *The Painted Word*. New York: Farrar, Straus and Giroux, 1975.

Woodlawn, Holly, and Jeffrey Copeland. *A Low Life in High Heels: The Holly Woodlawn Story*. New York: Harper, 1992.

Woronov, Mary. *Swimming Underground: My Years in the Warhol Factory*. London: Serpent's Tail, 2000.

Wrbican, Matt, et al. *A Is for Archive: Warhol's World from A to Z*. New Haven, CT: Yale University Press, 2019.

PHOTO CREDITS

INDEX

ABOUT THE AUTHOR

New York Times bestselling author **Laurence Leamer** is a leading biographer of the rich and powerful, whose books include *Capote's Women*, *Hitchcock's Blondes*, *Madness Under the Royal Palms*, and *The Kennedy Women*, among many others. He lives in Washington, DC, and Palm Beach, Florida.

VISIT THE AUTHOR ONLINE

Leamer.com

🅕 LaurenceLeamerAuthor

𝕏 Leamer